Midnight Fires

Midnight Fires

A MYSTERY WITH

MARY WOLLSTONECRAFT

Nancy Means Wright

2010
McKinleyville / Palo Alto
John Daniel & Company / Perseverance Press

A Perseverance Press Book
Published by John Daniel & Company
A division of Daniel & Daniel, Publishers, Inc.
Post Office Box 2790
McKinleyville, California 95519
www.danielpublishing.com/perseverance

Distributed by SCB Distributors (800) 729-6423

Book design by Eric Larson, Studio E Books, Santa Barbara, www.studio-e-books.com
Cover image: *Mary Wollstonecraft* by John Opie, oil on canvas, ca. 1797, courtesy of National Portrait Gallery, London

10 9 8 7 6 5 4 3 2 1

LIBRARY OF CONGRESS CATALOGING-IN-PUBLICATION DATA
Wright, Nancy Means.
 Midnight fires : a mystery with Mary Wollstonecraft / by Nancy Means Wright.
 p. cm.
 ISBN 978-1-56474-488-3 (pbk. : alk. paper)
 1. Wollstonecraft, Mary, 1759–1797—Fiction. 2. Governesses—England—Fiction.
 3. Murder—Investigation—Fiction. I. Title.
 PS3573.R5373M53 2010
 813'.54--dc22
 2009020415

For Llyn and for my extended Scots-Irish family

And in memory of Dennie Hannan,
who introduced me to his own
County Cork in Ireland

Acknowledgments

First of all, thanks and gratitude to my wise and wonderful editor, Meredith Phillips, who guided me through the wilderness of my first historical novel, calmed my excesses, curtailed my run-on sentences, and rooted my language and characters firmly in the eighteenth century. And to John and Susan Daniel, who welcomed me with grace and good humor into the folds of their press, which already feels like family. And thanks to Eric Larson, who served beyond the proverbial call of duty.

And as always, thanks to my own extended family for their encouragement and loving support; and to Llyn Rice, my *magister factotum*, who once again responded to a plethora of *how to, how about*, and *how can I* questions, who took my photograph, crafted the Family Trees, and brought my computer to life when it crashed. To my daughter Catharine and my writers' group, who offered readership and helpful feedback on portions of the book; to my son Donald and his Very Merry Theater children's production of *A Midsummer Night's Dream* which inspired Chapter XIV of this novel; to the Reverend Johanna Nichols and the Champlain Valley Unitarian Universalist Society who responded enthusiastically to readings and reflections on my favorite subject: the life and times of Mary Wollstonecraft.

A special appreciation to Kathy Lynn Emerson for reminding me of the importance of "Research! Research!" in her delightfully informative *How To Write Killer Historical Mysteries*, and to the online CrimeThruTime discussion group who responded to my queries and "kept me at it."

Last, and emphatically not least, I could not have written this book without the imagination and scholarship of the following books:

Janet Todd: *Mary Wollstonecraft: A Revolutionary Life; Daughters of Ireland; The Collected Letters of Mary Wollstonecraft*
Clare Tomalin: *The Life and Death of Mary Wollstonecraft*
Diane Jacobs: *Her Own Woman: The Life of Mary Wollstonecraft*
Lyndall Gordon: *Vindication: The Life of Mary Wollstonecraft*
Ruth Brandon: *Governess*
Frances Sherwood: *Vindication* (novel)

Also many books and novels of the period:
Mary Wollstonecraft: *Mary, a Fiction; Thoughts on the Education of Daughters; Original Stories from Real Life* (illustrated by William Blake); *A Vindication of the Rights of Woman*
William Godwin: *Memoirs of Mary Wollstonecraft; The Adventures of Caleb Williams*
Maria Edgeworth: *Castle Rackrent* (memoir-novel)
Sydney Owenson: *The Wild Irish Girl* (novel)
Fanny Burney: *Evelina*; *Cecilia*; *Camilla* (novels)
Charlotte Smith: *Emmeline*; *Desmond* (novels)
Eighteenth-century plays by Steele, Goldsmith, Fielding, and Sheridan; and Irish plays by J.M. Synge, including *Riders to the Sea* and *The Playboy of the Western World*, both of which I've directed and acted in, and are in my bones.

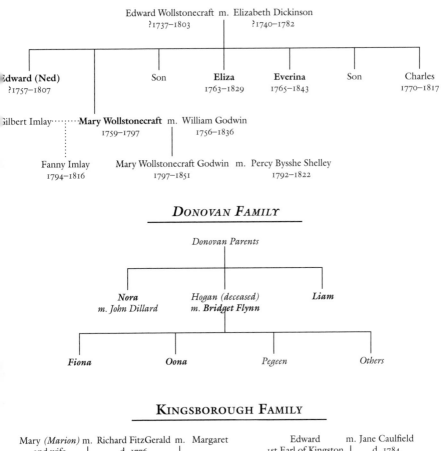

WOLLSTONECRAFT FAMILY

Edward Wollstonecraft m. Elizabeth Dickinson
?1737–1803 ?1740–1782

Edward (Ned)	Son	**Eliza**	**Everina**	Son	Charles
?1757–1807		1763–1829	1765–1843		1770–1817

Gilbert Imlay · · · · · · · **Mary Wollstonecraft** m. William Godwin
1759–1797 1756–1836

Fanny Imlay Mary Wollstonecraft Godwin m. Percy Bysshe Shelley
1794–1816 1797–1851 1792–1822

DONOVAN FAMILY

Donovan Parents

Nora	*Hogan (deceased)*	**Liam**
m. John Dillard	m. **Bridget Flynn**	

Fiona	**Oona**	*Pegeen*	*Others*

KINGSBOROUGH FAMILY

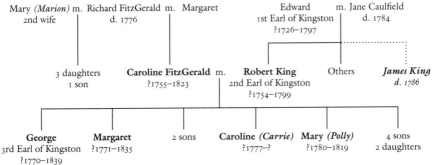

Mary *(Marion)* m. Richard FitzGerald m. Margaret Edward m. Jane Caulfield
2nd wife d. 1776 1st Earl of Kingston d. 1784
?1726–1797

3 daughters **Caroline FitzGerald** m. **Robert King** Others *James King*
1 son ?1755–1823 2nd Earl of Kingston *d. 1786*
?1754–1799

George	**Margaret**	2 sons	**Caroline *(Carrie)***	**Mary *(Polly)***	4 sons
3rd Earl of Kingston	?1771–1835		?1777–?	?1780–1819	2 daughters
?1770–1839					

NOTE: Fictional characters and nicknames are given in italics.

Contents

Preface

MARY WOLLSTONECRAFT shocked the eighteenth-century world with her outspoken views on marriage, child-rearing, and women's rights; her advocacy of divorce reform; and her endorsement of the French Revolution. She set off tempests of scandal through her passionate love affairs, the birth of her illegitimate child, and her suicide attempts. A "hyena in petticoats," a contemporary called her. Her short life was a continual struggle between her principles and her own sexuality. The struggle ended at the age of thirty-eight when she died after giving birth to a second, but this time legitimate, daughter, Mary Wollstonecraft Godwin. The latter married the poet Percy Bysshe Shelley, and true to her blood, wrote the science fiction fantasy *Frankenstein*.

Mary Wollstonecraft (pronounced *WOOLston-croft*) left numerous works to the world, including her famous *Vindication of the Rights of Woman*. Her spirited, often emotional letters are amply quoted in several excellent biographies, but no diary or journal has come down to us. Yet in her autobiographical novel, *Mary, a Fiction*, the author writes: "She retired to her cottage and wrote in the little book that was now her only confidante. It was after midnight."

There is no doubt in my mind but that Mary did keep a journal, one in which the writing would be infinitely more personal, more straightforward, more confessional than in any of her letters or literary works. This mythical journal has continued to gestate in my own late-night reveries. I had, in 1992, published a small-press chapbook of poems using the Wollstonecraft persona, and had often considered writing a fictional biography of her short, passionate life. But other projects invariably interrupted.

After publishing seven contemporary mystery novels, I finally

decided to tell her story in this genre, and as a third-person narrative, since many aspects of her life have the earmarks of intrigue. Mary herself was so strong-minded and impetuous, possessed of such a brilliant, inquiring mind, so intolerant of injustice and sham, that in my opinion she makes an extraordinary "sleuth." The dramatic real-life "kidnapping" of her younger sister from an abusive husband (mentioned only as background in this novel) is a case in point. Moreover, her unconventional life suggests that there were incidents that Mary would never describe in letters to her more conformist siblings—that were for her midnight thoughts only.

In that vein I have taken the liberty of reconstructing her actual months as governess to the Anglo-Irish Kingsborough family as a novelist would, while remaining, for the most part, true to time, place, and several of the individuals historically connected with Mitchelstown Castle.

Its chatelaine, Caroline FitzGerald, was proud of her descent from the medieval White Knight (his name derived, in part, from the color of his armor), who built his castle in Mitchelstown, County Cork. In the seventeenth century a FitzGerald heiress married into the King family of civil servants, and the united tribe began its triumphant climb up the social ladder to become the barons "Kingston." When Edward King attained the rank of 1st Earl of Kingston in the mid-eighteenth century, his son Robert took on his father's title as Viscount, Lord Kingsborough. And when Robert married his cousin Caroline (the catch of the season), he inherited Mitchelstown Castle and built a whole borough, or town around it.

Although the viscount and viscountess, Lord and Lady Kingsborough, and their numerous offspring were a real part of Mary Wollstonecraft's life as governess in 1786, the scenes concerning the Kingsborough family's involvement with the local peasantry are wholly fictional. I have tried to stay close to Mary's character and personality; if the sequence of actual events during this period of her life is slightly altered, or the local geography, or the people involved, the reader will kindly indulge me.

You, the reader will, of course, be the final judge.

Nancy Means Wright

Midnight Fires

CHAPTER I.

A Most Humiliating Occupation

THE CROSSING from Holyhead to Dublin had been relatively calm, but just as the Irish coast came into view, a contrary wind blew up. Wrapped in her black greatcoat, Mary Wollstonecraft clutched the railing and watched the sky go purple, the clouds turn grey. Her stomach churned, her breath quickened. Wind tossed the packet boat to and fro like a child's toy in a pond. "I am that toy," Mary shouted into the wind. "I am a vessel of fate!"

The words blew back to her like an echo from the wailing sea.

Mary was on her way to Ireland to be a governess—a most humiliating occupation. She was still reeling from a catastrophic love affair. She was deeply in debt to a pack of hungry creditors. Her mother was dead. Her younger sisters had failed at the teaching posts she procured for them; they were hammering at her gates for help. To appease them, she was about to be delivered into the hands of one of the most notorious families in Ireland, and all for the paltry annuity of forty pounds.

She thought of the pound of flesh exacted by Shakespeare's Shylock; she worried that the Anglo-Irish Lord and Lady Kingsborough would extort that pound from her. Oh, she did hope her employers would be kind.

"Ahh!" The final blow: her beautiful new blue hat, the gift of a dear friend—whipped off her head by wind. She lunged for it. She teetered on a boot heel; pitched forward....

A callused hand yanked her back on her feet. She glanced about, hoping to see the young clergyman who had engaged her in dialogue when she first boarded the vessel. But it was not Henry Gabell. It was a blue-jacketed, claret-haired sailor who handed over the drenched hat. "Powerful wind, eh, miss?"

Her feet more stable on the deck now, she thanked him and lifted her chin to show that Mary Wollstonecraft was not to be undone by a vagary of nature. In his solemn eyes she saw an appreciation for her person. "You're a brave one, you are, to be out here on the deck," he said in the thick brogue of the Irish peasant, "but 'twill blow over soon. I've seen the like. We'll be in port and headed for home, by the grace of God."

He spoke the word *home* longingly, as though he had been away a long time, and she asked if he had. Her spirits rose to be conversing with such a sturdy, well-formed lad. Men of her own class, she had lately discovered, were not only untrustworthy—but downright boring.

"In the American Colonies," he said, "and then back over the seas again, and of late in England."

Mary was intrigued: the English newspapers had earlier announced the ascendancy of the rebel colonists. *Boors*, the London journalists called them, but if there was one trait she valued in man or woman, it was a spirit of independence. She offered the sailor her opinion.

"And whose side did you favour?" she demanded. His thick hair was pulled back in the long pigtail of the common sailor—was the American Revolution fought, as well, by sea? She was not able to keep up with *all* the news. Or afford the papers that broadcast it.

It was the rebels who had his sympathy, he confided—in a half whisper as though an English officer might overhear and string him up from the yardarm for treasonous remarks. "An Irishman fight for the English? By Christ, I'd die first!" His voice grew husky, passionate, although he continued to glance about for eavesdroppers. He was only a year in the Colonies, he allowed; he had won a few pounds in boxing matches, and purchased a bit of land in a place called Massachusetts.

"Where they had the Tea Party!" she cried. She recalled talk of a Boston "tea party" that had eventually exploded into cannon shots. And then blood. She frowned to think of the blood. Her youngest brother, Charles, was talking of America. And having no other occupation, would probably go there and join the rebels—if, indeed, the bloodshed was over. Charles was no fighter; he wasn't much of anything, to tell the truth.

The sailor looked amused, then serious again. Someone was

waiting for him in Ireland, he said; he would take her back to America with him. He was blushing as he spoke.

Mary liked a man who was able to blush. She liked a romantic tale, although she struggled against the sentiment in herself, and in her sisters, who had a predilection for mawkish novels.

But he was still talking.

"In good time, that is," he said with an upthrust of his squarish chin. First he had things to do in his native country—he was a loyal patriot. He had been shipping between Ireland and England for ten months now, working toward his goal. He did not say what goal, but Mary suspected; she was aware of the Irish troubles. North Cork, for instance, where she was headed, had a long history of violence between rulers and ruled.

She smiled to show her support for his cause (and he *was* charming).

Mary had Irish blood herself on her mother's side—though this fellow was probably Catholic; her late mother was from County Donegal, a long way north of the Mitchelstown castle where her daughter was about to be incarcerated. Was it a prison she was headed for? She had heard tales of the confinement for a governess: the control, the isolation. And what would happen when they discovered her poor French, her lack of skill with the needle? Her halting fingers on the keys of the pianoforte? The application had called for a woman proficient in all those skills, and desperate for the position, she had applied. And then had to beg her older brother, Ned, for guineas enough to buy cloth for a greatcoat. It was damp, they said, in Ireland, damper even than mouldy England. She shivered to think of it.

"Now where," the sailor asked, "would a young lady such as yourself be going in Ireland? To Dublin, I suppose? There's a fine theatre there, they say, though I never been. Nor can I," he added, holding out empty palms to show his lack of birth and funds. There was the flash of a dimple in his rugged cheek, a hint of scorn in the blue, blue eye.

Did she hear the slightest mockery when he said *lady*? He was looking at her shabby boots. Never mind. She vented her concern about being a governess—an inferior sort of position, she added, neither fish nor fowl, neither lady nor servant. It was a species of nursemaid to three ungrateful and raucous (no doubt) young girls.

"And in the bargain," she said hotly, glad for an unjudgemental ear, "vulnerable to ill treatment by Lord Robert Kingsborough, heir to an earldom, I'm told, and master of thousands of Irish acres in Mitchelstown and its hapless peasants."

She paused to draw breath. She might have exaggerated about the ill treatment—she had only heard rumours about the family. But she made her point. The sailor nodded; his cheeks reddened as if he knew. Already the Kingsborough family had exploited her: she had been summoned to Eton College, that den of fancy dress and ridicule, to meet the girls who would be in her charge—to find the family already departed for Ireland. "And they left me to their son, George King, who handed me the fare as if I were some beggar girl, and then galloped off to play a match of cricket!" Her brow ached to think of the young snippet.

The sailor listened intently, clucking his tongue, blinking his eyes; they were the colour of the sea (Did he have salt water mixed with blood in his veins?). He seemed excited to hear her story, to hear the mention of Mitchelstown. He was about to speak when a burly seaman shouted his name: "Sean Toomey? You're wanted for'ard." And nodding an anxious apology, her sailor dashed off.

The storm appeared to subside as the packet sailed into the Bay of Dublin. But then the wind blew up again and kept the boat beating about the coast for the better part of an hour. Gusts of rain forced Mary back toward the ladder that led below decks. Grabbing at rope and rigging, she staggered about like the proverbial drunken sailor. She had almost reached the ladder when her sailor reappeared, thrusting something at her—a letter? He pressed it into her hand. "Deliver it for me, I'm begging you," he pleaded, his face as white as his teeth, his cheeks blowing in and out.

The ship lurched and threw her against him; he gripped her shoulders and helped her to grasp the ladder. She squinted down at the letter. *For Liam.* "Liam who? Where does he live?" Mary called to the fellow, who had already turned away. "I'm only going to Mitchelstown, I said. Mitchelstown," she shouted over the screech of sails, the howl of wind, the hallooing seamen. In tiny letters at the bottom of the letter she saw it was to be delivered to a Liam in Mitchelstown—the reason, perhaps, for his pursuing the conversation. "Wait! You must find someone else to deliver it." Holding

on to her hat with one hand, the rigging with the other, she reeled about to find him.

He was nowhere in sight. She was sorry now that she had told him her destination. If she could not find a Liam, so be it. She thrust the letter into the pocket of her greatcoat.

"Mercy!" a woman cried, clapping a hand on her arm. "Look!" She pointed toward the bowsprit. "Must of fell, eh, poor man?"

Mary glanced back to see a sailor plummeting into the water. Flying! She watched, incredulous, too shocked to speak. Down he flew like a wounded gull, somersaulting into the water. An outcry rose up: folk shouting, peering into the sea. It was her sailor; she was sure of it. That blaze of blue eye, the streak of claret hair.

The fellow did not come up at all. The sea had swallowed him whole.

"Ho!" she shouted, racing along the deck. "Help! Man overboard. Go after him—someone—quick!"

Wind and surf drowned her words. Already the sailors were scurrying back to their duties—none would dare those churning waters.

She yanked on the sleeve of a passing steward and poured her anguish into his ear. He looked at her blankly. "I saw it," she said. "He was there on the bowsprit. He fell."

The fellow shrugged. "Lose their balance, they fall. Happen he'll float up on shore."

Something had flashed at the sailor's neck as he fell, she was sure of it. A knife? Or a shaft of light on a button... For the wind had abated as her sailor had predicted; the sun was pushing through the shredding clouds. She demanded to see the captain but was told it was impossible. "Not now," the steward said, "not when we're coming into port." He waved her off like a buzzing fly.

"Then take a note to him! He must search the waters," she cried, hanging on to his sleeve, offering half a crown (Was it her last?). To be rid of her, the man agreed.

She stumbled down the ladder, out of the sea spray, to write it. But even as she wrote, she knew the officer would only yawn. What was the death of an Irish sailor to an English captain?

The steward who came for the note—grudgingly, though he pocketed the coin—informed her that a small boat would soon arrive for passengers who wished to disembark. Feeling a little better

for having done what she could for the hapless sailor, she gathered her things and went out to watch the preparations for landing: the furling of sails, the unloading of baggage and mail sacks, the anchor splashing into the sea. And finally, a boat was on its way to the packet, rowed by six bareheaded men in checkered shirts and trousers.

Just as they were about to lower passengers into the boat, the clergyman, Henry Gabell, loomed up behind, his face polite and smiling. He was a man, she had recognized, of sensibility. Would they meet again? Oh, she prayed so. It was cruel going alone into exile. She was in desperate need of a friend.

"If you come to Dublin," Mr. Gabell said, a little offhand, but looking her in the eye, "we must meet. I'll be at this address when I'm off duty." He delivered a note into her palm and she felt the heat up in her cheeks, the spray warm on her face. She squeezed his hand and flashed her gayest smile. For a moment she was younger than her seven-and-twenty years—almost carefree.

Though *carefree* was not a word, was it, in her life's vocabulary? An eldest daughter in charge of five siblings since the remarriage of a spendthrift father. Her shoulders shrank with the responsibility of it.

The clergyman hurried down into the boat. The sun turned his queue of brown hair to chestnut. He was waving at a bonnet full of feathers on the distant pier. His mother? He had not mentioned a mother. A sister? Oh, she couldn't bear another deception. Though he was not all that attractive, was he? Protruding ears, a receding chin. She found her Irish sailor more appealing. Nay, already past tense, she thought, for where was he now? Food for fishes? Would they find his body? Surely he must have a mother waiting, or a sweetheart. She touched his letter, soaked with sea spray, wetting her greatcoat pocket (Would it weaken the uneven threads?), dampening her mood.

What was she to do with it?

She was hustled down into the boat and seated between two massive men. The word *abducted* came to mind as she was swept through mountainous waves toward land. The oarsmen sang as they rowed; her heart was a set of trap drums. She felt faint, breathless. The sailor was falling and falling behind her eyes; the knife flashed again and again. She was crossing the River Styx and on her

way to the other side, her days already spent. Mary Wollstonecraft: 1759–1786. The epitaph bled into her shut lids.

And the letter: boring a hole in her pocket. Now she felt put upon. Where was she to find this Liam in a town full of Liams? Why, she knew half a dozen who had come to England to take menial jobs there! Why had this stranger assigned her such a task when already she had mountains to move? Was it her fault he had jumped off the ship?

Or was stabbed—or pushed… Dear God. She shut her eyes to the possibility; she clasped her hands together. "Our Father who art in…" (She was not one for frequent prayer; of late she had spent her Sunday mornings among Dissenters. But now and then there came a need.)

Before she could finish the prayer, they were at the pier. She was jostled by hawkers, tinkers, begging children, pickpockets, painted prostitutes; claimed at last by a dour butler and his pockfaced wife. They had been sent, they said, frowning at her scuffed boots, her ripped hems, her soaked and shaggy hair, to accompany her to Mitchelstown Castle.

She was shoved like a sausage into a smelly post-chaise. "Someone up there," she pleaded, silently lifting her eyes, "help me to bear this!" The chaise jolted forward, the only response not from above, but from the round-bellied butler:

A stentorian snore.

CHAPTER II.

Pandemonium—
and a Missing Letter

MITCHELSTOWN CASTLE loomed above the trees: a square Palladian house built of stone on the ruins of a medieval castle, complete with wings at its sides that led the eye up and up to the thirteenth-century White Knight's Tower. "Rapunzel, let down your hair," Mary whispered. She imagined herself imprisoned in that crumbling tower. But what white knight would come to free *her*?

The post-chaise rattled on past landscaped gardens, statued promenades, lakes, vineyards, conservatories, pastures filled with grazing cattle, woods replete with oak, beech, ash, and mulberry trees—all of it, according to Dillard, the butler, part of the twelve hundred acres that surrounded the great house. The King family, Dillard informed Mary, had rebuilt the entire town: Protestant church, almshouse, orphanage, dairy, hospital, gaol. A river wound through the grounds; it deepened here and there into red sandstone whirlpools and then poured like a snake into a great waterfall. Lord Kingsborough owned the river, too, along with the swans, eels, turbot, and dragonflies floating in it.

No doubt, Mary thought, he owns the birds flying overhead, and the seven blue-green mountains of the Galtees that surround the land. A great lord indeed, and still in his early thirties.

But there was something about the place that froze the blood. She felt swept through the great gates as if entering the Bastille, the cold and gloomy Parisian prison that turned one to stone; to a living death.

She repinned the blue hat on her pounding head—it had been knocked off some twenty times during the three-day journey from Dublin to Mitchelstown in County Cork—and stumbled out of the

coach. She twisted an ankle, was caught by Dillard, who was wide awake now. He was a middle-aged Englishman who spoke with a Yorkshire accent. His Irish wife, Nora, the housekeeper, was plump and plain, perhaps a decade his junior. Taking Mary's other arm, she muttered something in a thick brogue that seemed a warning; the words were inaudible against the cacophony at the main entrance where an army of housemaids, nursemaids, scullery maids, and grooms were pouring out on either side of the steps to greet her.

To greet *her?* Ha! She drew back. The great lord himself was emerging from a blue-and-gold carriage, assisted by a pair of simpering footmen. A rangy, elegantly dressed man, he sprang up the marble steps; the servants humbled themselves. Catching sight of Mary, his eyes widened as if to say, Ah, yes, there was some creature supposed to arrive today.

His unsmiling eyes took in her soiled person from skewed blue hat to mud-caked boots. Finding her wanting, he murmured: "Sorry, madam, but my wife is confined to her bed with an ague. I was to greet you but your coach is long overdue, and in a moment I must be off again. Affairs to tend to, I'm afraid. My people here will see to your needs." He waved vaguely at the assembled crew. A pack of yapping dogs raced out of the castle as he entered; his foot lifted as if to kick one aside.

Before she could mount the marble steps, a hurly-burly of children, along with a dozen dogs, surrounded her like gypsies. They looked her over, giggling, then raced around the front garden and back up the steps. Like wild Irish, she thought—the worst kind. Why had she come?

She knew why, she did not want to think about it. The staff shrank backwards into the house, leaving their party to enter alone. Exhausted, her nerves popping like fleas, she hung on the housekeeper's arm.

The place was in pandemonium. Children and servants were running in every direction, scolded now and then by the housekeeper; Mary hoped she would not have to learn all their names. She was mainly to concern herself with the three older girls: Margaret, Carrie, and Polly. A tall, awkward-looking girl with large, pale arms folded across her chest scowled at her, then dashed off into an adjoining room. Margaret? Such a lanky, disagreeable-looking

child! Mary understood at once that, as governess, she was to be the enemy.

Her attention was caught by a manservant who was sweeping the great staircase as he descended, with his wig. At the bottom, he clapped it on his head and a cloud of dust rose up. Maidservants scurried past with mops, pails, dusters, and trays. A big-bosomed woman hurtled towards her. Mary's first impression was of a canary with a birdcage on its head. The Canary managed to lisp out its life history in practically a single breath:

"I am fifth cousin to Lady Kingsborough. My husband is the agent here—he oversees the tenants. No rackrenting, I assure you, my stars, no—we never exploit! My husband, Willard, like Lord Kingsborough, is bent on improving the lot of the peasant. You can see already what milord has done. Stone houses for the staff, wood and slate cottages for some of the tenants. Soon we'll have all the mud hovels replaced—though they're never grateful, those peasants." She gasped between phrases (due to her tight stays, no doubt), and stared accusingly as though Mary had argued some contrary viewpoint.

Mary felt a sigh coming up out of her toes. She wanted to un-pack, that was all, to wash and change into a fresh gown. She was still itching from flea bites at the inns they had slept in during the tedious trip to Mitchelstown. She longed for a nap. Only then, if then, might she be ready to face down the gaggle of feathered Ascendancy ladies peering out at her from the drawing room.

The Canary gave a toothy smirk, pulled at a jade earring, and announced that milady wished to meet the new governess. "Lady Kingsborough is in bed—a monstrous wicked throat, you know. You had best keep your distance." When Mary frowned, she squealed: "Oh, I suppose you're tired from the journey. But you must greet her. Milady does not, I repeat, does *not* like to be kept waiting."

With each *not*, her extended palms pushed the new governess a step backward. Was Mary to go or stay?

A small boy came running after a white poodle; the dog reversed direction, jumped up at Mary, and the sailor's letter fell out of her greatcoat pocket. "Careful now, Tommy," the housekeeper, Nora, said, patting his blond head. She picked up the note. "Liam," she murmured, almost caressing the name, as though it were familiar to

her. She held out her arms for the greatcoat and returned the letter to its pocket. She ordered one of the running maidservants to "take it to the governess's bedchamber. And be quick about it."

"Do you know a Liam in these parts?" Mary asked, though in a half-hearted way, for she was quite overcome by this household: its size, smells, the sheer volume of it.

The housekeeper was wary. She glanced at the Canary who was whispering to the maidservant who was now cradling Mary's homemade greatcoat. "Liam," Nora said softly. "'Tis a common enough name."

"Her ladyship is waiting," sang the Canary. She wheeled about and her birdcage listed sideways; her whirling skirts and petticoats stirred up a small windstorm.

MRS Cutterby, for that, Mary was informed, was the Canary's name, curtsied deeply at the door of milady's bedchamber. "Say *yes* to everything," she told Mary. And curtsying again with a birdlike squeak, she withdrew.

"No," Mary replied when the viscountess asked if she'd had a pleasant journey. Already Mary had decided that she would present a forthright face to this turbulent household. She added a word or two of description about the previous night's inn—her flesh was still crawling—and to her surprise, Lady K laughed.

Lady K lay sprawled on satin pillows in a rose-coloured dressing gown, her hair full of feathers as though the pillows had come undone in a wind and exploded about her face. She was pretty, Mary had to admit, with her milky skin and mahogany hair, her fine-boned face, full lips, ebony eyebrows plucked in a high curve to suggest an air of innocence. A small, round black patch was stuck on beside her nose. Mary stifled a laugh.

The bed was a helter-skelter of stuffed animals, satin puffs, vials of rosewater and cough medicine. An assortment of pet lapdogs stared at the visitor for an indecisive moment, then set up a high-pitched yapping that split the eardrums. The smell of unwashed flesh and perfume was more than Mary could bear. She looked longingly at the mullioned windows where breaths of air filtered through, and flattened herself against the oak door. Another snuffling sound issued from the bed.

Was the governess being laughed at?

"We all have our crosses to bear," said the lady. She was thinking perhaps of her brood of twelve children, the eldest born, Mary had heard, when she was not yet sixteen. "But you will find your room quite comfortable, I dare say, Miss Wollstonecraft. If there is a problem, pray bring it to the attention of the housekeeper." *She* did not want to hear the complaint. A cross-looking toy bulldog licked milady's neck and the lady giggled again, titillated by the scratchy tongue. "Thweetum," she lisped, and hugged it to her breast.

Did the dozen offspring, Mary wondered, receive the same affection as these foolish dogs? And startled, she jumped aside when a poodle lifted its tail at her feet.

"*No* novels for the girls," Lady K ordered. "An hour each morning on French and Italian: they must be able to speak it to the chambermaids when we travel on the Continent. They must wear their backboards, yes—never mind pleas to the contrary. I do not want them growing up hunched over like peasants! And do *not* neglect the needle and the pianoforte. Oh-h-h, I've a wicked headache. Pray, go. I cannot speak another word right now."

She dismissed Mary with a wave of a pale, ringed hand.

Mary was only prepared to inform the heads and psyches of her pupils. And this, she vowed to do.

She hurried along the gallery with its parade of ancestral portraits staring scornfully down on her inferior person. She hustled up one flight of stairs and down another, made three wrong turns and screeched out her frustration. Finally, with the help of an amused servant girl, she arrived at the governess's bedchamber.

Lady Kingsborough was correct on one point: the room was comfortable. Her glance took in a bed with rose-coloured damask curtains, a night table with a bowl of yellow chrysanthemums, a stool, a chaise longue. And ah, a writing table on which she would place her quills, pot of ink, and paper. With two or three candlesticks, she should be able to read and write deep into the night. A fire burned cheerfully in the grate; the window offered a stunning view of the Galtees Mountains. The highest peak was capped with pink clouds, giving a look of great eminence.

Beyond the carefully manicured grounds lay the decaying Irish bogs. The sight of them brought Mary back to her own years of hand-to-mouth living. To a mother worn out in her early forties from childbearing, and too exhausted to show affection to her off-

spring. "A little patience and all will be over" were her mother's last words.

But what time had Mary for patience? Her life here was a stop-gap, a means of making a few guineas to support her future as an authoress. For this she determined to be. *Authoress.* The word rang sweetly in her ear. Should she tell Lady K that she had a book soon to be published on the education of daughters? A book full of advice and methods of which milady would disapprove?

No, she would hold back on the telling. First, she would win over the daughters and then, before her departure from this bastille, offer a copy of the bound book. She laughed aloud to think of the feathered head bobbing in disbelief. The lowly governess, an author?

Energized, she unpacked her portmanteau, stowed her two hats on a shelf: the old beaver, and the blue one made by a friend "to dazzle the Irish with." The maidservant had hung up her coat. She felt in the pocket and a few shillings dropped out, along with the note bearing Henry Gabell's Dublin address. She wondered again about the young woman he had greeted so warmly. Then she dismissed the thought.

But where was the sailor's letter? She had made the pocket too shallow. Her poor sewing—one of her failings. She fumbled for the letter.

Nothing there! She turned the pocket inside out, but saw only the silk lining for which she had paid so dearly. But who in this house would want that letter? Or did it drop out again when the maidservant brought it to the room?

She was too weary to search for it. Exhaustion was piling up, like the darkening clouds on the mountain top. Somewhere below stairs a fiddler was playing—something slow and squeaky—not a cheerful noise. It seemed only to point up the transience of this rich house, the bleak miles of bog. We are all here as servants, she reminded herself: cook, housekeeper, butler, footman—governess. We are here to serve one end: the comfort and whims of its autocratic owners.

Governesses, she had heard, constituted one of the largest classes of insane women in asylums. The thought was not at all comforting.

She was in no mood now to write to her siblings. Instead, she

wrote in her journal a few words about the last days' events that her sisters would not want to hear. They would disapprove, for instance, of her having spoken to that sailor; disapprove of the letter she carried for him and that, for some reason, was now missing.

She undressed and made her nightly ablutions in a bowl of cool water, used the chamber pot, and collapsed onto the bed. Behind closed eyes her body was jounced as if she were still in that carriage. She was hurtled out of control; she was dragged into a damp and desolate bog.

CHAPTER III.

The Room Humming with Intrigue

T HE SCHOOLROOM was a large, dim space with birds and angels in stucco on the walls, a slate floor that chilled Mary's feet, and child-size tables marred by carved initials. A globe stood in the middle of the teacher's desk. On it Ireland was miniscule beside a large, insular Britain, with tiny ships dancing in its harbors. Feathered savages pranced on the green surface of America; they reminded Mary of the drawing room ladies.

The meeting with the three girls was a failure. Fourteen-year-old Margaret (almost fifteen, the girl insisted), her skin a rash of broken pimples, her dun-coloured hair puffed out at the sides and frizzled in disarray, glared with angry eyes as though the new governess had come to draw and quarter her. Nose down into a copy of Fanny Burney's *Evelina*, she refused to look up when Mary initiated a conversation in French.

*"Bonjour, mes enfants. Comment allez-vous ce bel—*um*—beau matin?"*

The two younger girls examined her through huge hyacinth eyes, and then giggled.

Mary repeated the greeting—louder—as though volume would penetrate their silence. Finally Margaret looked up from her book. "We will respond when you pronounce it correctly." The minx repeated the greeting in immaculate French and went back to her book. Mary was on fire, head to toe.

But not easily defeated: she took a new tack. "Tell us about your novel, Margaret. I've been intending to read it. May I borrow your copy when you've done? And I've others to lend you. Burney's *Cecilia*? *The Recess*—that new novel about Mary, Queen of Scots? Not much genuine history there, but I daresay, entertaining."

Silence.

"Do not get taken in by sentiment," the governess said. "Some of today's novels are written to appeal to—well, you know, the romantic fantasies of women?"

"But Mother disapproves of romances." Margaret held up her book, her brows a straight, dark line. "She won't want to hear that you allow us to read any novels at all." The girl was in a mood to disagree no matter what the governess said.

Carrie, a girl of nine years who resembled her mother, said she hated to read; she hated the French language. "But Mama says we have to learn it for when we marry and take the Grand Tour around Europe."

"When *you* marry," Margaret said. "I will not." And she went back to her book.

Six-year-old Polly, grimacing through her crooked new teeth, said, rushing from the room: "Sick in my belly. It's Cook's porridge—too thick. It makes me want to vo-mit."

"Come back!" Mary called. But gave up when the door slammed. And there was Lady Kingsborough hovering like a plumed bird in the hallway. What now?

<p style="text-align:center">❧❧❧❧</p>

"WHERE are you going?" Caroline, Lady Kingsborough caught the child by the sleeve (The name had slipped her mind—there were so many of them). "Get back in there. Where is your backboard? You are to wear it all morning. Didn't the governess tell you?"

She shoved the girl back into the schoolroom and positioned herself by the half-open door. She was not here to listen in on the lesson—no, she just wanted a good look at the governess. She could not condone another Miss Noonan or Miss Crosby. Two or three pretties in a row and each one she'd had to dismiss for—well, for one reason or another. It was hard to keep on inventing the reasons, to keep up pretenses. When everyone knew *why* the governesses had been dismissed.

Her husband, for one. Her honorable Robert who took her to bed at barely fifteen, himself sixteen and just finished at Eton. She was the prize of the year! Half a dozen young aristocrats were negotiating for her. Her mother was dead; her father married her off for three reasons: she was rich, she was pretty, she was ripe for breeding. Never mind that she had a brain—no one noticed.

Last night, though, she had a respite: only the sweet dogs in her bed. Robert off with his bloody militia, the vulgar Protestant

volunteers he had rounded up to defend the land from the Catholic peasants. Off to parade about in a scarlet uniform with silver epaulettes. Though she had to admit he looked well in it. No doubt Miss Wollstonecraft would find him attractive. Most women did.

Ha. What Miss Wollstonecraft did not know was that the handsome Lord Kingsborough had his men horse-whip nine supporters of his opponent in a parliamentary election. Yes! And what would he do to the Catholic ringleader who was said to be entrenched here, right here, on the Mitchelstown grounds? Robert was determined to whip him out.

But what if that ringleader were her darling James, freshly converted (against her wishes) to Catholicism? She must warn him. She *needed* James by her side.

And what of the letter that Mrs Cutterby saw drop out of the governess's pocket? Something she had somehow acquired—along with the report of a local man overboard, possibly drowned? Well. Caroline might know something about *that*. Something she overheard and was to keep secret. She did love secrets. What else was there to love around here?

So. The girls were watching their governess. Intently. Caroline knew the look. It was not complicity, it was watchfulness. The mice, hoping the cat would make a misstep. Margaret smirking, the governess pinching back her anger. The high colour and the long-lashed eyes were most attractive. But not quite so pretty as the last one, Miss Eva Noonan. No. The coarse-cloth dress, the black worsted stockings. The brown hair, unpowdered. Not Robert's type, no, distinctly not. Even the new parlourmaid was better groomed. Caroline must watch that one.

It was time to step in. The governess was suffering. The girls were mispronouncing the alphabet in French. Waste of time, they already knew it. She flung the schoolroom door wide and entered: "It is time, I believe, for the pianoforte."

"It is time for a history lesson," the governess said. She tapped on the globe with her pointer. "There are Indians, girls, in America, but they won't bother you if you don't bother them." (*Wrong*, Caroline thought, *they are cannibals*). "This tiny black spot is Boston. This is where it began: the American Revolution. With a tea party. A revolutionary tea party, girls, against King George. Imagine it. A tea party?"

The governess was looking fierce, like an Amazon ready to leap

on her horse. For a moment Caroline was wary of her, the way she feared her husband when he spoke of that Catholic ringleader. And the word *revolution* always made her light-headed, nauseated—was she pregnant again? Oh, no, please, Lord, no. She hung onto the doorknob.

"Immediately before dinner," she cried, "the pianoforte!" She frowned at the governess and was rewarded with a nod of the shaggy head. Didn't the female know how to curtsy?

When the governess proceeded with her history lesson and Polly disgorged on the floor, she said, "So, Miss Wollstonecraft. Clean it up!"

<center>❧❧❧</center>

RAIN pelted the windows and greyed the landscape, just when Mary had half an hour to herself before the next meal, and craved exercise. The body fed the brain; it was all there in her book that the London bookseller was wise enough to publish. And God knows, she needed to escape the frolicking children, the dogs.

Someone in the dining hall had dropped a piece of fish down a servant girl's back. A visitor's wig popped off—a child had tied it to his chair. It was not her place to discipline little boys, so she sat down to a meal of mutton, squab, oysters, and crabcakes (seafood did not agree with her). Polly was staring in silence at her full plate, in spite of Mrs Cutterby's warnings that she was to "eat every mouthful, child, or I shall march straight up and tell your mother." Afterward, Mary led the girl into the great kitchen where half a dozen underlings were washing up. She let the girl open a china jar and take out a chocolate biscuit, and the girl smiled.

"Don't tell Mama, don't…" Polly whirled through the scullery door with her biscuit and out into the rain; she went spinning down the drive like a wound-up top.

The child is *afraid* of her mother, Mary thought.

"You've made a conquest, miss," said a kitchenmaid, curtsying. Mary smiled back. The curtsy made her all the more aware that she was a species apart, neither family nor household help. Nor did she wish to be part of the kitchen staff where one servant appeared to be adulterating the white bread with chalk, and a scraggy little dog was running round and round in a wall cage, turning the spit for the roasting meat. Mary vowed to set it free before her term expired.

The afternoon session went slightly better—at least Margaret kept her nose out of her novel. And when the girls mispronounced

the *uno, due, tre, quattro* Italian numerals on purpose, Mary twist-
ed her face in mock horror and laughed with them. What else could
she do? Once they saw they could not bring her to tears, they sub-
mitted to a lesson on the Elizabethan era. For the Virgin Queen,
Mary would brook no disrespect. When Polly asked, "What's a vir-
gin?" Mary replied, "A woman wise enough not to marry, that's
what." And Margaret giggled.

At five o'clock she was summoned to the drawing room. The
governess stood in the entrance hall with the housekeeper, Mrs Dil-
lard—or Nora, as she asked Mary to call her—awaiting an invita-
tion to join in. One of the male guests Nora pointed out, as he
strolled in with Mrs Cutterby on his arm, was James, first cousin to
Lord Robert Kingsborough. "James is a favorite," Nora whispered,
leaning toward the governess. "Lord K is indifferent, but Lady K
adores him. His voice will drag her out of her sickbed, you watch
now." The iron keys rattled at the housekeeper's side.

"And Lord K," Mary asked, "how long will he stand up in his
condition?" She watched from the doorway as his lordship lurched
across the drawing room to pour a second (or third or fourth) glass
of porter.

"You'd be surprised, miss, sure, and he can hold it, he can. At
one or two in the morning someone will bear him off to bed—and
then by midmorning won't he be himself again?"

"And what, pray, would his 'self' be?"

"His 'self' depends on who *you* are," said Nora with a sly smile.
"To the staff he's all politeness, you know, wanting to do right.
Wasn't it himself built the new stone houses for some of us? Dillard
and I live in one of them. I couldn't ask for a better employer, could
I now, in that respect? To all appearances, he's a good landlord."

"And to his children?"

"Och, he simply ignores 'em. Except for George, the eldest.
The lad's a handful, but he'll be the next lord and earl when Lord K
passes on. And milord is strict on the lad, so there's often squabbles
between them." Nora shifted position as if it were hard to stand
still for long. "Well, miss, if we don't get in his lordship's way, I'm
saying, we'll get along. Lady K, though—" She glanced about the
hall to be sure no one could hear.

"Yes?" Mary fanned herself with a borrowed fan. She loathed
standing *outside* the drawing room. But she did want to learn more
about the castle's inhabitants.

"Well, he's there for the breeding, you can see that. Else, man and wife each goes their own way. Now and then, saints! there's a fearful row we pretend not to hear, and ofttimes a rage if he thinks she's after having a flirt with a male visitor. But most of the time, he's for putting up a show of amiability."

"And to the governess?" Mary leaned against the bannister for support; she was unused to the thin-heeled pumps her sister Everina had persuaded her to purchase.

"If you're careful, miss, you'll be all right." She jangled her keys. "Lord K likes his female admirers, you see. But the governess afore you, Eva Noonan—a pretty young thing—was not so lucky."

"A visit from Lord K perhaps?" Mary's nerves were beginning to fray. She was still a virgin, in spite of the importunities of two or three male acquaintants. It was the mind that mattered most, she told herself, but increasingly of late, her body begged to differ.

"Worse," said Nora. "And hush now." For here was Lady K, descending the stairs in a lavender silk gown trimmed with silver beads, her hair full of feathers and flowers. Mary had the sensation that a flock of geese had just landed at her feet. Milady wanted a word with James—would Mrs Dillard send for him?

Nora obliged with a curtsy, whilst Mary was told to "go along to the drawing room now; my stepmother, Mrs FitzGerald, wants to meet you. But you won't want to *stay*, will you. Just answer any questions and then go your way." Her smile matched her cloying perfume.

Mary would rather hear more about the fate of Eva than meet the stepmother. But her employer was jabbing her ribs with a fan and the governess was obliged to move ahead.

The drawing room, like milady's coiffure, was elaborate: a virtual garden of embroidered seatcovers, velvet wing chairs, Hepplewhite tables, a Japanese screen, and wallpaper intricately painted with vines and purple triangles. A massive marble fireplace dominated one wall; above it an array of fans, plates, and gold-framed portraits stunned the eye.

The visiting ladies were an indistinguishable mass of feathers, flowers, silken gowns. Coiffured heads rose and fluttered like wings, Mrs Cutterby's birdcage among them. The land agent's wife was deep in talk with two middle-aged ladies, their heads nodding like a pair of colourful fowl; their rouged lips muttering *She and he,* and *Oh, imagine....* A second pair of ladies sat nose to nose, as though

scheming up a plot. Lord K was playing chess with Major Cutterby, a short, stocky, ingratiating man in his fifties who laughed fitfully at his employer's remarks. Now and then a word about rent was audible; she heard the word *evict*.

The room appeared to be humming with intrigue. And I, Mary thought, am a spy in their midst.

She thought again of that death at sea; she wondered how two such diametrically opposed worlds could go on, side by side. The sailor's universe of rough work and scant pay—and these spoiled ladies, their minds as feathery as their headpieces. She must find that missing letter and get it to the mysterious Liam. Who knew what vital news it might convey?

Now Lady Kingsborough was at her back, steering her toward a handsome woman, sensibly dressed in a cream-coloured muslin gown. She wore no rouge. Before milady could speak, the other introduced herself as "Mrs FitzGerald, the wicked stepmother"; then laughed at the storybook appellation. The stepmother and herself, Mary discovered, had similar thoughts on education—the former wanted her three daughters educated before they went "to market," as she termed marriage.

"Jiggety jig, my fat pig," Mary said and the two women laughed. But there was hardly time to pursue a conversation with "the wicked stepmother," for here was Lady K coming up to tap her fan on the governess's arm; her moment in the sun was up.

Mary was not ready to leave. She wanted to hear, as well, the end of a story that James King was regaling the ladies with. A woman had apparently chased him "practically to the front door. She was waving a marriage license. I had to hide in the scullery." The ladies snickered. Milady turned to shake a "Naughty" finger at him.

"And of course, James, you have no intention of taking that gigantic step," cried Mrs Cutterby, tinkling a teacup into its saucer. Her foot kicked at a small dog that was nosing up under her gown—though Mary could not imagine what it would find of interest there.

James smiled back at the agent's wife and colour rose in the Cutterby's cheeks—was there something between those two? But James was speaking of a young woman whom he was shortly on his way to visit, and the painted faces leered. "Her name! What lady is this?"

"She is not exactly a *lady*," he confessed, and winked at Lord

K, whose knight, Mary observed, had been cornered by a clever play on Major Cutterby's part. His lordship was in no mood to wink back. He scowled at James—for more, Mary wagered, than the chess move. She wondered if it had to do with his wife's fawning over the younger kinsman, and at that very moment pinching the fellow's ruddy cheek.

The governess was barely out of the room when James King brushed past, all scent, sweat, and wine. He glanced appraisingly at her and she moved on faster. When he asked how she liked being here, she could only say, "Very well, sir," and hurry up the central staircase in her clattery heels. There, from a round window, she watched his lanky figure hoist itself atop a chestnut mare. He rode not toward the main road, but back through the grounds. On his way perhaps to the tenants' cottages? Was that where he would rendezvous with this female who was "not a lady"?

Someone tapped her on the shoulder. It was Nora, inviting her to follow. The housekeeper led her up into a storey of the White Knight's Tower above her bedchamber that had been converted to a library. She cried out in delight to see exquisitely carved wooden chairs, polished tables, a virtual acre of books bound in brown and black morocco. Plato, Aristotle, Galileo, Locke, Ovid; volumes of Shakespeare's plays. She fingered the spine of *Hamlet*—she had long felt a kinship with the melancholy Dane. Then she pulled out a copy of *Macbeth*. The Macbeths lived in a castle like this one—and plotted murder.

"The family almost never come here," Nora allowed as Mary held the volume up to the light from a window that was little more than a slit in the wall—for shooting arrows, no doubt. "In my opinion, miss, they just liked the thought of a grand library in this place. The White Knight, you know, was ancestor for the both of them. A FitzGerald he was, and a bloodthirsty fellow to boot. How many he'd of kilt from that slit of a window I can't even imagine."

"Oh," said Mary, envisioning the enemy throwing up ladders to climb the walls—then toppling back, with arrows through their bleeding chests....

"Well, miss, make use of the place. Miss Noonan did. Lord K does bring the occasional guest just to show it off, I'm thinking, but that's rare."

Mary would make it her own, yes. She slipped the *Macbeth* under an arm and followed Nora out. The housekeeper's short legs

churned swiftly as she led the way down the spiral staircase to the governess's bedchamber.

The fire was almost out and Nora blamed it on a maidservant. "That Annie," she complained, "always forgetting. And superstitious? Och! She can't enter a room, can she, without crossing herself? A rap on the head would make her remember, God knows."

"Don't hit her!" Mary thought of her mother, who for a time was a servant and bore the scars until her death.

Nora's smile pushed the pockmarks on her face into a ruddy flush. "I shan't touch the wench," she said, holding up her hands. "But you can be sure she'll have a good talking-to." She stirred up the embers in the grate and stood a moment to bask in the fire's warmth.

"I suppose the other governesses slept in this room?"

"Aye, some did." The flames gave a shine to Nora's black hair. She did seem an honest, capable woman. She was literate, whereas most peasants were not. But a certain ferocity seemed to underlie her good humor. Mary must be careful with her.

"The one before last, Miss Crosby," Nora went on, frowning, "was a proper Catholic girl, but she was let go, a victim of—" She hesitated, perhaps for the drama of it. "Mrs Cutterby." When Mary widened her eyes: "Sure, and one day I'll tell you about all the rumours she spread. Didn't she tell Lady K there was carrying-on between Miss Crosby and Lord Robert?"

"And was there?" Mary sat on the edge of the bed, ready for a story.

"I can't say yes or no to that, can I, miss, but Lady K believed that rumour and told the poor girl to be off. *Poof!* But then there was a sort of agreement drawn up whereby the girl would get an annuity of fifty pounds a year."

"Fifty pounds? But that's more than I'll earn from a whole year's work!"

"Aye, a handsome sum." Nora rubbed her fingers together. "For a girl but three months with us. I'm thinking, well, what she'd of done to warrant such a sum?"

What she would have done lay unspoken between them. "And the governess after Miss Crosby? Miss Noonan, I believe you said?"

"Did I now? Oh, aye, Miss Eva Noonan. She were Catholic, too. Surely a reason for the Kings to choose a Protestant like your-

self, miss—disliking Catholics the way they do. Didn't I overhear Lady K say so herself?"

"And why did Miss Noonan leave?"

The housekeeper glanced at the open door, but no one was there. "I can't really say, miss. She left, was all. There was a scene—och, you can't imagine it! Lady K shouting that the governess was after training the girls to be barbarians, that she can't teach a child to piss in a pot—her very words, pardon me, miss! But there was more to it, aye, than not teaching them pianoforte, I can tell you that."

"And what was that?" Mary moistened her lips; she felt herself a fox, ready to pounce on a rabbit. She couldn't help herself. She must know things for her own safety.

"I can't say exactly, miss. But you see, Miss Eva came to see his lordship only a month ago. They were talking behind closed doors so I couldn't hear what was said, no. But when she came out, her hands, God help her, were all fists. And milord smiling, like he's enjoying the upper hand of it. Talking down to her, you know what that is, surely."

Mary nodded. She knew.

"Och, and me heart went out to the wee thing—she only came up to me cheek when she stood beside and I'm a small woman. She must've had a great grievance, surely."

"That was why you warned me." Mary was overheating now from the fire. "So I won't end up with such a grievance myself—whatever that grievance was." She dabbed a bit of water from the basin on her hot forehead.

Nora thrust out her arms to the fire as if she'd had a sudden chill. When her sleeves fell back, her forearms looked sinewy, as though she had been picking up rock in a field or lifting barrels. "Sure, and I don't think you're of that sort, miss, to be led astray by—well, whatever ill wind blows, as they say. The other governesses afore Eva were more timid souls—it fair amazed me, it did, to see her in such a temper."

The housekeeper stared into the fire, then lifted her head, wheeled about, and curtsied. "Sure, and I'm saying too much, I am. I've work to do, miss, I must get to it."

Her face was a shut purse. Mary was to learn no more about Eva Noonan's fate. She thanked the housekeeper for her confi-

dences; then just as Nora was about to leave, she thought again of the letter.

"I lost that letter," she called after Nora, who was already at the door. "The one you picked up. It must have fallen a second time out of my coat. If you come across it, would you kindly return it? It was from a sailor on the boat. He was—" She paused, not wanting to mention the sailor's death before she saw his kin. "It was addressed to a Liam, you might recall. I think he must live nearby, else the sailor would not have given it to me to take to him. Do you know a Liam here?"

Nora gave a half nod; her brow glistened with heat from the fire. "Later," she said, "I've work to do, I'm telling you." When Annie came racing up the narrow back steps with a pail of water in either hand, she turned on the servant girl. "You let the fire go out. I had a turrible time, I did, starting it up again. Don't let it happen one more time, or I'll speak to Mistress, I will. You're only on probation here, you know."

Annie took a step backward in her fright and tripped on the hem of her skirt. A pail sailed out of her hand as she grabbed the bannister; the sudsy water cascaded down the steps. "Bad luck!" she screamed. "Oh, Jesus, Mary, and Joseph, water flowing backward and someone going to die!" Her big, homely face broke into wrinkles; tears spilled out.

"Foolish girl," Nora screeched. She retrieved the pail and the pair was off down the stairs, the housekeeper haranguing the hapless maid as they went.

But a young sailor is already dead, Mary thought as she shut her door on the clamour. She'd had a clue to that death but then she lost it. Nora knew the addressee; she was certain of it, the way the housekeeper's cheeks flamed. Tomorrow, Mary determined, she would question Nora until she revealed the identity of the mysterious Liam. She would discover someone who was waiting for a young sailor named Sean to come home.

And who would not see him again.

CHAPTER IV.

Blue-eyed Lad with a Bogged Cow

"THE SURNAME is Toomey," Mary whispered to Nora the next morning at breakfast. It was another noisy meal with only herself and three harried maidservants to keep watch on the horde of King children. The parents and their guests had cavorted half the night long; the fiddles squeaked on and on into the wee hours. Did this great house ever rest?

When Nora looked surprised, Mary said, "A mate called him by that name. I don't know why it has just come to mind. Is there a Toomey family nearby? Can you take me there? The very least I must do is bring the news of the poor fellow's death."

Mary told the story of the plunge into the sea, though omitting the suggestion of a knife. "You knew him," she said. The words came out like an accusation, and so she offered a smile.

"Aye," the housekeeper said, dropping her shoulders with a sigh, "and I'll point out the path if you'll meet me at half-after four in the fern garden. But I can't very well go with you. I'm a Dono-van, you see, and the Donovans had a long-ago quarrel with the Toomeys. 'Twas all over a Donovan pig got loose in the Toomey tattie patch." Nora looked apologetic, and then shrugged. What could one do with one's relations?

When Mary smiled, she said, "Oh, 'twas a silly thing, mind you, but the two families hasn't spoke for five years now—'cept for young Sean Toomey who wanted to marry me sister-in-law's girl, and stayed friends with Liam. Aye, that's who I'm thinking your Liam might be, miss—me own young brother. A bit of a rebel he is, but a good lad withal. And—" her voice dropped to a whisper "—Sean and Liam were bound together in more ways than one."

"Which ways?" Mary asked quickly. But received no answer be-

44

cause young Margaret was sidling up with a sly smile and a copy of *A Tour of Ireland* in her hands. The author, Mr Young, the girl said, running her fingers through her flyaway hair, was the Kingsborough land agent before Major Cutterby.

"You want to learn more about the family, don't you?" the girl demanded. "About the rackrents—the exorbitant rents, nearly equal to the property's value, that the peasants owed the greedy landlords? Then read this account. My brother George had to smuggle in the book—my father won't allow it in the house." She grinned. "You see, Papa likes to call himself a benevolent master. But he and Major Cutterby don't care a straw about those poor folk. Do you know about the rebel my father set on fire?"

"What?" Mary was appalled.

"Oh yes, it's a new invention of his, to bring the Catholic 'croppies' in line. He calls it pitchcapping. The short-haired peasants—they're not supposed to grow their hair long and loose, you know, the way they like—have a cap filled with tar and gunpowder poured on their heads and set alight. Sometimes it blinds them. And my father just smiles—he doesn't want any peasant uprisings on *his* land."

Mary grimaced. "His land isn't your land, too?"

"I'm female, aren't I?" The girl's fingers curled into fists under the lacy cuffs. "It's for my brother George to inherit the castle, not me. Oh, I'll get a few portraits and candlesticks. Things I don't want." She stamped a booted foot and Mary felt her nerves jump. "Can you believe they've already picked a husband for me?" She stared at Mary as though it were the governess's fault. "Yes! A boring creature with a large estate and a small brain. Who cares if he's to be an earl? Won't he be surprised when I say *nay* to his ugly face?" She pushed her face towards Mary's. "Even if I *could* inherit this castle, I'd refuse it. I would, too. I want no peasant blood on my hands." She stuck out a plump lower lip.

"Bravo!" Mary applauded in spite of herself.

The girl laughed. Then, remembering whom she was talking to, said primly, "You can borrow Mr Young's book if you like. Just ask." She swept off to greet her older brother, George, who had just arrived from Eton, laden with cricket bats, fishing rods, musket, and forbidden books. "What have you got for me? Show me, quick!" Margaret said, and George grinned.

Mary was filled with self-pity to see the two siblings together. Her own brother Ned was at this very moment usurping the modicum of inheritance that should come to his three sisters. She would write him a stern letter this night—though it would not do a bit of good. Ned was his father down to his greedy toenails.

AT half-after four, while the visitors were gathering in the drawing room, Mary slipped out the kitchen door to meet the housekeeper. She entered a garden filled with tall, feathery plants that waved like pale green scarves in the cool Irish air; she breathed in the pungent scent of grasses and dampish leaves. But when a quarter of an hour went by and Nora didn't come, it occurred to her that she might be in the wrong garden.

She knew it for certain when James King appeared in the hedge opening, strode toward her, and then retreated. But he caught up his disappointment with a smile and bowed over her gloved hand. Whom *had* he come to meet? It was like a scene out of *A Midsummer Night's Dream.* "Where the lovers are all paired off wrong," she mused aloud. Then was embarrassed to have mentioned "lovers," for she was not expecting a lover, but only the housekeeper, Nora.

"You see," she said quickly, to cover her blush, "Nora said the fern garden. We are to walk about the grounds that I might become more acquainted with the place." For some reason she did not want to tell him they were to visit one of the cottiers.

"Why, madam, this is the grasses garden," he said, smiling. "You can't tell ornamental grasses from ferns? Look. These with purple and bronze blooms—" he dropped to his knees in the middle of a patch "—are fountain grasses. This is cloud grass, and this, Job's Tears. The children string the pearly seeds for necklaces."

He pulled off a few seeds and tucked them into a handkerchief and then into Mary's sleeve. Her cheeks bloomed with the intimate gesture. "So follow me, dear madam, and I will conduct you to the ferns."

He walked her through a maze of gardens, arbors, and hedges—barberry, yew, column berry. "Cockspur thorn, arrowwood," he enumerated, like a teacher instructing his pupil. They arrived at a place where Nora was seated on a bench beside a marble Dionysis. The housekeeper jumped up and lifted a dark eyebrow when she spotted Mary's companion.

"I was waiting in the wrong garden," Mary began, but James interrupted: "Miss Wollstonecraft and I have discovered we have a common interest, am I right, madam? Our love of the Bard?" He gave a slight bow in Mary's direction. And a wink?

Mary reddened, recalling her suggestion of misplaced lovers. But James laughed; he hoped they would soon have "further discourse" on the Bard's plays. With that he strode back through the hedgerows. Mary recalled a small gardener's shed at the far end of the grasses garden, and hoped, perversely, that *she,* whoever *she* might be, was no longer waiting.

"You said James is Lord Kingsborough's cousin?" Mary asked when James was out of hearing. "But milord doesn't seem pleased with his presence."

Nora lowered her eyes and smiled—a smile that said there might be a secret attached to the kinship. "Officially, a King cousin, aye. But maybe a half-brother—and out of wedlock, too, says Cook, who worked for the elder Kings when he was born. Now that's all I can tell you, miss. But stars, he's a charmer. All the ladies are in love with him. Parlourmaids he teases—Mrs Cutterby even. Why, last summer, she caught him in the library—bared her bosom to him— aye, she did! And believe me, miss, he was taking full advantage. Don't I know, for I walked in on them. And didn't he just laugh?"

Mary was not happy to think that the library was being used for clandestine affairs. She chose to think that the Cutterby deliberately followed James in and offered herself up.

They wove through a labyrinth of gardens and conservatories, out a walled gate, and along a path that ran by the River Funcheon. The contrast with the manicured grounds was at once evident. They were in a wholly natural world. Ducks and wild geese flew up at their feet. A rabbit scurried out of their path; a fawn poked out its soft brown nose from a bush of yellow furze and scampered away from their rustling skirts.

They passed a row of modest stone houses—Nora pointed out one as hers; it had a pleasant garden of asters and chrysanthemums. Half a mile beyond, on the edge of a peat bog, was the Toomey cottage. Nora halted. "I'll be waiting at my place. It were best I don't appear, miss, though that cursed pig in their tattie patch was none of *my* doing, surely. But old Malachy Toomey has a long memory."

Mary slogged on through the damp grounds, wondering how the potatoes grew in such a boggy place. But there was a small potato rick, and beyond, the cottage itself, built of loose stones and thinly thatched with straw. Smoke blew out of an opening in the roof and seemed to circle back in again. The door she entered was half-fallen off its hinges; inside, a virtual gloom. If there was furniture she couldn't see it for the smoky turf fire and the throng of half-naked children.

She inquired for Mrs Toomey and a little girl took her by the hand. The mother was seated on a stool, peeling potatoes. Beside her, an older girl spun and hummed a tune in a high, sweet soprano; a second girl was dyeing cloth out of boiled rowan berries. The two glanced up at Mary, but she could not see their expressions for the haze.

"Mrs Toomey," she began, breathing in the fumes, her voice hoarse, "I fear I'm the bearer of bad news."

The woman looked up full in her face. Mary could not describe her except to use the colour grey. Everything grey: dress, hair, eyes. It was an accident, Mary went on; she couldn't bear to say what she felt to be the truth. Murder. Nor did she mention the letter, not yet, as it had been directed to a member of the rival Donovan family. But she placed beside the woman's potatoes a rasher of bacon that Nora had appropriated from the castle kitchen.

At first the woman seemed not to understand; she continued to stare into her visitor's face. But when the daughters leapt up from their work and howled their grief, the mother joined them. She pulled at her hair and beat at her bosom. She flung up her arms. Potato and knife went flying in the air—Mary jumped back.

No one heeded her then, or had questions, as though they all knew the cause of Sean's death and had even expected it. When Mary turned to leave, an old granny she had not seen before grabbed her arm. "I told young Sean, didn't I now, to stay at home and not go running about with the rebels? 'Twas the Defenders got him kilt, I told him they would! But he wouldn't listen, would he, and now his mam has lost her only son, God rest his soul. Och, it's destroyed we are now, surely." She threw her mantle up over her head and began to keen—a sad, almost animal-like sound that raked Mary like the knife that, in her dreams, was still killing Sean Toomey.

Sorry for the family but needing to get out of the cottage: the smoke, the keening, the grieving—Mary left. She gulped in the fresh air and ran up the path to Nora's stone house; she banged on the door. "What—who are the Defenders?" She told Nora what the old granny had said about the Defenders getting him killed.

"Who said he was kilt?" The housekeeper's cheeks blazed. "Why, 'twas surely an accident, you said so yourself. Forget you heard that about the Defenders. And don't, for God's sake, mention it at the great house!" Nora shouldered the sack of chestnuts she was getting ready to carry to the castle, and the subject was closed.

Still, the question smouldered as they tramped back along the river walk. Mary's forebears on her mother's side were peasants; their rebel blood ran in her veins. Mary was determined to find out who these Defenders were—if not from Nora, then from someone else.

At a turn in the path, they came upon two men hauling a brown-and-white cow out of a peat bog. It was a pleasanter landscape here: heather and bog cotton were still in bloom; she breathed in the spicy smell of myrtle.

"Liam!" the housekeeper cried.

Mary saw a lean figure with a mass of ginger-coloured hair. His clothes were patched and shredded; his feet caked with mud. He was whistling as though he half enjoyed the work of yanking the bawling beast out of the ooze. There were creases about his eyes and mouth, though he couldn't be much above her age; his face looked scarred from untended cuts. But he had a straight, classic nose and strong cheekbones. When he glanced up, Mary thought, it was like walking out of a wood and coming upon a summery blue lake. The two women waited until the men had the cow back on dry ground and tethered to a stake, where she bawled out her frustration.

"She's just borne her first calf," Liam said, "but she's a feisty thing. We got to keep her tethered or she'll run off. And good Lord, will you look at the work she's caused us." When Nora introduced Mary, he turned his blue gaze on her with a broad smile, and like a schoolgirl, she could barely stammer out a response. And she was to tell this young god that his friend was dead?

She did not have to. Nora took him aside and blurted out the story. He paid no attention to Mary after that; he put his face in

his hands and let out a howl that would scare off a pasture full
of bulls. He hefted the turf he'd been digging and bolted out of
sight. The cow turned a wild eye on the two women, and bellowed.
The whole world of creatures, it seemed, was in mourning over the
death of the young Toomey sailor.

As they walked back to the castle grounds Nora spoke of an up-
coming celebration. The evening of October thirty-first, she said,
was a special day for the Irish: It was the festival of Samhain, to
mark the end of summer. A great bonfire was to illumine the night,
all the culinary fires having first been extinguished. In the old days,
Nora said, bones of the dead (or slaughtered cattle in their stead)
would be thrown on the fire, and the ghosts of the dead might
themselves appear—"if you can believe in such rubbish," she said.
There would be feasting and dancing half the night long before
folk would relight their own hearth fires with burning wood from
the bone-fire. In this way they hoped to strengthen neighbourly
bonds, "although," she allowed, "it never helped the Donovan–
Toomey quarrel, did it? But I'll be going for the amusement of it,
and thought you might like to come along, would you now?

"Liam," she added, with a lift of her eyebrow, "will, of course,
be there."

Liam? Had Nora noticed? Mary was ashamed of her transpar-
ent feelings. Nothing could come of a liaison with an Irish peasant.
On the other hand, Liam was Nora's younger brother. And didn't
Mary owe him a full explanation of Sean's demise? Certainly he
would want that of her, once he was over the shock of the death.
Would the lost letter turn up in time—or at all? "Thank you, I
would like to go," she told Nora.

They walked on in silence. Mary's thoughts returned to the
Toomey family and their grief. How strange it was, how pagan, all
that howling, that tearing of hair. Though it was doubtless health-
ier to vent one's feelings than to let them fester in the heart, as
she herself had done in the past. Yet even those thoughts vanished
when they reached the gardens and a girl in a yellow flannel gown
hitched up by her large belly emerged weeping from the shed. The
girl forged ahead up the river path in the dimming light, though
Nora cried, "Fiona? Wait, Fiona!"

The girl disappeared and Nora stopped calling. She offered no
explanation. They parted company at the servants' entrance; Mary

marched, on principle, around to the front (they would *not* make a servant of her). She ran up the staircase that rose from the entrance hall to the first floor and strode past the drawing room where a gaggle of human geese were holding forth; and then up again to the sanctuary of her bedchamber. There she found the fire in ashes, the room chillier than the outdoors. She unhooked the black great-coat to put around her shoulders and poked at the ashes. Feeling a sneeze coming on, she slipped a hand into her pocket and pulled out a linen handkerchief. Something else came out with it.

The "lost" letter to Liam! But it had been opened, she was quite certain, then resealed.

Or was it here the whole time and she had only imagined its loss? She flopped down on the bed, clutching it. No, it was not in the pocket when she left for the Toomeys'—she knew this for a fact. Someone had come into the room and replaced it.

Someone who had no doubt read it.

She held it until she could no longer bear the suspense. Then she broke the seal (not difficult—someone *had* done it before her) and unfolded it.

It was written in a foreign language!

Gaelic.

Midnight Murder

THE GOVERNESS was at the foot of the stairs when Caroline descended with Mitzi at her heels. She was carrying a gown and petticoat. The gown was burgundy poplin with shiny gold braid on the sleeves—but there was a dark circle of perspiration under the arms. She would have had it washed, but James had once announced that he did not think the colour suited her.

"Here," she told the governess, holding out the gown. "Take it. It's yours." Caroline had seen ladies who treated their servants like chattel. Caroline was not like that. Miss Wollstonecraft had a brain—Caroline's stepmother said so; there was something about a book the governess had written (Imagine!). Now, one could not talk long with a governess, but one could have brief discourse now and then. Caroline had some thoughts about Shakespeare's *Tempest* she would like to share—she quite equated the monster Caliban with her husband, ha! Besides, the governess would make an interesting showpiece for friends.

"But I saw you wearing that gown last evening," Miss Wollstonecraft said. Her face was flushed, her brown eyes wide (or were they green—they kept changing colour).

Caroline smiled, and stroked Mitzi, who was crouched at her feet. The poodle nibbled her fingertips and Caroline spanked its little black nose. "Mustn't use its teeth, thweetum." She heard the governess sigh.

"Silly girl," she said, "it's yours now. Oh, and Wednesday next I have invited a young poet for tea. He likes a good conversationalist and I would like to, well—" she was feeling charitable "—show you off." She waited for a smile of gratitude. When it did not come— the woman had no social graces whatsoever—Caroline went on.

"And I certainly cannot show you off in *that*." She pointed at the plain blue frock Mary was wearing. Worse, there was a grass stain on the hem as if she might have been walking beyond the immediate castle grounds. Where? Caroline did not like that, no.

The governess was hesitating. In her eyes, Caroline could see the conflict between desire and pride. Governesses should not show pride. "It should fit. You can let down the hem."

Caroline was making a gift to a person who had nothing. Never mind that book she had written—whatever it was. Caroline had looked into her wardrobe. The female owned only three gowns, and none of a quality cloth. "Take it," she cried magnanimously, holding it out, smiling. Mitzi bit the hem of the gown and she scolded, "No, naughty thing, this is *her* gown, not yours to wear." She laughed with the delight of it.

"No, thank you," the governess said.

"I beg your pardon?"

"I said, no thank you. I don't want it."

"What?"

"No, thank you. I do not need the gown."

Caroline was shocked: she gasped for breath. Her cheeks flushed, her temples burned. She hurled the gown at the girl's feet. She pointed a shaky finger: "Go pick it up."

The governess made no move to pick it up. Caroline was beside herself, unable to think. "You are not properly disciplining my daughters," she shouted. "Yesterday Mrs Cutterby saw one of my girls with a *novel* in her hand. I do not want my girls reading *novels*." She stamped her foot: Mitzi barked. She scooped it up; the poodle loved her. It did not question, it did not refuse her gifts.

"Madam, I am teaching your daughters to think."

"Men do not care for women who *think*!"

Now the governess had turned her back. Unthinkable.

She lowered her voice, though she was still breathing hard. "I might remind you, Miss Wollstonecraft, that your references are far from impeccable. Mrs Cutterby tells me that your French is lacking. And if you sewed that clumsy greatcoat I saw in your bedchamber, it is you who should be the instructed rather than the instructor." She pulled in a breath; she squeezed the dog until it yelped. "So if you wish to remain in your post you will concentrate at once on these deficiencies.

"James?" she shrilled, spilling over with emotion as her darling boy entered with a riding crop in hand. She yanked him toward the drawing room. "You were absent all last night and again this morning. What have you been up to, naughty thing? I want no love trysts without my approval."

She pulled him down onto a crimson chaise longue. Had he overheard her altercation with the governess? Well, what if he had. The girl had insulted her, James would agree. At least she had prevailed in the end. And she did not tell the governess what else she had found in the greatcoat pocket—something that greatly surprised her. She had decided not to tell Robert, but perhaps she would change her mind.

"Now speak," she told James, pushing a finger between his lips. "Tell me all about this new love. Everything!"

But James was glancing back to where a servant girl was picking up the gown, smoothing it out with chapped hands. Caroline followed his glance. "It's yours," she called out to the girl: "A gift from your mistress." She smiled as the girl (whatever her name was) curtsied, and ran off with the gown. The governess would be sorry, oh, indeed she would.

MARY pictured the burgundy gown as she looked in her wardrobe Tuesday evening for something to wear to the Samhain festival. If only she had not been so stubborn. If only she had sent the gown to her chamber with a maid who would have removed the stains and left the gown on her bed. At the very least, she might have tried it on before returning it. But under the circumstances, there was no way she could have accepted it—like charity for a lowly maid. If she had no talent for sewing, at least she had her pride.

"Though sometimes, that pride is a heavy thing to carry about," she wrote her sister Everina, having a half hour on her hands before meeting Nora: "I rail at Lady K's faults—and find the fault stirring within *me*."

She thought of the young giant Liam and felt her chest swell. "I know not myself," she wrote. Now she was overcome with self-pity. She was to meet a poet—if milady had not already changed her mind. And if so, what *was* she going to wear?

She was smoothing out the letter to Liam when the realization struck her: Lady K had been in her bedchamber, looking at the

coat. How else was she able to examine the sewing? Had she come expressly for that purpose? Or had she come to return a certain letter? Last evening Mary had Nora translate the Gaelic for her. She had felt guilty for doing so, but someone else had read it before her, so why not?

Nora's face, as she read the letter, turned a slow, pocky red. She had seemingly found the letter quite compromising for Liam. Mary wouldn't know if the housekeeper had translated it aloud exactly as written or not. But she'd had to take the chance. Herself, she had found the letter both romantic with its mention of a sweetheart—and worrisome. Something about a mysterious "package" he wanted "removed"?

Did milady read Gaelic?

She pulled on the best of her three worn gowns and tucked the letter into a pocket. Then she closed her eyes for a moment, and imagined their fingers touching as she handed it over to Liam....

MARY was not overly pleased to see Margaret in the garden with Nora. But the girl had apparently begged to come, and the housekeeper had given in. "You didn't think you could keep me away, did you?" the girl said. "I lo-o-ve Samhain Eve." And Mary sighed.

The three arrived at the festival to find a crowd of peasants already dancing about the bonfire to the jigs of pipe, harp, and fiddle. A variety of fruits, flowers, and nuts was spread out on a trestle table around an altar of leaves. A woman with faded auburn hair was slicing up a roasted pig—it was her sister-in-law, Nora said, and called out to her. Folk were pulling up cups of water from a nearby well—a holy well, Nora called it; the water was supposed to bring good health and fortune in the coming year. "And don't we need it now with the rainy harvest we been having."

Mary watched the maid Annie swill down a cupful and then fling up her arms to dance a solitary jig. Beyond the well a pair of lads was wrestling; one was holding down the other whilst a crowd of young people were laying bets. When the victor, a lad with ginger-coloured hair long and loose about his head, sprang up from his bruised knees, she sucked in a breath. It was Liam.

She glanced about to see if her companions were watching. But Nora had hauled up her skirts, and like Annie, was dancing a jig. A young man sidled up to Margaret and the girl kicked up her legs.

She hardly looked at the boy, but her face was suffused with colour. A black-haired girl came forward to crown Liam with a wreath of leaves and yellow chrysanthemums. He was paraded about the bonfire and back to the wrestling site, where a second pair had begun to battle it out. His face was flushed with victory. She heard him whistle a lively tune.

Ah! He had spotted her; she held up the letter. He squinted—even in the light of the bonfire, his eyes were a spellbinding blue. He moved slowly toward her, as if on wheels. She stepped back into a grove of young trees, wanting privacy.

She was quite destroyed, as the Irish put it, by the sight of his bare chest, full of soft, coarse reddish hairs—though he was pulling down a white linen shirt from a cedar branch and thrusting his muscled arms into it. He inclined his head respectfully. Even in her blue poplin, with a late yellow rose Nora had pinned to it, he had to be aware of the difference in class. Yet if she was his superior in class, why then he was at least her equal morally, one might say. He was like a fresh wave from the sea, splashing at her feet. But his expression altered to sorrow when she handed him the letter and he recognized the handwriting.

Out of politeness he did not read it immediately in front of her, though his fingers trembled. She ploughed on with her story: "Your friend Sean seemed a fine fellow. I could tell he coveted liberty. He had it, too, in America, where he went after the Revolution. He had purchased a bit of land, he said. He talked about a girl he would take there to live."

She did not mention that the land was now Liam's; it was in the letter, along with information concerning the package to be moved *"at once. Do that for me, you know where to find it. And if I should die, Liam—for I've enemies—the land is Fiona's, should she want it. Yours, too, if you like."*

From Nora, she knew that Fiona was Liam's niece and Sean Toomey's childhood sweetheart. Though when Mary recalled the big-bellied young woman who had emerged from the gardener's shed like a Venus out of her seashell, she knew it could not be Sean's child Fiona was carrying. Sean had been gone for more than a year.

"Aye, he was a fine fellow," said Liam, his eyes devouring the letter, "a free man. Never mind they got us in chains after taking

our land. But faith, I can't go to America, not now, not yet. There's work to be done here in Ireland."

"Which is exactly what your friend said. I am English," Mary rushed on, the excitement of conspiracy in her breath. "I know you distrust us but I—well, I think like you. I do. As a mere governess here—why, I'm just as trapped."

It was hard not to let it all gush out, the way the sharp eyes fixed on her—though she read a certain scepticism in the eyes, a wall against intimacy. She was English-born, despite the Irish mother. What red-blooded Irishman did not harbor an innate loathing for the English?

She wondered again about the Defenders. What exactly were they, and did Sean Toomey die because of that group? Had the Defenders something to do with what Sean wanted "moved"? They were obviously enemies of the English, yes. Now she was beginning to think of her native England as her father's, not as *her* land at all. "My Irish mother—" she began.

"Slaves," Liam said, his eyes catching light from the fire. "The English tried to make slaves out of us. Not the men only, mind you, but women as well. I've no great love, I'm telling you, for the grand house you're staying at. They might've built some of our houses of stone, but they've buried our souls in mud, God help us. I promise you, Sean Toomey won't have died for naught!" He gazed off into the trees; he seemed unaware of this Englishwoman who could not deny her father's heritage: the horrors of Cromwell, the hypocrisies, the massacres.

"Be careful," she warned, thinking not only of Liam, but of her own fragile status at the castle where Lady K this afternoon had given her the chilliest of looks to see Polly run up for a caress.

Already his eyes had dismissed her, his face clouded over. She followed his glance: a dark-haired boy had an arm about the girl who gave Liam the crown of flowers. And the boy was not a peasant at all, but the Kings' eldest, Eton-educated George. Even as she looked, the boy was drawing the girl off into the underbrush.

Liam shouted, "Oona!" and the girl wheeled about. She pulled away from George: "Uncle Liam—I didn't see you there."

"Gavin O'Reilly's been looking for you," he shouted at his niece, his brows drawn together. "He'll be wanting a dance." When

she came closer: "I've warned you. Stay away from the castle folk. You've seen your sister, have you?"

The girl gave her uncle a quick pout and ran off toward the bonfire. But not without a laughing look back at George. The rogue winked.

Mary must keep an eye on George. She frowned at Margaret, too, dancing by the bonfire with the coarse-haired peasant boy.

Liam turned to look at Mary as if for the first time; he thanked her for the letter. "Come visit me sister-in-law, if that'll please you. You'll find she's an independent one. Like you, I think, miss." He flashed a smile, and started off after the girl called Oona.

"I have Irish blood, truly I do!" she called after him, but he was already part of the throng.

A cold wind was blowing up as she walked back toward the fire where Margaret was still dancing. It was almost midnight. One by one the fiddles ceased; she saw an old woman carry some of the fire home in a pan to her hearth. The talk grew softer; folk huddled closer to the sputtering flames. It was time, she told Margaret, to return to the castle: "Your mother will worry."

Margaret's peasant boy seemed quite puffed up to be coupled with a girl from the big house. And the girl was not beyond enjoying the conquest she had made. "Worry?" she called back. "My mother worry? If I were a dog, perhaps. It's Kara who worries— Kara's my old nurse. She's the one who makes the nightly rounds. But she's half-blind; she won't see the pillow I humped up in my bed."

The boy laughed at Margaret's daring and Mary smiled to show she was not a prude. But the girl was her responsibility. She must be made to obey.

"At least see me back," she told her pupil. "I'll never find my way alone through that labyrinth of gardens." Nora had gone, she discovered, back, no doubt, to the stone house where her English husband was waiting. John Dillard would never tolerate a Samhain bonfire. "Accompany me and you can be a half hour late for class tomorrow," Mary called back.

And that turned the trick; Margaret bid the boy adieu. It was only because he was a good dancer, the girl allowed, that she had given him her time. "He can't carry on a conversation at all. He's probably illiterate like the rest. It was Mrs Dillard taught the older

Donovan children to read and write a little." She turned to face Mary. "Perhaps I should start a school for the tenants, you think?"

"And what would your parents say to that?"

"Mama wants us to help the poor. And you and I are to visit the tenants. Anyway, in a little over three years I'll be eighteen. But not to marry and breed, mind you. No! You'll help me escape that fate, Miss Mary?"

"Well, I don't know." Mary was flattered. But she didn't want to tell the girl that in less than a year she hoped to be in London. Who knew what might await her there? She took the girl's arm and they walked on together past the bonfire that was losing the battle against the wind and a light rain.

A shadow moved past without a greeting as they started down the path, but not before Mary recognized the figure. James King. Margaret squeezed her arm. "Most likely he's late for his rendez-vous," the girl whispered.

"Oh? And with whom would that be?"

"Fiona Donovan. I overheard James telling Mama. Mama pumps all his love affairs out of him—it titillates her. Though secretly, I think Mama would like James to herself. But this one—Fiona—is different, James says. This one is a 'true love.'"

"But Fiona was Sean Toomey's sweetheart! That is," Mary stammered when Margaret glanced up, "I was told of such a liai-son. Not that I'm acquainted with any of them." Mary looked back toward the bonfire to see a girl run up and throw her arms about James. The girl was clearly not the pregnant Fiona she had seen in the grasses garden.

Man, she thought, thy name is Judas.

BACK in her bedchamber, Mary took up her pen and journal and wrote down the adventures of the day: the tale of the burgundy gown, the talk at Samhain with Liam. She put down her pen a mo-ment. There was so much she *might* have said to Liam: "I would like to join your Defenders, Liam," she said aloud, addressing her pot of ink. "That is, now and again. I can be fierce, when provoked. Did you know I rescued my sister from an abusive husband? Well, I did, yes!"

She pictured Liam's shocked face as he listened—his frowning admiration as she waxed on: "Such a mad chase, Liam, through

the streets of London. And the husband in close pursuit—I could almost feel his fiery breath on our necks! But he never caught up, no, he never did."

But too late now to say such things.

On the whole, though, she felt satisfied: she had done her duty by both the dead sailor and Liam. He would be beholden to her, and had he not invited her to visit his sister-in-law? A friendly liaison with a native, she thought, might help to assuage the miseries of life at Mitchelstown Castle.

She prepared for bed, and with a grateful sigh removed her cumbersome stays. She found it hateful to have to control her body with whalebone. To torture her head with wads of false hair, greased with lard. "I will never—repeat, never—powder my hair," she vowed as she climbed into bed. "Never mind what ugly gentleman Lady K brings to show me off to. Show me off, yes—as if I'm a sheep, too, newly shorn for its wool."

She was talking to herself again, a bad sign. She must control herself or she would become a daft old spinster. She settled back on the thin pillow and prepared to count sheep.

Though no sheep would cool her brain that was still on fire.

TOWARD dawn she woke to shouts and barking dogs without the house, and then a stampede of feet down the stairs and up again. Then Nora burst into the room, her pockmarks standing out on her cheeks like bee stings.

"He's dead," Nora gasped, "dead as a stone."

"Wha'? Who?" Mary sat up. "Who?"

"He's been stabbed, God rest his soul, and then charred all over his poor flesh where he'd fell—or been dragged—in the ashes of the bonfire. They're letting Lady K sleep longer till she's told. Oh God, oh Jesus, and she'll be in a frenzy, won't she, that one, she'll be beside herself! James was such a favorite, I'm telling you. Och, and she'll never get over it, surely."

Outside in the hallway Annie was wailing, swabbing the stairs with her tears, her prophesy come true. The irony of it, Mary thought; there had indeed been a death in the house. Human bones in the bone-fire? But whose did Nora say?

"James?" Mary said, rubbing the sleep from her eyes, coming to a full awakening: "James? But I saw him, just hours ago, walk-

ing toward the bone—the bonfire. It was a little past midnight. I couldn't see his face in the dark. But he was moving along with great purpose."

"Aye," Nora said, "I know that purpose. And she wasn't there just then. Didn't her mother tell her she was to go home? Why, the poor girl is entering her ninth month! She'll be nearly undone from the murder. For wasn't he stabbed, twice, God save his soul? Once in the neck and once in the heart? And near the holy well, too?"

"The holy well? Oh Mary, Blessed Virgin, save us all!" Annie screeched out on the stair landing. "Murder and misery," she wailed, and there was the sound of spilling, splashing water.

Murder? Mary could hardly say the word to herself. Stabbed? In the neck? A handsome neck at that—it seemed such a waste.

In the heart, too? She clapped a hand to her breast. She knew what it was to be stabbed in the heart.

Heart, she thought. Liam. Where was Liam at the time of the stabbing? Gone from the scene, oh yes. She could not imagine him involved in a killing. "James was stabbed, you said?" She slapped cold water on her face from the blue basin.

"In the neck and heart, I said," Nora cried. "'Twas old Willie Duffy found him first. He stumbled over the body in the dark."

"And Liam had gone home with his sister-in-law and nieces? Or wherever he lives?"

The shock and lack of sleep had muddled her head. She pulled a blanket over her chilly shoulders. The fire was a single ember in the hearth; she hastened to revive it.

"Had nothing to do with Liam!" Nora cried, standing over Mary—sounding angry now. "Liam was with old Willie when they found him. I can't account, can I now, for Liam's whereabouts afore that time? Liam claims he saw no one could of done it. He told as much to Major Cutterby. The agent rode straight up to find him when he heard the turrible news. And Mrs Cutterby? Her face purple with the shock of it, and weeping up a rainstorm—you'd think James was *her* lover! Och, they was woke out of a sound sleep, says she, and it was her duty to deliver the bad news to the mistress. I don't envy her that, I don't."

Nora was wrapped in a black mantle; she was going out, she said—couldn't help with the fire—the governess would have to excuse her; she must see to Fiona. "The girl will be destroyed with

her lover dead and a babe on the way. I don't know what I can do but give a spot of comfort. Two of the parlourmaids will take my place. I thought you should know though, miss, seeing as how you've been recently acquainted with the Donovans."

When the door shut on Nora, Mary took fifteen deep breaths to calm herself, dressed, threw another stick on the struggling fire, and placed her covered chamberpot by the door for Annie to empty later—the maid had wept on to another part of the castle. She tiptoed downstairs to find Lady K in her bed gown: red-eyed, unrouged, clinging to her husband. Lord K, dressed in hunting coat and boots, was absently patting her back. He nodded at Mary over his wife's shoulder; his face lacked expression. A relief for him, Mary wondered, to have his young kinsman out of circulation? More inheritance for him, if indeed, James was a legitimate cousin?

She moved on into the dining hall; the children would need a sympathetic but rational face in view of the killing. James was their kinsman; she had seen him now and then, down on his hands and knees with the little ones. And he was pleasant to her, he was one of the few to offer a kind word. She must think kindly of him.

Was the murder at random or was it planned? She suspected the latter, but what did *she* know? She must not involve herself—she must soon go to London and make her fortune. Yes! She was here to mentor three girls and that was enough for forty pounds.

"Eat up," she told Polly, who had moved her chair so close, Mary could scarcely lift an elbow without knocking the child's. Polly dipped a spoon into the porridge and sucked at it whilst Carrie just stared at hers with wide, watery eyes. Her little brother Tommy toddled over to push his chair in close beside Mary's. He had sought her out ever since she came to his rescue when he fell off a tree limb into a "pit of snakes," as he called the damp leaves. The other children were at their usual tricks, comprehending little of death or killing.

She envied them. She wished she could roll time back to midnight when she last saw James alive and purposeful, striding (so she thought) toward his pregnant love. Or was it some other pregnant love he was to meet? Mary didn't know. She rubbed a tense shoulder. Who was she to judge whom the man should love? Did God judge? She doubted it.

If the tenant girl Fiona was below James's station, so be it. The

young woman who met him at the bonfire was in all likelihood a
friend, coming to explain why Fiona could not make the appoint-
ment. Yes, this must have been the reason. She recalled how affec-
tionate James was toward the grasses, how he knew one from the
other. Anyone who could talk to a plant could not be a bad person.
Who would want to kill a lover of grasses?

Several seats were vacant at breakfast. Major Cutterby was mak-
ing arrangements with the local coroner; Lord K had gone to town
to summon a constable. Margaret had not come downstairs at all,
nor young George. The latter was still at the Samhain festival when
Mary left. How long, she wondered, did the boy remain there?
What intrigue was he hatching with the young Donovan girl? Was
he there when James was killed? What did he see?

She could hardly eat a morsel of the hard breakfast biscuits; the
chocolate was tepid and sour. Tommy and Polly were all but sitting
in her lap. They were not eating. She wanted to fling up her arms
and wail at the wrongs of the world. No one would hear of course,
there was such a brouhaha in the castle. It was as though the whole
house had suffered a nervous breakdown: maidservants were run-
ning in circles, footmen were bumping into one another. "Begone
with you!" the Cutterby screamed at a footboy when he spilled
her tea, and the mortified lad wound himself up in the maroon
drapes. The agent's wife pounded at the velvet lump; there was a
howling and twisting until footboy and drapes crashed to the floor.
The framed wall panels of classical figures looked on, it seemed, in
disdain.

"Why did they hurt Cousin James? Why?" asked Polly, knocking
Mary's elbow and splashing chocolate on her frock that was already
splattered with spills.

The child repeated the question, and for once Mary could not
think of a response.

Rebel on the Run

MARY AND NORA joined a funeral procession on their way to see Fiona at the Donovan cottage. But the corpse was not James. Sean's body, according to Nora, had floated up two and a half days before with the Dublin tide; his comrades had brought it home. It was laid on fine white boards and wrapped in pale blue linen. "Blue, I expect, to represent the sea," Nora mused as she and Mary joined the mourners—some weeping and some carrying jugs of whiskey. The procession swelled at each step as village folk converged from all sides. It was one's moral duty to participate, Nora informed Mary—out of respect for the dead. Margaret had begged to come, but had been put to bed because of a sore throat and fever.

The keening women were mostly elderly, eyes brimming with tears as they lifted their wrinkled arms and voices in a high, thin rise, and then a waterfall of grief. They were professionals, according to Nora, *hired* (to Mary's astonishment) to enhance the melancholy mood. Nora pointed out her and Liam's sister-in-law, Bridget, a few yards ahead. She was a short, plump woman in her thirties with untamed, reddish-brown hair—almost the colour of Mary's own. Her high cheekbones revealed that she was once quite lovely; her ill-fitting flannel frock showed off a pair of fine ankles. Today, though, she looked old beyond her years and full of anguish.

"I thought the families were feuding, Nora, so why is she here?"

"Well, me brother Hogan—her husband—passed on a year ago," Nora said, "and Bridget wanted no part of the quarrel to begin with. Of course the fathers objected to Fiona's troth to Sean—the vendetta, you know, betwixt the families—and Sean after run-

ning off to America? Och, if he'd taken Fiona with him then…
'Twould've saved her from James. Oh, the pot was full of troubles,
I'm telling you, that James stirred up."

Mary was curious about that "pot of troubles," but already
Nora was running to catch up with her sister-in-law, who had left
the mourners and "had to see," she'd called back, to her troubled
Fiona. "Step lively now," Nora shouted at Mary.

When Mary scraped the mud off her boots and entered the cot-
tage, she found Bridget Donovan already at her spinning wheel.
She was turning it rapidly, like a ship she would steer out of danger-
ous waters. A small girl with uncombed auburn hair was raking the
turf fire; a dark-haired young beauty stirred a thick, savoury soup.
And where was Fiona? Bridget nodded absently when Mary was
introduced; she waved Nora's gift of bacon to a low table set with
a red cloth. Mary sat on a round oak stool that the girl had wiped
off for her, whilst Nora squatted cross-legged on the floor beside
her sister-in-law's seat. "I'm thinking it's all for the best," she said.
"For Fiona. Is it not, Bridget?"

Bridget allowed that "Aye, James is gone. But the damage is
done. The girl is destroyed. The scoundrel never meant to wed
her and thank God for that. And who'd want her now, with Sean
gone?" She yanked at the wheel; the threads spun into a tangle.

Like a scene in a dramatic play, Fiona entered the cottage, a
wicker basket of potatoes balanced on the bulge of her belly. Her
eyes looked sore from weeping. She knows, Mary thought, at least
we don't have to tell her—Mary didn't think she could bear an-
other scene of keening and hair-pulling. It was only a year ago that
she had broken the sorry news of her mother's death to her father.
And he did his mourning in the bed of a local widow.

"Is it a decent wake they'll give James?" Fiona asked in a stran-
gled voice.

Bridget Donovan snorted. "Aye, no doubt, and you won't be
welcome there, my girl. What do they care at the big house for us
folk? You knew the fellow would never marry you."

"He would! He said as much, God bless him. He would." Fiona
let go of the basket and the potatoes spilled out—one struck Mary
on the ankle. Nora bent to gather them up. Bridget grasped her
sobbing daughter about the shoulders.

"We'll make do, aye, we will." She hugged the pregnant girl as if

she were a lifeline to a sinking ship. "Liam will help us. 'Tis not the first time, I'm thinking, a lord from the big house has interfered."

The dark-haired girl slapped the pot of soup down on the table and scurried out of the cottage, as though all this death and baby-making was too much for her. "Oona," Nora scolded, "come back and greet your visitors properly."

Oona came slowly in again. She ran her fingers across the strings of a small harp beside the door. Then she pecked Nora on the cheek and curtsied to Mary. "You're from the castle, are you not?" When Mary nodded, Oona's eyes widened. She gazed at the governess with interest as though the governess might have brought a note from young George—for this, Mary realized, was the Oona she had seen with George at Samhain.

Mary would have a word with the lad. One unwed mother was enough. She felt a slow burning against the irresponsible creators of these natural children. She scowled even at Liam when he walked in, whistling. But his engaging smile soon warmed her mood. His smile faded, though, when Fiona inquired again about a wake for James, and Nora said in her peace-making voice: "Oh there'll be one, child, though not for us. It won't be a Mass, I'm saying. Prot-estants have their own ways—though there must be feeling under all that chill? I have to say Lady K is all in pieces over the death. Hasn't she summoned the mantua-maker to sew her up head to foot in black?"

Liam did not want to hear about Lady K. He called her grief "a front—she's a cold-hearted one. She beds down with a dozen dogs each night and leaves her own flesh and blood to the servants." He added, glancing at Mary, "To the likes of you, miss."

Mary bristled. Servant she was not. They might consider her one at the castle, but she was her own person. Liam stood by the pot of soup, his arms tight across his chest as though he would strangle the world of fine ladies and hypocritical lords. He was oblivious to the wound he had just given to the one who had brought his friend's letter.

Nora was hungry for details about James's death: "Was he still alive, Liam, when they found him or did he die at once? Did you see anyone about? Think hard on it! Who would it be now, I'm ask-ing—who hated enough to kill him?"

Liam responded briefly, vaguely, perhaps to spare Fiona, though

it was obvious from the flames in his cheeks that he loathed even the thought of James. Oona threw an arm around her sister and Fiona's eyes overflowed once more. The belly twitched under the tent-like shift.

"'Twasn't a cottier killed him, surely." Nora glanced sidelong at Liam as though in warning, but he looked away. "It'd be someone from the gentry," she went on. "They must believe that—they must! Lord K, now, has racks and racks of knives and swords. Not that I'm accusing him, no, but I'm saying the constables can't be after one of us."

"Oh they can't, can't they?" It was Liam, wheeling away from the pot of soup, holding up a hand as though the soup had scalded him. They all turned to look at him.

Now he was turning an errant potato round and round in his large hands. Mary wondered again about the Defenders and what weapons they used. Like Lord K, Liam had access to knives and guns and she was frightened for him.

If he was afraid, he was not going to show it; he tossed the potato in the air as though he would play a game of Catch. He whistled a few bars of song. Finally he said, "Faith, and I can't sit around with womenfolk all day, can I now? I've firewood to bring in for the big house." Whistling again, he started for the door.

"Get down another bit of turf afore you leave, Liam," Bridget said, her shoulders held stiffly back as though to fortify herself for what might lie ahead. "The fire's dying. You'll have to go out in the peat bog and cut more. And Oona, the heifer needs graining. You're forgetting your work!" Her voice rose shrilly; she squinted at her wheel and, seeing errors, snatched the work off the spindle. Blue veins knotted the backs of her hands.

But she gave a brave smile as Nora and Mary took their leave after Liam; she thanked them for the bacon. "Don't I crave it though, now they've taken our next-to-last pig?"

The Donovans' ham and bacon, according to Nora, when they were lucky with piglets, were sold in the town marketplace and the money went to the castle as rent. "'Tis rackrent," Nora said. "And much of it goes into the agent's pockets." Now, though, the rent was in arrears. "If 'twasn't for Liam coming round every day to help," Nora went on, "the family would be—" She shook her head; she couldn't seem to complete the sentence.

"They've no reason to suspect Liam. They've no evidence at all, have they?" Mary asked as she and Nora started back up the path.

"And why would they *not* suspect him?" Nora looked closely into Mary's face. "Didn't he have every reason in the world to kill the man? He and James had a disagreement, you know. Surely Lady K would've heard about that. *She* and James were like a key in a lock, were they not?"

"A disagreement? And what would that be?" Mary was impressed with Nora's simile, but something sour was rising up in her throat.

"Didn't Liam want the fellow to marry Fiona? He did! If Cook's right—and Cook is an honest woman—James is a natural son himself. It's Lady K has turned him into such a fine gentleman." Nora gave a short, hard laugh. "Lord K didn't care, I'm telling you."

"And James said no?"

"He did that, miss. He said as much to Liam, he did. He loved Fiona he said, but he was a King, he had to remember that. Could a member of that proud family, natural son or not, wed a peasant girl? And yet—"

"Yet?"

"You see, Lady K has peasant blood in her veins. 'Twas maybe why she took such an affection for James. Her own grandfather wed a servant girl, can you imagine?"

Nora laughed; she did a quick stamping step forward and back in her glee.

Mary was intrigued. "Truly?"

"Aye, I saw a document once she'd left on a table. The grandfather was a converted Catholic, to boot. 'Tis a wonder his lordship tolerated James as much as he did. So. James promised to support Fiona's child, did he now? Said he'd marry her? Humph. The devil he would. Do you think she'll be getting any money now? Nay, not from the grave. Not from Lord Kingsborough."

"More reason, then, to believe Liam did *not* kill James." Mary's cheeks were heating up. "Why would he, if James promised, as Fiona says, to support mother and child?"

"There's the rub, miss. You don't know Liam. He's a proud one, he is. 'We want none of your money,' Liam told him. Didn't he tell me and Bridget that—it was one day I was helping to skin down a rabbit. They argued right out there in the tattie patch, a

fortnight ago just. And didn't James knock Liam to the ground!" She pointed back at the cottage; her fingernails were bitten to the quick—from work or nerves. She made Mary think of a scarred jackrabbit.

"Don't tell," Mary warned. "Don't mention that quarrel. It may be that James didn't speak to Lady Kingsborough about it."

Nora steered her around a puddle in the path. "Someone already heard, Liam said. Someone who'd come up the path as they argued. But the intruder turned back and Liam didn't see the face."

"Someone from the castle, you think?" Mary could scarcely hear a sound beyond the ringing in her ears.

"Aye, maybe so. They all come to visit the tenants at one time or another. The agent comes to collect his rent. Lady K brings a bit of embroidery to give the womenfolk. Imagine. Embroidery! Where, I'm asking, would you put a bit of fancywork in a place with up to a dozen folk living inside? And betwixt you and me, miss, Lady K is not the seamstress she makes out to be."

"And she deigns to criticize *me?*" Indignation filled Mary's throat. Until the absurdity of it made her laugh. She smiled all the way to the castle where she was accosted by the ancient nurse Kara.

Mary was needed in the sickroom, Kara said, hanging on to her crooked stick like a large grey spider. "The girl's in a high fever, miss, and won't let her mother in the room, so milady's sent for you." Kara waved her hand as if to say she had heard it all—and given up.

Mary followed the nurse to Margaret's bedchamber, where the girl lay under a blue-striped duvet. The room reeked of vinegar and some alien cleansing-type fluid. "You ought to let her in," Mary chided the girl. "She is your mother, after all."

Margaret sucked in her lower lip. "Mama just moans and shrugs her shoulders. She makes me feel worse. And then she blames my illness on *me* for running out in the rain. Or she turns on Kara for not getting me well at once—as if old Kara has magic at her fingertips."

Kara giggled, then squatted in a corner of the room. She took up an embroidery frame and squinted closely at the work; the needle quivered in her arthritic fingers.

Mary sat beside the bed and listened to the girl's woes. Margaret's

voice was hoarse, her temples hot. She did indeed have a fever and Mary was sorry to have suspected otherwise when the girl didn't appear at lessons. "The physician tried to bleed me," Margaret said, "but I'd have no part of it."

The fever powder he gave his patient was still in a fat blue bottle on the night table. The girl had refused to take it, Kara whined from her corner. When Mary saw it was composed of antimony and phosphate of lime, she was glad that Margaret had objected. Kara slumped sideways in sleep a few minutes later, so Mary stowed it away on a top shelf of the cabinet—too high for the nurse's reach. The great Dr. Johnson, Mary recalled from her one visit to his sick-bed, had himself doubted the efficacy of that powder.

The girl found talking painful because of her inflamed throat so it was up to Mary to keep her entertained. "Samuel Johnson was stooped—practically bent in half when I saw him," Mary related. "He was continually opening and shutting his mouth, blinking his short-sighted eyes, twisting his hands, shuffling his feet—a veritable spinning top."

Margaret smiled. "And what did he wear?"

"Oh, a large powdered wig, with a snuff-coloured coat, all wrinkled, of course. He was ill and suffering from scrofula. But he was excited about a new word he had just discovered for his Dictionary. It was the word 'neeze,' which he defined as 'to discharge flatulencies by the nose.' Amusing, yes? 'Neeze' is simply a Scottish word for 'sneeze,' but he was thrilled with it."

At that Margaret gave a whopping "neeze," blew her nose, and they both laughed until Mary described the visit to the Donovan family. The girl did not yet know about James, and Mary was not going to be the first to tell her—not when she was ill.

Margaret sat up in bed. "And did you see Oona? George will want to know."

In spite of their very different temperaments, Margaret and George seemed to confide in one another—unlike Mary's relationship with her own elder brother, who was as close-mouthed as a turtle. "I did indeed," Mary said. "But had no time for small talk. Not in front of Fiona."

"Oh. Poor Fiona. I'm angry at James, truly I am. He loves Fiona, he does! I once arranged a tryst for them," Margaret said. "I'm the only one he could trust. And no one believes him but Fiona.

The cottiers hate him. Nora hates him and Dillard hates him and my father hates him most of all. But James is my friend. We share our secrets."

"Secrets?"

Margaret looked smug. "Have you ever had a friend to share secrets with?"

"Fanny Blood," Mary said. "Fanny was my dearest friend; she died a year ago this month. In childbirth it was, in Portugal where she went to live with her new husband. She was consumptive. She was breeding and dying, all at once." Mary would have given her life for Fanny, she loved her that much.

With her hair spread out on the pillow, her spirit diffused by the fever, Margaret seemed to become Fanny. For a moment Mary's voice was trapped in her throat. She moved to the basin of water on the chest of drawers; she cleansed first her own cheeks and then the girl's hot forehead, as she had done Fanny's.

Margaret's skin was an oven to the touch; she was starting to shake. Mary sent a maidservant for a bucket of water: "Cold," she ordered. When the girl returned, Mary woke Kara to undress Margaret and helped to wash her down. Cold water worked better than any fever powder—it had helped her mother through a bout of pneumonia.

Mary had little faith in physicians. They let her Fanny die.

Now the girl had fallen asleep, and Mary tiptoed out. They shared secrets, she thought—James and Margaret? Ah.

CAROLINE heard the floor creak outside her door and sent her maid to see who was there. She was feeling peevish. The lampblack she had applied to her eyelashes had run into her rouge. Her looking glass told her she looked ridiculous with this leather strap on her forehead. It was meant to deter wrinkles, but when she took it off, the lines were still there. A Dublin acquaintance had once tried a forehead bandage steeped in vinegar and cat excrement, claiming it worked, but the thought was repellent to Caroline. And how would her dogs react to the cat faeces?

She reached for a bottle of Lady Molyneux's Liquid Bloom and slathered it on her face. According to the advert, it offered "the rose of nature without the appearance of art." She hoped that was so. Age was bearing down on her like an army of iron rakes.

"'Tis the governess, madame, passing through the hall. Shall I send her in?" The French maid gave a deep curtsy.

"Pray do," Caroline said, lying back on her pillow. Poo Poo and Mitzi had snuggled into her armpits, and for a moment she felt ready to take on the exhausting woman.

"You have seen Margaret?" she asked when the governess appeared in the doorway, with the barest nod of her head. Caroline had given up trying to get her to curtsy—the female was stubbornness personified. "I'm concerned about my daughter," Caroline went on, with a tremor in her voice. "She felt like—like a hot bath when I put my hand on her forehead."

She *was* concerned, Caroline told herself. She loved her eldest daughter, she did honestly think so. She just didn't understand her, that was all: her perversities, her little rebellions. The way she would keep claiming James when it was Caroline who owned him. Needed him! And now James...

Stop thinking about James, she told herself. James is gone. You have your children to think about. Children. It was not that she didn't love all her children, but there were so many of them. It would be so much easier with just one or two to indulge. And to think that her father-in-law had chided her after Carrie's birth for not doing her procreative duty! Keep her breeding, the earl told his son. And so Robert had.

It was not only herself he kept breeding. There were other babies, she was quite certain—with Robert's prominent nose, the cowlick in his curly brown hair, a hint of a dimple in the left cheek. She shut her eyes to those—what else could she do? Robert was such a booby when she married him, so rigid, so unsocial. But he bedded her at once—he was outgoing in that respect. And she had never let James come to her bed.

Though he had never asked, it was true.

What was the governess saying now? The woman was talking on in an affected voice as though she, singlehandedly, had brought Margaret out of a crisis: did she think she was God? Caroline was outraged.

"I called in a physician," she shouted, her temper taking over. "He left a fever powder but the girl won't take it. If she grows worse it's her own fault. I don't know what more I can do."

The lampblack was running into her left eye; she rubbed at it.

"Get me another handkerchief," she screamed at the idiot maid who was just standing there, doing nothing. The governess was a blur, standing at the foot of the bed in her worn blue frock. The poet was coming Wednesday and the woman had refused her gift of a gown. With her unpowdered hair she was way behind the times. Or ahead of them—oh damnation, Caroline didn't know! Here she was, stuck in this backwater of Ireland. Fashions changed and her own fell behind. If she ordered a lady's magazine from London it came two months late.

And now James, her beloved James, her mirror of self who noticed everything she wore and complimented her on it—was dead. She couldn't bear it, couldn't! She didn't know his killer, though she had her suspicions. Someone had to find out who it was.

"Go away, go," she cried, waving away the governess. "Leave Margaret's health to the nurse. Leave her to the physician. Leave her to me. I'm getting up this instant to see to the child. She needs me. I'm her mother, for God's sake."

She wiped her eye with a corner of the satin sheet and her vision cleared a little. The maid reappeared with a handkerchief and Caroline dismissed her. The governess had turned her back; she was leaving. There was mud on the woman's shoe. Where had she been anyway? The woman was incorrigible! What would she teach an already rebellious Margaret? How long could they keep this officious female? Why had they offered part of her salary in advance? Caroline's own money was running through Robert's fingers like liquid honey.

But the governess was clever—she had written a book. She could be of help. "You saw James at that bonfire," she called out. "Margaret said so." And the governess turned back to face her. She looked defensive. Did James approach her in an intimate way? He was surely capable of it. Governesses were a wily lot. That Miss Noonan—well, she did not want to think about Eva Noonan.

Now the woman was standing right over her, ranting on about that pagan festival, about seeing James. What was she trying to say? Something about an ancient tenant finding the poor body...

"He was stabbed in the neck and chest," the governess said in that authoritative voice of hers as though she was always right and everyone else was wrong. "That's all I can tell you. It was a terrible act, I understand your concern."

Caroline wanted to trust the governess; she needed her support. There was no other woman to talk to in this place. To ask for help. Major Cutterby was an ass, Mrs Cutterby worse. Her stepmother, Mrs FitzGerald, was a decent sort, but secretly mocked Caroline, oh yes, in that quiet way of hers. Caroline had seen that little smile.

And Robert! Robert had summoned a constable; then rode off to hounds as though James was no more than a fox run to earth or a rabbit in a trap. When James was all Caroline had. He was her confidant, her flirt. She missed him, oh, dreadfully. She blew her nose into a flowered hanky. Now the hanky had turned black.

"Find out who killed him," she begged the governess. "I need to know. I want the murderer brought to justice." She was wholly distraught; the lampblack, mixed with tears, dribbled down her neck and spotted Poo Poo's pale fur. "Ask questions," she cried. "They'll talk to you, you're clever with words. Find out who killed my darling James!"

She had lost the hanky. She wiped her face with a sleeve and for a moment could not see at all; her eyes were on fire. When she blinked, the door was shutting. "Curtsy, damn you," she howled. "Why in God's name can't you learn to curtsy?"

❦❦❦

MARY felt a great weight on her head and shoulders; her legs buckled on the stone floor. She was not going to curtsy to a face she could barely make out for the oozing artifice. She was not here to trace a murderer. How was *she* to discover who had killed James? For that was what milady was asking—nay, begging. If the woman was capable of loving at all, the object was James. More than her pet dogs, more than her twelve children who seemed simply to baffle her, like a tumble of kittens left on one's doorstep.

A fine lady, she thought, is but a new species of animal. How ludicrous the woman looked with that paint dripping down into her chin! But Mary had to admit, she was still pretty. *Always* pretty, she qualified, drenched in Lady Molyneux's Liquid Bloom.

Mary passed quickly through the gallery of portraits. She did not need to glance up at the parade of spoiled, fine-boned Kings and FitzGeralds dressed in wigs, pearls, and luxurious gowns—she had memorized them. They first came to Ireland in Queen Elizabeth's reign, eager to drive out the native Irish and appropriate their land. And they were still trying to do it.

And what of Mary's Irish ancestors? Digging up turf in the bogs, no doubt, squatting at their rustic tables, spooning up potato soup. How unfair the world was.

"Unfair!" she cried aloud as she hurried through the gallery and down the freshly polished staircase. "Unfair," she said again, and lifted her eyes to the frescoed ceiling.

For the first time she saw that the frescoes depicted *The Rape of Proserpine*, that goddess of fecundity who was captured by Pluto and taken to the underworld. The sight of the half-naked goddess made her miss a step. She stumbled—ah!—landed on the bottom stair.

A parlourmaid came running: "Oh, miss."

"I'm all right. Go, go." Mary struggled to her feet, though she might have turned an ankle. The maid dashed off into the dining hall with a feather duster in her hand, nearly stumbling over a toddler sitting on the floor with a toy dog. The maid dusted his tousled head and ran off laughing.

A bell rang at the front entrance and a footman scurried out of an adjoining room. Dillard straightened his bobwig, adjusted his posture as the castle butler, and watched as the footman swung open the door.

A man stood there in a wig too small for his head, a green-and-yellow waistcoat under a dark red coat—Mary thought of a caged parrot she had seen in a friend's house. Dillard gave a slight bow and accepted the paper the fellow was waving imperiously at him. Mary removed her shoe to massage her ankle; she wanted to hear what was happening. The butler glanced down at the missive; spots of red popped into his cheeks.

"You won't find him here, Constable," Dillard informed the Parrot in his correct butler voice—lowered an octave from its usual timbre. "He happens to be one of Lord Kingsborough's tenants. But my wife is a relative of the family. If you will kindly take a seat in the blue parlour—" he gestured elaborately with his hand "—I shall find someone who can lead you to him."

Dillard left the document on a table, while he trotted into the servants' quarters. Mary found the butler stiff and punctilious; she wondered how lively Nora had come to wed him. It was a step up in the world perhaps, a way to become Mrs Dillard, the housekeeper. But that was not the governess's affair. When the Parrot pulled

out a paper of snuff and sniffed it up his nose, she limped to the schoolroom to retrieve her Italian language book. "He happens to be one of Lord Kingsborough's tenants," Dillard had said.

She limped back into the hall. The Parrot was still occupied with his snuff and so she took the opportunity to glance down at the document: *Warrant for one Liam Donovan, accused of—*

She could not read the rest for the pounding in her temples, the blurred vision, the pain in her ankle that had flared up again.

There was a stampede of footsteps, a hissing of whispers: maids, cooks, and footmen lurking in doorways; children and dogs racing from a dozen directions and congregating at her feet. The entire household, it seemed, had heard the news that a constable had come for the tenant, Liam. Major and Mrs Cutterby appeared, looking triumphant. Nora arrived, bent over as if with a belly ache. She told the Parrot to follow her—what else could she do, her anguished face told Mary; she must lead the man to the Donovans' place. But not, Mary hoped, without first finding a way to warn Liam.

Mary's ankle was on fire. It was just as well. It stole the pain away from her temples.

When the great door burst open again and three men appeared, pumped up with importance, she wanted to run to Liam and hide him in her skirts. She wanted to tell the men that Liam had gone to America where they would never find him in all that uncivilized wilderness.

But Liam would be at home, working the "tattie" patch to feed his sister-in-law and nieces. The men would find him there.

Now Lady K was on the stairs in her black silk weeds; her French maid stood behind, straightening milady's black lace cap, adjusting the veil that hid her ruined face. Milady demanded to know what the commotion was about: she had a "debilitating headache"—would everyone "stop screaming, stop!" Informed it was Liam they were after "for the foul murder of James King," she shrieked, then clapped her hands and cried, "Bring the fellow here. At once."

"But your ladyship, they'll take him directly to the gaol," said Mrs Cutterby with a tremor of her jet headdress. "You won't want him here, my dear, no, no. If he could kill poor James, there is no telling what—" She yanked out an embroidered handkerchief and blew into it. Then remembering her grief, she half swooned into

her husband's ready arms. Her steep headdress tipped forward and she shoved it back in place. Mary thought of an overturned pot being slowly righted.

Lady K took hold of her senses: "On what proof?"

The Cutterbys stared at her.

She repeated her question. "What proof have they to allow them to take young Liam?" Her lower lip quivered. Mary had to admire the mistress's intervention. At the same time, she wondered, why so much passion. Had milady imagined a liaison with her young tenant?

"Why," said the Cutterby, standing upright again and glancing at her husband for support, "he had every reason to do so, had he not, Mr Cutterby?"

The agent nodded. He gripped his pale hands together; he would not catch Mary's eye when she glared at him.

"Everyone knows that James got that Donovan girl with child." The agent's wife looked properly shocked at the thought of how he might have done so. "'Twas the girl provoked it, we all know the kind." She glanced at Mary for support but Mary had none for her. "Liam did not like it," she brayed on. "Nay, not one bit. So he took his revenge. And what more convenient time than the Samhain festival. In a crowd where no one would see him thrust a knife into darling James's neck!" She squeezed her eyes shut with the horror of it.

Lady K was apparently overcome by the image of a hole in James's tender neck. She staggered a little, then pitched into the arms of the agent, who held her like an overripe grape, and shouted for her maid. Mary could bear it no longer. She inched out of the room, back into the servants' quarters and out a side door into the yard. She found herself half running (that miserable ankle) through the labyrinth of gardens, past the gardener's shed, and on up the path toward the tenants' cottages. She had no plan in mind except to find the Donovans. An injustice had been done and she could not allow it.

Rounding the path, her skirts muddied from last night's rain, her shoes oozing in and out of the puddles, she heard Nora's voice, and then the gruff basso of the constable. She halted; she was directly in their path. Her heart was in her feet, her injured ankle. But here was Bridget, the constable's men supporting her like an

overflowing jug of wine. She seemed half out of her wits; she was babbling on in Irish. Mary stepped aside to let the group pass.

"Liam wasn't there, praise God." Nora crossed herself, she was out of breath. "He must've heard them coming. Now Bridget's crying out she must see his lordship. Liam was home early, says she, from the celebration with his young niece. She's after telling that to the men a hundred times over. But will they listen? Nay, they will not! So she's off to the castle, and she's starting to run. Then falls in the mud, poor desperate thing. And afore I can get to her the men've yanked her up—they'll take her if she insists. They know her, they're not *all* bad—didn't one of them play with Liam as a child? They're just doing what they're told to do."

Nora scurried after the small posse and Mary followed.

"Innocent!" Bridget was screeching, "Liam did not kill the man, no! You must believe me. Oh, I should die but for my young ones—who would feed them? And Fiona, with a babe in her belly. Dear God in heaven, let me speak to his lordship!"

"Why did the fellow run off if he didn't kill the man?" asked the Parrot, who had fallen behind to walk with Nora and Mary, perhaps to prevent their whispering. "Aye, but Liam did it all right. He's guilty, aye, he's guilty all right. He was one of them Defenders, you can be sure he was, aye. We know they've weapons—knives and guns and pikes. We'd a skirmish up to Dunmanway a fortnight ago and one of our men left for dead. He owes us for that, too. Well, we'll find the rascal, believe you me and we will, we'll find him all right. We'll make him confess. We got our ways, you know."

He squeezed Mary's arm; she cried out at the impertinence, and wrenched away. It was obvious he relished his "ways" of making a person confess. She thought of the pitchcapping Margaret had described. She imagined beautiful Liam with burning tar and gunpowder on his scalp, and the blood almost drained out of her head. But she kept moving forward—what else could she do?

Without Doubt a Man of Genius

LORD KINGSBOROUGH had just returned to the stables with an exhausted pack of hounds. His curly hair was damp with sweat; he smelled of horse. Mary loved animals but horses were not at the top of her list; she had been sprayed and dirtied in the London streets by more than one of the snorting beasts. She had no desire to see Lord K—only yesterday his hand had brushed her breasts when they passed on the stairs, and she was certain it was no accident.

Still, when Nora was called away, she waited by the stable door whilst the Parrot harangued him with the tale of Liam's escape. "He's our man, he's our man," the Parrot kept repeating, as parrots did.

Lord K pushed him off with a gloved hand: "Then go after him. Don't just stand by and prate about it," and he strode on toward the castle. One could see the great thirst in his throat the way he kept swallowing his saliva.

Bridget Donovan ran forward to clutch at the man's knees. "He's innocent I tell you, milord, wasn't he home with me when it happened? He would never kill a man from the back, I'm saying—not me Liam. Pray, sir, for the sake of me daughter, who—" She stopped and hung her head; she had gone too far. She slid to Lord K's feet, a crumpled heap of soiled flannel.

Mary half expected him to kick Bridget, the way she'd seen him shove aside a cringing dog that had defiled a parlour rug. But his expression was benevolent. A dimple popped into his left cheek.

"You should have kept that girl at home," he said in an avuncular tone. "James, well, James was a young blade, he had, um, his needs. But I'm not apologizing for the fellow—if indeed he was the

father, hmm?" Bridget cried out, but Mary put a hand on her back. "All right, we'll see to it your daughter has help when her time comes. Send someone to me. Though Mrs Dillard's done a bit of midwifery, she'll see to it, eh?"

He tried to move on, but now Bridget was clasping his knees. "It's Liam I'm here for, milord, not Fiona. He's innocent, I'm telling you. If he went off, well, he was frighted, that's all. Liam's me only man, milord, since the death of me poor Hogan. Och, the girls are strong but they can't bring in the harvest the way Liam can, your lordship. And how now, in God's name, without the lad, oh Christ save him, how are we to get on?" She ended in a shriek.

Lord K had lost patience. The dimple faded in his cheek; his face seemed raw and red. He pulled Bridget back on her feet and looked her hard in the eye. "I'll speak to my land agent about it. That's all I can promise. It's out of my hands now. The boy's been seen in places he shouldn't be, eh? In bad company? But if he's innocent as you say, there's nothing for you to fret about, eh, Bridget? Eh?"

Bridget's face said there was a great deal to fret about.

"Go back to your cottage now. Those girls of yours can do the work, we'll make allowances. You're strong and able yourself, I can see that." He appraised her as he would one of his horses and squeezed her hands until she grimaced.

Mary shrank back; she did not want him to see her witnessing this strange little scene.

"You'll see, milord," Bridget said, "you'll see he didn't do it. Not Liam, nay, not me good Liam. You know Liam, milord. Why, he's Nora Dillard's brother! He'd never kill a man his niece was fond of. Oh, never in the world, you know that, God bless you."

A stable boy, followed by the agent Cutterby, brought a bay horse to show his master a mark on its hide, and Lord K was obviously glad of the interruption. Bridget looked after man and horse, trusting, Mary supposed, in his lordship's promises. Though what else could the woman do? She was at the man's mercy.

For herself, Mary had doubts. She would have to keep an eye on the outcome. She would have to keep an eye on Major Cutterby as well. She hardly knew the man, knew little of his relationship with the tenants. Yet he appeared too diffident and weak, too controlled by his wife to deal with delicate matters like errant brothers and peasant girls with child.

Though Mary was unsure now about Liam. He was a fellow of

strong passions—that attribute had attracted her to him. Still, if innocent, he should have stayed to face his accusers. She did not like to hear of his running off like that, she did not like it at all.

Nor did she like the sound of her ailing pupil's shrieking tantrum from an upstairs window. What now?

"GET away. Don't touch me!" Margaret sat up in bed, her face glowing like a bonfire. The little physician was after her again with his bag of leeches. She shoved him off and his periwig slid down his balding head. She banged her fists on the bedpost and her bedclothes fell back; her arms were like ghost arms, bone white. How ugly she was, she thought. She flopped back on the mattress. "Send him away or I'll smother myself," she screamed at her mother. "I just want to die. Die, I said." An hour ago the new young nursemaid had told the news of James's death. Murder, she'd said. Murder! And Margaret was the last to know. She didn't like that—James was her friend, her confidant. She put a pillow over her face.

Mama tugged it off. "Stop that nonsense. How are you going to get better if we don't do the cure?"

The nursemaid cowered in a corner, her eyes like green marbles. "Begone!" Margaret screeched, and the physician went.

"Make her stop that tantrum. Do something—anything," her mother shrieked at the nursemaid. "I cannot bear this, my health is too delicate. I can*not*." She teetered out of the room in her satin high heels and slammed the door, leaving the dogs behind; they set up a howling.

"Get those dogs out of here!" Margaret burst into tears.

Someone opened the door to let them out. It was Miss Mary. The nursemaid pounced on her. "She been in a tantrum all afternoon, miss, since she heard about Mister James," the nursemaid wailed. "It were my fault, I didn't know, and now she's angry for not knowing sooner. She won't let the physician near, miss, nor her ladyship, neither."

"The fever?" Miss Mary asked. The governess is an angel in blue, Margaret thought. A sensible angel.

"Oh, she's still hot," the nursemaid told the governess. "I been awaiting your help to cool her off since she won't let no one else do it. I was afeard we might lose her, miss."

Margaret was moved to hear that; she wiped her damp face with a corner of the sheet. The governess sponged her off. The sponge

was cool on her bare skin; the cool entered her bones. She dismissed the nursemaid: "I want to talk to my governess. Privately."

"Thank you," Miss Mary said to the nursemaid. And then looked at Margaret, who suddenly remembered how angry she was with the governess for not telling her this morning about James.

"How could you let me talk about him, and you knowing he's dead, and—" Margaret's eyes were full with unshed tears.

"I was told not to tell. And I obeyed." The governess stared her down. Margaret was too ill to argue. She wanted to hear about the Donovan family, about Fiona—how the girl was taking James's death. About Oona, her only friend, though Oona could not be a real friend her mother said, for she was a simple peasant. Though why peasants were simple, and rich people complex, she could not comprehend. There was nothing complex about her mother's lady friends and relations who congregated in the drawing room like a flurry of coloured moths.

Mary told her about Liam and she cried out. "He should never have run off like that. Why did he run? It only seals his guilt!"

"My thinking exactly." The governess sat on the edge of the bed; her slim body hardly made a dent in the mattress. The blue dress needed a wash. Margaret wished she would at least liven it up with a colourful brooch. Something to match her personality. Which was quite colourful, Margaret was discovering.

"...lacking hard evidence," the governess was saying in that lilting voice of hers. "I was pleased to hear your mother say that, Margaret. It shows that she—" She paused, as though she should not be discussing Mama with Margaret.

Sometimes Margaret hated her mother. When she was a child, for instance, and Mama would make her play and sing for visitors, and then she would play a discord just to upset the teapot. Sometimes she was afraid of Mama, as when she'd come upon her parents arguing, and Mama would turn into a harridan—a furious woman, who once poured a kettle of boiling water on Margaret's father's head. And when her father reacted, she feared for her mother's life.

But deep down Margaret wanted to love her mother. Longed to... "She has her moments, Mama has," she told the governess. "She's not all frippery the way you might think." When the governess raised an eyebrow: "Oh, I know she comes off a fool—the dogs, the face paint. I despise all that, truly I do! But her grandmother was a peasant, did you know that?"

"Nora mentioned it," Miss Mary murmured, looking interested.

"My grandfather was nearly disowned for it. So you see there's humble blood in Mama's veins. If they had brought her up differently—she might be a real mother."

Margaret felt a pressure behind her eyes. She opened them wide—she did not want to cry in the governess's presence.

"My mother put me out to a wet nurse," the governess said, her brown eyes blinking, "until I was four. She piled all her love on my brother Ned and favoured him until she died."

"And Papa favours George over me, for he's a boy." Margaret sat up and grasped the governess's sleeve. "Boys are always favoured over girls, it's so unfair. George is a rascal, but Papa tries to ignore it. And Mama, well, she prefers my younger brothers and sisters over me—and over George, too, if she tolerates any of us, that is."

They were spiritual orphans, Miss Mary agreed. Margaret reached for her hand, and felt the return squeeze.

"Poor George," Margaret said. "He's in love with Oona, did you know that? Papa would be furious if he knew."

"It's just an infatuation, don't you think? Surely nothing can come of it. George must know that."

Margaret pulled her hand away. She did not like the governess making assumptions like "nothing can come of it." She loathed the concept of class. "George is stubborn. He's like a cat with a mouse: he won't let go, though you shake him. He loathes the rebels; he wants to join Papa's militia. In some ways though, he's a rebel himself. Why, he was furious at the way Uncle James treated Fiona. Furious! He knew James never intended to marry her."

"But you said this morning that James—"

"That was to divert you. I told you we had secrets. He did *not* intend to marry her, he told me so. Fiona kept hoping, but *she* knew, as well. James loved her. I do believe he thought so. But in my view all he really wanted was to shock our family."

"And so he did." The governess looked indignant; her dark eyebrows lifted and bunched together. Her hair fell forward into her face. She could use a pin or two to hold it back.

"But Mama blames Fiona, oh yes. Mama has practically memorized Mrs Piozzi's book—*The Lady's Dispensatory*. Have you read it?"

Miss Mary made a face—as if to say she would not stoop to that kind of book.

"Well, it claims that females of the lower classes are more likely to be corrupt than those in the aristocracy. And we *know*, Miss Mary, that that is not so. One has only to enter our drawing room, am I correct?"

Miss Mary smiled. Of course she agreed—that was what Margaret liked about her.

The governess asked: "You said George was angry at James?"

"I said *furious*. Ready to kill! No, no, he would never, no... But he said so himself, he said—"

"Miss Wollstonecraft?" It was Mama again, entering the sickroom with a trail of smelly poodles. "You may leave now. I'm here. The physician will not return, I will see to that. You were quite right, Margaret, those leeches are disgusting. I have dismissed that man for good."

"I want Miss Wollstonecraft to stay, Mama. Oh!" Margaret giggled, then put a hand over her mouth. There was George, peering out from behind her mother's voluminous skirts, frantically signaling. Mama frowning, pulling him out in front. And Miss Wollstonecraft not moving a foot. And George grinning and grinning, the fool.

"We leave at seven tomorrow for Dublin," Mama announced, "to attend a memorial service for James." Her mouth twitched as she spoke. The body, Margaret had learned from the nursemaid, had already been carted off to Dublin in an oak coffin for burial near James's town house. "Not that I want that dreadful journey in the carriage—my nerves cannot endure it. But one must, for James's sake." Her mother was holding a lace handkerchief to her nose. "George, as the eldest, will accompany your father and me. But you, Margaret—"

"Oh, Mama, I'm better, let me come!" Margaret held out her hands, she wanted to go. She *longed* to go. To see James off. To see the city of Dublin.

"Funerals," her mother said with finality, "are not for young girls. You will remain here with Mrs FitzGerald and Miss Wollstonecraft."

"No, Mama. You can't leave me here!" Margaret pounded the mattress until a fine dust flew up. She wailed. She put on her loudest tantrum. She had developed it through the years.

"That is all I am going to say on the matter." Her mother held up a restraining hand. "And you, Miss Wollstonecraft, will be in the drawing room at five o'clock to welcome Mr Ogle and his wife. Mr Ogle is a poet. You will know how to talk to him." She turned to go; then turned again, her black silk skirts swishing with her. "That is, for a few moments. A quarter of an hour, perhaps. And pray do something with your hair."

"I shall brush it," said Miss Mary, with a bobbing curtsy. Margaret held back a giggle.

Mama frowned again with her blackened eyebrows (Margaret preferred the black lead comb to the mouse-skin brows she sometimes stuck on). She beckoned to the governess, and rustled away in her mourning gown and her wobbly black heels.

This afternoon, before the funereal journey, Margaret thought, there will revelries. It is the Kingsborough way of celebrating death.

But this was more than death—it was murder. She accused George, who was slumped on a corner bench, forgotten by his mother. "You said you wanted to kill James, you did," she cried. And George laughed.

George could be so infuriating when he laughed. Sometimes she would like to kill him.

❧❧❧

PRECISELY at five, Mary took a half dozen deep breaths and entered the drawing room. George Ogle, poet and parliamentarian, leapt up to take her hand. "Oh," she said, and felt oddly refreshed. One could not call him handsome—his nose was rather large for his face. But he had soulful brown eyes and fine manners. Best of all, he was a celebrated poet. Lady K had lent her a copy of his verse; Mary had memorized a stanza:

> *Youth soon flies, 'tis but a season,*
> *Time is ever on the wing;*
> *Let's the present moment seize on.*
> *Who knows what the next may bring?*

It would bring the poet himself, yes, and here he was! She seated herself between Mr Ogle and his pale wife; Mary asked him to repeat the stanza aloud and he did, in a deep, thrilling voice. He gazed into her eyes as he intoned the refrain:

> *All our days by mirth we measure,*
> *Other wisdom we despise…*
> *Follow, follow, pleasure, follow, follow!*
> *To be happy's to be wise.*

Mary liked the last line, although she was not sure about the pleasure part. The whole room was following that advice, it seemed. And the poem *was* reminiscent of Robert Herrick's verse "To the Virgins." But Mr Ogle was without doubt a man of genius—everyone said so. An *unhappy* soul, who longed for happiness, she could sense it. His wife, though sweet, seemed the palest of brown sparrows beside this ethereal man.

When he finished the final verse, he pelted her with questions and of course she complied with answers. The fever of the two deaths she had encountered since her arrival paled beside the attentions of this talented man in his black coat, frilled shirt, and violet waistcoat. She could not resist telling him about her forthcoming book, *Thoughts on the Education of Daughters.* "It is about the way we bring up our children." She warmed to her topic. "How we put them out to wet nurses, like calves to pasture. How, I ask you, are they to bind to their mothers?"

In a whisper, she told how Margaret was ill, how the younger children ran about half-clothed, with colds, fevers, coughs. "Who knows what diseases the wet nurses have passed on? Consumption runs in this family."

"Ah." He leaned toward her until his head was close to hers. Could he hear the rush of her breath? If only she had a book in hand to show him—nay, to give him. "When it's printed," she invited, "when my publisher, Mr Johnson, sends it on—why, *you*, sir, shall have the first signed copy."

He beamed with pleasure (he had a lovely smile), and she determined that he *would* have it. Never mind that she had promised copies to her sisters and to several others.

Mr Ogle announced to the entire room that Miss Wollstonecraft "is a noted authoress" and the fluttering fans went still to hear praise from the mouth of a famous poet.

"I do hope it has some common sense in it." Here was Mrs Cutterby, throwing cold water on his words, shaking a head full of black feathers, jet, and crepe. "Girls should be made to listen to their elders. It is shocking the way they neglect their embroi-

dery! Why, they cannot play the simplest of melodies on the piano-forte."

Mary reddened, being deficient on both counts. Did the poet know she was a mere governess? Had Lady K told him?

If he did not yet know, he found out when milady entered the room and settled like a a burnt cockatoo on a green settee. The poet jumped up to kiss her hand; he sneezed twice when he encountered the black feathers.

"We had to dismiss the last two governesses," Lady K said, "because of that neglect—that is, in part. You perhaps recall that, Mr Ogle." The poodle nursed on the crimson flowers at her bosom.

Spots of red popped into the poet's cheeks.

"Miss Wollstonecraft created her very own school in England." It was sensible Mrs FitzGerald, coming to Mary's rescue.

"Did you now?" Mr Ogle's quiet wife asked Mary, seemingly impressed.

Mary smiled. The tide was turning in her favor, and Lady K was swimming along. Mary must bring her sisters to Ireland, milady said; she might be able to place them with friends. She was rewarded with a smile from Mr Ogle, who seemed an egalitarian.

"Perhaps I shall." Though Mary doubted they would be up to it. Eliza, in particular, had been unpredictable since she had escaped her husband. And Everina had not written a syllable since her sister's arrival in Ireland. Mary was piqued with the pair of them.

She was not allowed more than fifteen minutes in the sun of her poet before she caught the eyebrow signal to exit. When she finally rose, Lady K rustled over with Mitzi to occupy her seat. Mr Ogle, it became clear, was her flirt. Mary had been called upon to amuse, the way a puppy might cavort and entertain. She was not here to captivate.

She was surprised when the poet jumped up to see her to the drawing room door. To make conversation, she asked if he had been acquainted with James King. She didn't know why she blurted that out—it just came to her lips.

He hesitated, then said, "I knew the man, yes. I am sorry he died, of course, but, well, I did not..." His voice was harsh, drifting into a gutteral rasp.

Surprised at the unexpected change in his demeanour, she nodded; he bowed; and a cold wind pushed her toward the stairs.

CHAPTER VIII.

Witches—and a Cave after Nightfall

DESPERATE FOR an evening away from the castle after the Kingsboroughs' return from Dublin, Mary joined them for a presentation of Shakespeare's *Macbeth* at a school in Mitchelstown. The Weird Sisters were Irish girls; they chanted, "Dooble, dooble, toil and trooble" in their local accents. The scenery wobbled precariously when Birnam Wood came to Dunsinane: a troupe of small boys marched on, bearing evergreen branches that could not hide their grinning faces. The evening was amateur, yes; amusing in some ways, yes. But it evoked suspicions that Mary's mind couldn't seem to quell. When the aging Lady Macbeth wailed, "Who would have thought the old man to have had so much blood in him?" Lady K, too, cried out. Lord K's elbow assaulted her ribs, but still she whimpered.

Mary narrowed her eyes at the pair. She glanced over at young George, the only child allowed to attend—Margaret had been sent back to bed after throwing a fit. He was staring at the stage, mesmerized; his huge eyes mirrored Lady Macbeth's grief—and perhaps, Mary's fancy suggested, her guilt.

Were they in concert, the three of them? Did Lady K harbour some grudge against James? Because he did not return her advances? Was her grief a façade? Did James go against the family's wishes in some perverse way?

Ridiculous, Mary told herself. Yet the mad thoughts galloped on.

In the row behind, the Cutterby was whispering loudly in her husband's ear. About the play? Or had it to do with the demise of James? And if so, what was the secret there? Everyone, it seemed, had secrets. Even young Margaret, who insisted on keeping most

of them to herself. Mary did not like that. If there were secrets, she wanted them flushed out into the light. She did not like this great house where poison was served like sugar in the dish of tea.

Everyone was smiling, though, after the curtain call. Lady K was quite gay, fanning up a breeze that chilled Mary. The Cutterby mimicked one of the witches who had missed a cue, and like the actress, clapped a hand to her mouth. No one laughed, and she sulked as she pulled on her cloak and gloves. On the return trip, it was Mary's ill fortune to sit opposite the agent's perfumed wife. To compensate, she pushed up the glass to let in the night air. The wind was bitter; she had to pull her coat collar up about her ears. But she needed cold air on her feverish brow. Shakespeare was right: the world was in a state of disorder and she was in the midst of it.

That night in her bedchamber she dreamed that Lady Kingsborough and Mrs Cutterby were witches. They were clad in sable, with lampblack ringed about their eyes; they were tossing dead fish and snakes into a cauldron. They cackled as they stirred the loathsome brew. "Fair is foul, and foul is fair," they croaked, and all at once it was Mary herself they were stirring into the pot. She woke up screaming.

Then it was Nora, standing over her with a cup of warm ass's milk; she was making her nightly rounds before going home. She heard Mary cry out, and was relieved, of course, to know it was only a nightmare.

"Plays," Nora said, "och, they're made up, and dangerous, are they not, for the state of the humours? Meself, I'd never go to see one. They're after stirring Lady K's blood—you should hear the nightmares that one has. She'll be quite mad in six months' time if she keeps on play-going."

Mary wanted to quote Aristotle to the housekeeper: about how the play was a catharsis, arousing one to pity and fear but seldom overheating one's cup of tea. But the words, she decided, would go over practical Nora's head. Still, the housekeeper had a point: the tragedy had stirred up a boiling pot in Mary's breast; it was the governess who might go mad in six months' time.

"I seen Liam." Nora leaned into Mary's ear, and the pot went on boiling. "He was bringing a rabbit back to the cottage. But he swore us all to secrecy. Wouldn't tell where he's hiding at. They've

rebel cells all over the county, you see. Liam'll find the true killer himself, he insists, for *he* didn't kill James. Then he ups and leaves in the middle of supper, and Bridget, God help her, is clinging to him and shouting he must go to Lord Kingsborough. 'He'll help, he promised,' says she, but Liam's pushing her off. He won't stay. He'll do something rash, miss, oh, I know it. I'm afeared for him, miss!"

Nora's candlestick trembled in her hand. She appealed to Mary as though the governess *could* do something to help. Mary held out her empty palms and finally the housekeeper left. The ass's milk tasted sour; Mary felt ill from it. She put a pillow over her head to quiet the turmoil in her brain.

The loathsome witches pranced on.

TWO days later the black crepe came off the doors and windows. Lady K, Mary noticed, was no longer wearing the obligatory black. She had switched to a hot pink that matched the crimson of her cheeks. With Margaret's fever gone, although the girl was still coughing, her mother was free to concentrate on her dogs.

Since Margaret had not been allowed to attend *Macbeth*, they read the play aloud in the schoolroom. It provoked a lively discussion, although Margaret, who had begun her menses the year before and was theoretically ready for marriage (she said not), refused to accept that Macduff was "not of woman born." Stubbornness and temper, inherited from her mother, were two more of Margaret's faults that Mary had to wrestle with.

But then, she saw the same faults in herself, and so made allowances.

Carrie, whom Mary had privately named "the self-righteous one," took up her sister's position. "My brothers and sisters all came out of Mama. And I saw her the day before one came out, and then the day after when her stomach was flat again. Nurse brought us in to see the new baby and I heard Mama say her insides were bruised and she didn't want one more child. 'Never, never!' she said."

"But she did get *lots* more, didn't she?" said little Polly, who had already accepted the fact that life for women was a carousel of babies, wet nurses, and marital spats.

They went on to discuss Macbeth's reasons for killing the king, and the question of who was responsible: the Weird Sisters—or was

it Macbeth's own "vaulting ambition"? Or was it Lady Macbeth who goaded him on, begging to "unsex me here"?

The response was divided. Polly and Carrie agreed that it was Lady Macbeth at fault, while Margaret said: "Macbeth! He was to blame. He was the one kept his lady there in that miserable castle. She just wanted to get out, that's all. She was tired of having to please everyone."

Herself, Mary quite admired Lady Macbeth for speaking up to her husband. She pitied her, too, truly she did.

"My mother—my own blood mother," Margaret cried, stamping a foot, "could kill if she had to. You underestimate her, all of you."

Do I? Mary asked herself.

In the afternoon the governess was in the tower library, choosing another Shakespeare play for the girls—something lighter. *A Midsummer Night's Dream*, yes. Carrie, the most romantic of the three, in spite of her occasional smugness, would like it, and Polly would be amused by Bottom with his donkey ears. Mary was writing notes when she heard footsteps outside in the hall. The door banged wide and George loomed large and impassioned in the doorway. He took a seat so as to be at eye level with the governess; he was already taller than his father, and huskier. Like Margaret, an inner fire glowed in his face. Mary was trying to reverse her negative impression of him from when he met her at Eton. Sometimes, she had to admit—one more struggle within herself—that her mood of the moment and her preconceptions often coloured the truth.

She clasped her hands together and waited for him to speak. For it appeared that he had sought her out.

"I know where Liam Donovan is," he said, and when she wriggled in her chair: "I mean where he *was*. Oona and I came upon him near the cottage, digging turf."

Mary stared at him. Why was he telling her this? What did he think *she* had to do with Liam Donovan? Why *she* would want to know where he was—she, Miss Mary, the governess, more lowly than the smallest child in this august King family?

He leaned back in the chair and fixed her brown eyes with his dark blue ones. They took one another's measure. Could she trust him? She had more to lose than he. She could see his face tighten; his nervousness calmed her own.

"Oona," she said coolly, mimicking his mother's preachy tone

of voice, guessing why he had come, "is a peasant girl. She is a class below you. Why, two or three classes! As such she is vulnerable, she cannot be her own person. If the son of the great lord of Mitchelstown Castle approaches her, where can she hide? How can she protect herself?"

She heard something that sounded like a sob. She glanced up, surprised. George's eyes were crowded with tears. He looked so vulnerable with his slack jaw, his hands clasped tightly together in his lap, his damp eyes pleading. She was still unsure of Liam's motivation. If Liam indeed had killed James to protect his niece, would he kill again? Would he kill young George? She felt suddenly protective of the lad.

He sensed her sympathy and leaned toward her. "Margaret sent me to you. She said you would listen."

Mary was mollified; it was the tears that softened her mood. "Liam saw you then?" she asked. "Did he speak? He doesn't want you to be with Oona. I heard him say so—it was the night of the bonfire. You must stay away from her, George. She is not for you to dally with."

"She loves me." His voice was thick with adolescent passion. "I'm not playing with her, I mean to marry her. I do, and I will!" He stuck out his lower lip. "Father was wed at my age."

How well had that marriage worked, Mary wanted to say—but held her tongue. Instead she repeated her question about Liam. She didn't know where all this was leading. What did George want her to do? What could she do? She had no real power over anyone beyond her three female charges.

He leaned his elbows on the escritoire. She noted the fine linen of his sleeves, the expensive waistcoat, the gloss of his brown hair that fell over his brow, hiding his eyes. He resembled one of his mother's lapdogs. "Liam said he would kill me if he saw me again with Oona—those were his very words." He reached out for Mary's hand and grasped it, hard. She winced with the pain of it. "But I can't *not* see her! We can't be apart. We'll—we'll g-go to America, that's what we'll do." His passion made him stammer. Mary found it endearing. He hung his head.

He was still a child. His body had matured beyond his mind, as it did with most men, she had discovered. Some, of course, like her old beau, Joshua Waterhouse, never grew up.

"America?" said the governess. "The two of you? But you're underage! Have you money of your own? How would you live?"

Of course he didn't know, he had not thought it all through. He loved the girl, that was all. She thought of Romeo and Juliet and how they ended up in graves because of their many adversaries. She thought of her sister Eliza who married for love—security perhaps—but found only abuse. When Mary had rushed her away through the streets in a hackney coach, the girl was so crazed she bit clean through her wedding ring. A gold ring—was it hollow? They had left the baby behind—whose fault was it the baby died? And what if George got Oona pregnant?

"I can't help you with this," she told George. "It's too dangerous for you to keep seeing one another. Do you really think Liam would kill you? If so, you must be careful. Do you think—" she hesitated: there was a question she should not ask but she asked it anyway "—that Liam killed James? You were there that night at the Samhain festival. Did you see where Liam was?"

The questions flew out of her mouth; she hardly gave the boy a chance to speak—impetuous, her sisters would call her. But he understood her intent.

"I did see someone," he allowed. "Someone moving off in the brush after they found the body. One of those filthy rebels after James, I don't know. But I couldn't see his face."

"Was he tall? Was he lean, did he have the springy walk that Liam has? Did you see a knife?"

"It was dark away from the bonfire; it was starting to rain," George said stubbornly. "I couldn't tell what size or shape the man was."

"But you think it was a man."

George squinted, as though trying to materialize the fleeing shape. "I couldn't tell that either. It was dark, I said, there were shadows. But a man—I think so, yes."

He looked as though he might cry. He did not really want to pursue this subject, that much was clear.

Mary reminded him to think through this infatuation for Oona, to examine all sides of the question; then they would speak of it again. "And don't put yourself in any danger, George. I'm sure Liam wouldn't deliberately hurt you, but he does seem fiercely protective of his nieces."

George nodded, and trudged out into the hall. His shoulders hunched as though he had just been defeated in a game of cricket. Yet a cricket match was what a young lad should be worrying about—not fleeing murderers or vindictive uncles or pretty peasant girls.

She turned back to *A Midsummer Night's Dream*. She loved the way the couples drank the wrong love potion and became mixed up in the dark—a metaphor for the complexities of their lives. And she saw again that although things would turn out all right for those characters, in the Kingsborough realm the world had spun out of its natural order. Two murders? Young aristocrats running off with peasant girls? It would not work—never mind that Lady K's grandfather married a peasant girl and doubtless tore the family apart in the process.

She imagined what it was like for that girl: the cold stares, the whisperings, the condescension. And how long did that passion last? At most a month or two, she reckoned. She had known those ephemeral passions herself, had she not? That sensation of being helpless, impassioned, out of control?

No, such a liaison would not work for George and Oona. Not in this society built on class. Surely, it was a governess's responsibility to cut it off at the root. She prayed, of course, that it had not yet come to fruition.

MARY was passing through the ornamental grasses garden the next afternoon when Margaret came running up behind. The minx had spied her leaving, had dodged this way and that, she admitted, until she caught up with the governess. "You're going to see the Donovans, aren't you?"

Mary was. But she did not want Margaret along. The girl had a sentimental side, though she would loudly deny it. "Well," she said, "just to bring the family a bit of bacon." She had saved it from her own portion at breakfast. It might serve as an introduction to Oona.

"I saw you take it," Margaret said. "I saw you put it in the napkin."

"So?" Mary was not going to let this young spy get the better of her. "Go tell your mother, I don't care."

Margaret laughed and tucked her arm under her teacher's. "It's

all right, I'm glad. Mama doesn't need the bacon. Mama has a for-
tune in her jewelry box—have you seen it?"

Mary had: it was wide open one time when Mary went in. A
rainbow of diamonds, emeralds, rubies—a plethora of dazzling
stones set in silver and gold.

"A single ring," Margaret said, "could build a grand new house
for the Donovans and Toomeys. But it's not for Mama to sell, not
really. You see, my father controls her now. She even has to ask his
permission to wear a precious necklace to a ball. Some highway-
man might snatch it from her neck and gallop off with the booty.
George and I despise our father's attitude."

"You and George think alike."

She tilted her head. "Not always. He's not the quiet, amiable
George he used to be. And," she whispered, "you cannot mention
the Defenders to him—he sides with Papa and the English. While *I*
want to join the rebels when I come of age. See if I don't!"

"I've no doubt," Mary said, smiling, "but that you *will* join
them."

"But you see," the girl went on, "with all our differences,
George was the only one I could talk to around here—until you
came, Miss Mary."

The girl's words were flattering. But Mary could not lose sight
of the afternoon's objective. And Margaret's presence could be a
liability. She glanced sidelong at her pupil. "You approve of his liai-
son with Oona Donovan, do you?"

"He wants to elope with her." Margaret stopped walking. She
lowered her voice; it took on a breathless, pleading tone. "He wants
me to help him. But we need the help of a grown-up. We need your
help, Miss Mary. You understand, don't you? How one should fol-
low one's heart? You have such a fine sensibility."

Mary laughed, though the word softened her resolve. To have
sensibility was, well, to know mind over matter, the need for a mor-
al fineness over social rank and birth. To one like herself who was
prey to melancholy, a fine sensibility made up for not being born a
lady. Or so she told herself.

She wanted to turn to Margaret, to tell her that she would be an
accomplice. To whirl the lovers away to—what end? Shakespeare's
comedies ended with the embrace, the moment of sensual love.
Curtain. Even Mary's unhappy mother, she supposed, knew that

moment of what she felt to be true love. And then the long years of ennui and pain.

"I *cannot* do it, I cannot help children elope. It's not, well... prudent," she called after Margaret. But the girl didn't hear; she was running ahead to where a cart, laden with people, chickens, a pig, an off-balance load of household things, was labouring toward them. Bridget Donovan was trudging alongside Mrs Toomey; behind them trotted three young dirty-faced Toomeys.

"Holy Mary, save us, for we been evicted," wailed Mrs Toomey. She bobbed her head at the two females. "The agent says we had to leave, he's another family coming in. He give us a day only, God help us! He say his lordship bid 'im do it. But there wasn't time enough to dig up tatties, was there? The ones still in the ground?"

"They couldn't pay the rent," Bridget told Mary and Margaret, as though they were the judges who might reinstate the family. "Not with Sean gone and old Malachy too crippled to work the castle harvest. And her," she pointed at Mrs Toomey, "having to drop her pride and beg for help. For 'twas time to end the feud, we both said so, and so we did, though old Malachy would never. But he's back there still, digging up his bloody berry bush."

They were all talking at once, Margaret turning first to one and then to the other. Meanwhile the Toomey granny squatted atop the packed cart, pulling at her hair and wailing, no doubt, for the whole world of woes and rackrents and greedy landlords. Mary's blood was at boiling pitch. She would have a word with the egregious Major Cutterby.

"Miserable fool!" Bridget Donovan hollered when Malachy Toomey hobbled up the path with his sack of "tatties." "You're in trouble now. It's time to take on help from your neighbours and let old dogs lie."

"Never!" he shouted back, stumbling along. "Your pig dug up my tattie patch and the blackberry bushes I'd newly planted, and no compensation. I can't forgive. I'll never, never!"

"He's dead. My man is dead!" Bridget screeched as the cart rumbled off. Her eyes flashed fire. But the old man just pressed his lips together and looked only backward in his mind.

Mary put a hand on Bridget's shoulder; she'd had experience with unforgiving folk. "Let him go now, he won't change. You have enough else to bear, Mrs Donovan." Bridget nodded, worn

down by the shouting. She had a weatherbeaten look and her hair was matted with dust; she seemed to have aged a decade during Fiona's pregnancy.

She let Mary and Margaret each take an arm to walk her back to her cottage. "They could evict me if we don't get Liam back," she moaned.

"And where would he be hiding?" Mary asked. "Can you tell us so we can bring a supper?"

"Close by," the woman whispered. "To help with the last of the harvest. Major Cutterby has come by twice, surprised we've been able to do so much work. Och, the questions he asks! They're suspicious, you see." She pulled at Mary's arm. "Liam won't be able to come now. I want you should see him, miss; tell him to ask for a meeting with Lord Robert—you can set it up; you're from the big house. He won't listen to Nora." She was pinching Mary's arm with her vehemence. "Milord promised, aye, to take care of him, he did."

Mary was surprised to hear such blind faith in the Kingsborough lord. She removed the woman's hand. "Tell me where to find Liam, and when he might be there."

"In a cave by the river," the woman whispered. Aloud, she said, "Oh thank you, miss, thank you. God bless you. Lord knows I have to trust someone. I'm half-destroyed, I am. I'm half gone out of my head! You won't tell the others? Oh, merciful heaven, oh, Holy Virgin, pray for me." She made the sign of the cross over and over.

"You can trust me," Mary said, and nudged by Margaret: "You can trust Margaret, too, not to speak out of turn." The girl's cheeks were flushed with excitement at the secrecy of it. The thought of seeking out a cave at night, Mary had to admit, thrilled her as well. Her strength flowed back; she was a mother saving a drowning child.

Despite the directions Bridget gave her, Mary would have no idea how to find the place. She would have to rely on Margaret—or Nora. Yes, Nora. Who knew what young Margaret might let slip, prodded by her father? She and Margaret started back to the castle; Mary's reason—Oona—for visiting the Donovans, was quite forgotten in the shock of eviction and news of Liam. *Tonight*, she thought, with butterflies in her breast, as if it were a romantic tryst and not a young man's life in the balance. *Tonight*.

But Liam was to appeal to Lord Kingsborough? She had grave doubts about that.

The day dragged on with meals, dishes of tea, children's antics, and interminable history lessons. From time to time she and Margaret glanced surreptitiously at one another, making Carrie cry: "What are you two scheming up now? What am I left out of?" Polly shadowed the governess until suppertime; afterward, Mary persuaded the nurserymaid to take the child up to bed. Even then she had to follow and tell young Polly a bedtime story (the girl did stir her maternal feelings). At nine o'clock, when Lord Robert was already half-drunk and arguing the pedigrees of horses with a hunting companion, Mary slipped away.

It was a forty-minute trudge through bog and brush to the cave that bordered on the River Funcheon. Mary had only Nora with her: Margaret, coughing and feeling once again betrayed, had been forcibly put to bed and locked in by her mother. Nora knew the cave; she had played there as a child. But she had known all along that Liam was there and never let on. There is no true confidante for me, Mary thought, in this great house.

The night was rainy, yet the smells and sounds of the country night were a boon after the smoke, perfume, and clatter of the castle. But after a half hour's walk through the bog—even with Nora, even with their lanthorns—Mary was anxious. An almost primeval odour welled up: she evoked bullfrogs, giant tortoises, reptiles. She half expected to see a dragon loom up in the path, breathing fire! Yet because of her fear perhaps, she felt fully aware, wholly alive in this ancient place. She breathed the scents of earth and water deep down into her lungs.

They had shuffled some fifteen feet into the cave when Nora gave a whistle, and Liam appeared. He shrank back to see the governess. "What the deuce is *she* here for?" He folded his arms against the package of victuals she had filched from the castle pantry. Mary's fear turned to hurt.

She cleared her throat, explained her mission. "Bridget wants you to give yourself up to Lord Kingsborough. She says he promises to help you."

She saw the doubt in Liam's face. Why was she here? What help did she have to offer the fellow? Why did she want him safe when he might well have killed James?

Nora patted his arm, and grudgingly he retreated to the interior of the cave and accepted the cheese, bread, and ale that Nora had brought. He wolfed it down as though he had not seen food for days. Mary's offering lay unopened on the cave floor.

He waved at a flat rock for the women to sit upon. "'Tisn't the plush drawing room you're used to," he told Mary with a hint of scorn.

"A plush drawing room?" She had come this far and he was ungrateful. "I'm employed in the castle," she reminded him. "I am *not* a family member." Though in truth her buttocks ached for the soft-cushioned chaise longue in her bedchamber.

"Well, you can stop right now," he said. "I'll not give in to any spoilt Lord K, never mind what Bridget says. Faith, and you can't trust the man! Look what his agent did to the Toomeys. And that's not all, no, that's not all." He waved away the thought of the untrustworthy agent and landlord.

"You heard then about the eviction," Nora said.

"Fiona told me. What do the Kings care for but their animal comforts? The man's full of porter at noon, aye, I seen him. If *we* take a drink now, it's the 'drunken peasant, the sod,' is it not? But it's all right for a great lord to swill it down." He laughed bitterly. "When he's out of his senses what does he know about us? Does he care what the English are doing to us? Sure, and we have our parliament now, but will it last? Nay, it's naught but a mouthpiece for the Proddy English. They want our *souls*, that's what they're asking!" He slapped a fist into his palm. "But they won't get mine. I'll die first, I'm telling you. They can draw and quarter me and throw me to the dogs, I'll not give in to any Lord Kingsborough, nay, nay!"

He stamped on an insect that was crawling by his feet. "The very name galls me," he went on, "but Bridget's under their thumb. The Kings bring her bacon and a leftover gown and she's grateful. Grateful for what, I'm asking you? A poor Catholic can't own his own cow!"

He took gulps of the ale after the long harangue. Mary felt the intoxication in her own head. She wanted to go at once to Lord Kingsborough, to shake him till he consented to give a bit of land to the Donovans. A small enough gift with his thousands of acres. She would confront him this minute if she could. Had she not, on the way back from Fanny's grave in Portugal, persuaded an English

captain to take on the passengers of a sinking French ship? "Pull them aboard," she had warned the pompous fellow, "or I'll report you to the powers that be!" And he did pull them aboard.

Though her appeal to the captain on the Dublin packet boat, she had to admit, brought no rescue for the drowning Sean.

"But what can we do for *you* at this moment?" she asked Liam. "How can we be sure you are safe? Do you know who might have killed James?" The questions tumbled out in no reasonable order. But the lad just sat there in silence, shoulders slumped, his candlelit face all blue hollows and creases.

Nora touched his arm and he cried out. Nerves, she thought. "I will be leaving soon," he said, "I don't know for where." He looked cagey, as though once again he didn't trust the women. His eyes were cold, wild and blue. Even so, a part of her wanted to crawl into his arms to comfort him.

Unthinkable. Whatever was the matter with her? The fellow wanted nothing to do with an Englishwoman. She could only ask questions and hope for answers.

Well. She was determined at least to prove him innocent of killing James. Had not Lady K given her the assignment?

"George said he saw someone flee into the woods at Samhain—shortly after they found James's body." She looked hard into Liam's eyes. She could not, would not, believe him guilty. She had to look away. Her body was still speaking a different language; she folded her arms across her breasts to subdue it.

"It was never me," he said, gazing at the stone ceiling. "I took Oona home that night. When I came back—" He was quiet for a long moment.

"When you came back?" Mary said.

"They were shouting that James was dead. But I'm telling you I saw no one that might've done it."

He jumped up; Mary could see the muscles shift through the worn cloth of his breeches. He threw his few belongings into a sack.

"You're not leaving tonight, are you, Liam?" Nora asked.

He nodded; he was a rational fellow. "It were best. Too many folk know where I'm at." He looked at Mary when he said that, then gave a half smile.

There was a certain sensibility in him in spite of his lack of

breeding. She sat absolutely still; she didn't trust herself to move. She didn't know what she might say. She watched him leave. She noticed that he picked up her packet of food and dropped it into his sack and nodded at her. He was very appealing—in a raw sort of way, she allowed.

Moments later he was gone. Sack over his shoulder, the round green cap stuck on the back of his bright head like the mythical Robin Hood, his feet bare—how far was he going to walk in bare feet?

Nora said, "The Defenders will hide him. They'll give him weapons."

"Where would they get the weapons?"

Nora looked at Mary as though she were an ignorant child. "And what do you think Sean Toomey was doing, crossing and recrossing the Irish Sea? He can bring in only a few muskets at a time. But they mount up. The Defenders are getting ready for—" her voice dropped to a whisper "—the revolution. It's the terrible rents and the unfair tithes on tatties, eggs, and chickens they're fighting. It's getting bigger and bigger, just you watch. Like the American Colonies. But it takes time, surely. Generations, I don't know. What do I know, just a woman?" She wrung her hands but her eyes were shrewd in the candlelight.

"You know where they have their headquarters?"

"Oh no, mercy no, 'tis a secret. Everything secret: handshakes, cells, meeting places—they keep moving on, you see. Today it's one place, tomorrow the next."

"And they carry their weapons with them?"

"Well, I can't tell you that, can I? Most likely not. And I don't know where they're stored. I wouldn't want to know where, would I—should the authorities come sniffing about? Why, they've cruel tortures, those Protestant soldiers, for anyone connected with the Defenders."

Mary was eager to hear her speak of the rebels. She considered herself something of a revolutionary. She asked Nora if the Defenders had women with them.

The housekeeper gave a crooked little smile. "Would you want to go, miss? Would you want to hide out in caves and dark woods and be full of fear and always on the run—never knowing if you'd have a meal or no? Would you want to do that?"

Mary thought that she would. She lifted her chin and made a fist. She wanted to run after Liam and cry, "Take me with you. I can learn to shoot a musket!"

Nora laughed and clapped her arm on Mary's shoulder. "Nay, miss. They don't want the likes of you with them. You're too well-bred, you see, and you're English. If they have women, well, they're wives or sweethearts, or ones that happen into their path with food and drink. Like you and me today, is what I'm saying. You've helped, miss, in your own way. Sure, and you done what you can, God bless you."

Mary shrugged off Nora's arm. What had she done? Liam was being hunted and there was seemingly no other suspect for James's murder. And certainly none for Sean Toomey's killing. She blew hard into her cupped hands. She could feel the chill in her bones.

"And now, miss," Nora said, "we'd best be getting you back to the castle. You'll be missed. Even in his drink, milord knows who's in and who's out. Like poor Eva Noonan? She'd take walks at night—och, she was a romantic, that one. And Lady K would send me or one of the maidservants or footmen out of doors to fetch her."

"But why? Why can't a governess take a night walk if she wishes?" Mary felt Eva's resentment at being called into the house, like an errant child.

Nora smiled knowingly and led Mary out of the cave. "Oh!" Mary had stepped into a rivulet and soaked her boots—the leather was already stiffening from the dampness of the area. Such a small thing and she was upset; her eyes filled. And she would have courage enough to follow a band of Irish rebels?

I would, she thought. I would to escape tyranny.

They were walking up the path under a half moon when lights winked through the trees a short distance ahead. She heard the sound of tramping but no voices, as though a body, or bodies, were moving in secret. Was it the Defenders coming to claim Liam? Or was it... She clutched at Nora's arm.

"Shhh." Nora drew her off into the brush.

Four or five men tromped past in stout leather boots. Mary dismissed the thought of the barefoot Defenders: these were militiamen. When they had gone out of hearing, the women hurried on up the path, running at the last, and into the maze of gardens.

Mary's ankle was hurting again; she should stay off her feet but there was no time for that.

"He's safe, God bless him," Nora said. "They won't find him now. But who would have told he was there in that cave? Who would have known besides me, Bridget, and Fiona? And you." Mary flushed under her gaze.

"Margaret, yes," Mary said. "But she wouldn't tell, you know she would not. Unless someone overheard us talking. And the castle has ears, I swear it has! The walls listen and whisper." She groaned to think of the listening ears. "But what of your husband?"

Nora was indignant. "You think I'd tell *him*? Why, John Dillard's an Anglo through and through. He's loyal—not so much to King George as to Lord Robert Kingsborough. He would die, I think, for his lordship."

Mary pictured a drunken Robert staggering up the grand staircase, and lifted an eyebrow.

"You see, he saved his life," Nora said. "Lord K pulled him out of the waters one time when he was near drowning. 'Twas down by the cave at the bottom of the falls; there's a sort of whirlpool there. John was fishing and the waters sucked him down. Milord heard his cry when he and his men were after a rabbit, and he jumped down off his horse—aye, he did!—and pulled John out, at the risk of his own life. Milord has some loyalty in him—and me husband has never forgot it. So you see I cannot confide in him. Not about the Defenders, not about Liam. No, 'twasn't me told John where Liam might be hiding."

Unless, Mary thought, Dillard overheard, or saw something, and felt obliged to report to his lordship. And what of James? Did Dillard kill James, knowing Lord K's antipathy for his kinsman? Even dumb loyalty could kill, she was certain of it.

When she and Nora parted company at the foot of the castle stairs, she thought of all the deaths caused by religion. In Ireland, England, France, Spain, the Colonies: was not freedom of worship a reason for revolution? Greed was at the bottom of it all, yes. If England wanted to stamp out Catholicism in Ireland, she had heard, it was partly for the use of Ireland as a base: to avoid a foreign invasion. Then, when England succeeded, she went on to claim the land for herself.

Mary was not always proud of her mother country. Patriotism

was a double-edged sword. Was it Julius Caesar said that? Mary might go to America herself, to escape the tyranny of class. She imagined herself one day in America with Liam, for he had no sweetheart in Ireland, as far as she could see....

Alone that night in her bedchamber, she gazed into the hearth fire and fancied she saw her blue-eyed rebel rise up in the curl of smoke. She wrote in her journal: *Certainly I must be in love—for I am grown thin and lean, pale and wan.*

Then she smiled at the words. Where had she read them before?

She pulled off her gown and petticoat, the miserable stays; lay back on the bed and imagined herself barefoot and striding along, belly-free, with Liam. He would be her only "stay."

A woman, too, can be a revolutionary, she wrote.

She blew out her candle and crawled beneath the blankets. It was already after midnight. She liked to stay awake with her thoughts— it was the only time, she felt, that she truly *lived*.

The room was partially lit by the dying embers of the fire. Illusion, she thought, it is all illusion. Liam. America.

Love.

A Fatal Leap and a Late Night Visitor

MAJOR CUTTERBY was a fastidious eater. Mary watched him dip into his rabbit stew with the outer edge of his silver tablespoon, lift it delicately to his lips, and with a slight slurp, swallow. In the silences between the clicking of spoons she imagined she could hear the broth trickle down his esophagus and into his stomach. He wiped his lips daintily with a napkin and tucked it back into his ruffled shirt. More than once he glanced down the row of faces to where Mrs Cutterby was seated beside one of the male guests. She was flirting, one might say, the way she tossed her mountain of hair from side to side and giggled at the man's every word.

The governess seized the opportunity to ask questions of her companion: "Do you enjoy your work as land agent, sir?"

Surprised at the question, he lifted a grizzled eyebrow, tore off a hunk of white bread and stuffed it into his mouth. "It's interesting w-work," he said, chewing, "although—"

"Although?" she urged.

"Although I wanted to have a sh-shop," he said with a slight stutter. She nodded, to encourage him. "I make c-candles, you see. I have a small workroom in my house."

"Ah." The Cutterbys, she was aware, lived in a large stone house, built for them by the Kings. "But your wife prefers that you be their land agent."

He frowned; he wanted to appear independent. "It was my desire, madam. Mr Young—the former agent—did not, well, perform as they had h-hoped. There were issues with—that is, well, there were issues. And I accepted the p-post when my wife—that is, when Lord K-Kingsborough invited me, um, to—"

He popped another hunk of bread into his mouth and chewed slowly and laboriously as though the chewing would stimulate the thought process. Mary laid down her spoon; he had quite put off her appetite. Mrs Cutterby let out an explosive giggle at the end of the table and the agent coughed; he sprinkled three spoonfuls of sugar into his dish of tea. The other adults were drinking white wine—Mary had never seen the agent with a glass of wine or spirits. He was perhaps the only man of sobriety on the premises.

"I saw the Toomeys," Mary said, sipping her bitter tea. She could not indulge in wine with afternoon lessons coming up. They were to discuss *A Midsummer Night's Dream*, which the girls had been reading aloud. "It must be hard to have to evict tenants. Where would they go? Have they land of their own elsewhere?"

He coughed again over his tea and biscuit. "Of course they have no land of their own, madam. Peasants don't *own* land, you know. Certainly not C-*Catholic* peasants."

"But I thought under the new parliament they are allowed to own land. I believe I read something about that?"

"Well, in theory perhaps. But where would they get the m-money? Nay, they will move on to another estate. S-Someone will take them in." He shrugged, then lifted his hands as though he would send the Toomeys to the moon.

"Do you believe it was a tenant who killed James? I understand James had a town house in Dublin. Did someone there wish him ill, do you think?"

He twisted his head in her direction. His grey-eyed stare asked what this lowly governess was doing with an opinion about a murder. Governesses, his eyes said, should confine their opinions to their pupils. "I have no idea. It is not for me to c-conjecture."

She watched the colour push slowly up his neck and into his cheeks. She took pleasure in pursuing the subject. The man's friendship meant little to her. In her view the agent should be allowed to sit all day in his workshop and make candles—an infinitely more beneficent occupation than turning innocent folk out of doors.

"I imagine you and Mrs Cutterby were playing cards that evening? You did not attend the Samhain celebration?"

"Nay, madam, we never attend those p-pagan festivals!" He punctuated his statement with a bang of his fist. A crust of bread jumped across the table and landed in Mrs FitzGerald's dish of

chocolate. She looked up in surprise. Mary smiled to reassure her that she and the agent were not arguing.

"You were here then?" Mary asked. "At the card table?"

"I was indeed, madam," he said with great indignation. "And now I must go to visit the new t-tenant family. They will require my assistance." He rubbed his mouth with the back of his hand and rose from the table. His forehead was damp—whether from guilt at evicting the Toomeys or from discomfort at the talk of James, she didn't know.

Mrs Cutterby glanced up as he passed her chair; she had seen the governess and her husband in dialogue, and disapproved. Her husband put a teasing finger on the summit of his wife's headdress. She affected a smile. When he was out of sight she tilted her head closer to her admirer—if such the visitor was—and poured an inaudible confidence into his ear.

Out in the hallway a brash young footboy barreled into Mary's path, giving her elbow a rap; the pain spun through her body and landed in her swollen ankle. The lad raced on towards the drawing room without an apology. He was holding up a sheaf of day-old *Hibernian Chronicles*—perhaps his lordship had sent for them. "Here, boy, give me one," Mary called out, and he tossed a copy back over his shoulder. It flew into her hands with a slap and rustle, and with it the headline: SUSPECT ELUDES THE LAW.

Mary smiled as she read the fine print. Liam had given his pursuers a merry chase indeed; they had followed his trail around and beyond the mountain and then lost it.

At the same time she was downcast. Liam's flight, according to the paper, was "proof of his guilt. When taken into custody, he will be hanged by ye neck until dead."

THE entrance hall erupted in excitement the next afternoon. Dogs and children raced to greet a female newcomer. Dillard and a footman attempted to close the door in the newcomer's face, but the woman hooked a foot in it and pushed herself forward. She was a small young woman with long, unpowdered brown hair set off by a simple white cap. She wore a billowing plain green muslin gown—she was a person after Mary's own mode of dress. But with a difference. The woman was pregnant. One could see life stir in the swollen belly.

"Miss Eva!" Carrie shouted, and ran to embrace the young woman. The latter gave a whoop, and hugged the girl.

"Dillard. Let her pass," Mary cried. She had hoped to seek out the former governess, and now the woman had come to her.

Eva moved slowly, as if she had irons on her ankles. But the green eyes were lit with fire. She pushed through the herd of children and marched into the drawing room where Lord K was sunk in a wing chair, sleeping off his dinner wine. His stomach bulged slightly in its azure waistcoat; his ringleted hair and thin legs in their silver breeches gave him an aura of delicacy.

Eva planted herself before him, arms about her belly, which was breathing heavily. "It is yours, milord." Her eyes were as round as dinner plates, her legs wide apart to make room for the foetus. "I will not raise it a bastard. I want a name for it. I want money for its bringing up. Milord." She might have been inhaling a drug from the bold way she spoke.

Lord K's eyes widened. He leapt up and lost his balance a second; regained it. His face was the colour of mashed turnip; he grabbed her by the elbow. Now it was Eva off-balance; she fell to her knees and butted her head against his calves, the way a dog might cling. Mary thought, Go on, make your demands. And Eva's fingernails raked milord's white stockings. She held out a palm for "fifty pounds for now, and then a yearly annuity for your child—milord."

Milord's eyes were furious; his fingers locked together. "When is it due, Miss Noonan?" he asked in an icy voice. "Tell me that." He sucked in his belly.

"February, milord, in the middle." Now Eva was all sweetness; perhaps she would get her way. She sat back on her heels and gazed up into his eyes. She was very pretty with her shiny hair, the fire in her cheeks.

Lord K was mentally counting back. When he came to the figure he desired, he smiled with satisfaction. The stomach he had sucked in bellied out again. "In June, my dear, when you apparently conceived, I was in London. The entire month. Six weeks in fact. Now, pray tell me, madam, whose child could this be? Eh?" He leaned toward her in a priestly way.

Her face paled; her lips moved as though she would speak but some impediment in her throat was working against the words. She did not move. Milord wanted nothing more, it was clear, than to

get her out of the drawing room. The Cutterby was lurking in a corner with two visiting butterflies.

Lord K pressed his point home. It was as though he had thrown a dart, and scored. He spoke to her as he would to a stubborn parishioner. "Now, Miss Noonan, since you gave us, eh, good service until you, uh, had to leave, we might—*might*—consider, well, twenty pounds. But really, my dear girl, that is as far as one can go. One has expenses, you know, the maintenance of this house—it's more than I can afford without tearing the clothes off my back. Would you want me to do that—would you, my dear? Eh?" He smiled indulgently. The pair of ladies giggled in a far corner of the room. The Cutterby hid her painted face behind her fan.

Tearing the clothes off Eva Noonan's back is what the man would like to do, Mary thought, watching him leer at the girl. Obviously he had already done so. She pictured *The Rape of Proserpine* on the staircase ceiling. Milord was attractive, he was rich; on the death of his father he would be an earl.

Mary would like to know where he really was back in June. For no doubt the poor girl was taken in this castle. She looked now like a girl clinging to a twig on a precipice; at any moment it would give way and she would catapult downward. Her skin had a pallor that was almost ghostlike—except for the spreading flames in the center of each cheek. Mary willed her to get up, but she remained on her knees.

"Where am I to go then, milord? My own mother has turned me out." Now the scene resembled a sentimental romance, the kind Mary scorned. She would like to run in and shake the girl.

Lord K did not know or care. He loosened Eva's fingers; she fell back on the carpet, clutching her belly. He refilled his glass, then stood at the window with his back to her. He was amoral, Mary concluded; there was no sense of guilt. She despised all he stood for—church, king, aristocracy. She inwardly declared herself wholly Irish—not Anglo-Irish, but Celtic Irish. Down with the English. Down!

Eva Noonan pulled herself together and walked slowly out of the room; Mary could hear her laboured breathing. She tapped the young woman's shoulder: she would speak to her, offer encouragement. But the latter broke away, and shouting Lord Robert's name, raced back toward the drawing room.

The Cutterby loomed up in the doorway to block the girl's entrance. "You know perfectly well who it was got you that child," the woman cried—she was, of course, an ally of Lord K. "But you won't get a farthing out of *that* one, will you? Now if you don't want *everyone* to know what *I* know, then leave this house at once. You must *not* plague his lordship—it is not to be borne!" She held up a long embroidery needle. "It is not to be—"

"Miserable woman!" Eva cried. "You were responsible for—for—" She rushed at her adversary.

The needle gleamed like a dagger in the Cutterby's right hand. The woman lunged and the needle pricked Eva's breast. With a grunt, Eva rotated its point back toward the Cutterby's bosom and pushed it slowly into the mountain of pink flesh. The agent's wife howled; she collapsed into the arms of a footman. Half a dozen servants came running with salts.

There was a tangle of bodies as Eva plunged through the maids and up the main staircase—down a long corridor, past Mary's bedchamber and up again into the White Knight's Tower. She caught her skirts on an outcropping of stone; wrenched them away.

"Wait. Stop!" Mary called. Below, the Cutterby was still shrieking; Lord K was shouting for a bottle of porter. Eva Noonan's fate, it would seem, was left to Mary. She was on the young woman's heels as they climbed; Eva was surprisingly quick for the weight in her belly. She veered off into an unfurnished chamber, hesitated there a moment, and just as Mary went to grab her and bring her to reason, she flew out a second door, past the library, and up a narrow stone stairway that spiraled to the castle roof.

The stairwell echoed the quick, sharp intake of breaths as the young woman climbed, her footsteps slowing with each steep step. Mary's steps slowed as well; she'd had too little exercise of late. There were drops of blood on the stone from where the needle had punctured Eva's skin before it sank into the Cutterby.

"Miss Noonan? Eva? I want to help."

But when Mary arrived, panting, at the top, Eva was already at the edge of the parapet. She stood, motionless, as though uttering a last prayer; then shouted back, "My journal!"

She plunged into space, her skirts billowing like seagull wings. For a moment, to Mary, she was the sailor again, flying from the ship's bowsprit. But this time, no water—only the unforgiving

limestone. Her body thudded, spread-eagled, on the pavement below. Shocked, Mary burst into tears.

A group of stable boys looked up from their work, astonished; they scurried over to inspect the body; servants ran out screaming. Nora pressed her ear against the girl's chest—she looked up and shook her head. Carrie fluttered over the inert body. Lord K appeared, summoned from the drawing room; he barked out orders and a pair of footmen swung the limp body between them, back into the scullery.

They will bury her like other suicides, in a pauper's grave, Mary thought as she wound slowly down the spiral stairs; Lord K will spend the few pounds he offered her on horseflesh and drink. At the bottom, she closed her eyes in silent prayer.

And opened them again as Lady K appeared, cross and fiery-cheeked: "What was all that commotion? I was trying to rest. Daisy threw up on the duvet, I was up half the night with her. Where would she pick up worms?" She made a gagging noise.

Mary might have answered that, but they would be metaphorical worms, and milady would not want to hear.

MARY could not get to sleep that night for reliving the day's horrific events. She pointed the paternity finger first at Lord K, then at James. Then at Major Cutterby, though that one seemed unlikely; he was too old for Eva Noonan, too devoted to his wife. She considered young George, for Eva looked scarcely three-and-twenty, and age sixteen, as George was, was a time when young men looked to older women for their first sexual experience.

Or so they said. No sixteen-year-olds had come panting to Mary's door.

Who was to know the truth? Only Eva Noonan could have told. If Mary could have halted that fatal leap! But the young woman was too undone by her pregnancy, her poverty, her reputation—the unspoken things that lay in wait for unwitting girls—for sensible talk. Mary lay there in mourning for a lost girl. It will not happen to me, Mary told herself. Never!

She had no sooner made this resolve when she heard a thumping on the stairs, and then a banging at her door. Nora. With news, perhaps, of Liam? "Pray, enter," she called.

And then gasped. It was Lord K, candlestick in hand, wearing

a shirt and waistcoat stained with ale, his face a waxy yellow in the flickering candlelight. His dark hair hung loose about his face.

"Milord!" Her linen shift scarcely hid her body; with both hands she yanked the blankets up to her chin. But milord kept on coming. He sat himself down on her stool and leered at her. He leaned forward, squinted his eyes, and blinked; he was stone-drunk. She pulled her knees together and locked her arms across her chest. She tightened her muscles and joints—what female animals did, she imagined, when they wanted to be left alone after a day's hunting.

He tried to apologize in his slurred speech. His guilt, it appeared, was the reason for his intrusion. "I wouldn' ha' come but—well, y'see, I felt I had to explain. You bein' the one to see 'er, um, jump. Eva Noonan—I gather you, um, heard her tale. What, that is, she thoughta be her tale. That is—"

He pulled the stool closer to her bed and slapped the candlestick on the floor. It shone upward on the black stubble of his chin, on the blue shadows in the hollows of his cheeks and under his eyes. A servant had taken down the bed curtains for washing; there was no hiding from the man. To get to the door she would have to pass him. He could easily detain her; he was slight of figure but strong withal, with broad hands, long fingers that might play an instrument had he leaned in that direction.

Instead, the fingers were calloused from pulling on the reins of a horse. He was a gentleman, a man of his class, almost a stereotype. He did what gentlemen do best: ride to hounds and seduce the ladies. It seemed inbred in such a man.

The window was out of the question. The ground was two long storeys below and she did not want to join Eva Noonan on that unforgiving stone.

She said nothing. For the moment she lacked the correct words; and in truth, she was unable to summon more than a croak. Nor did she look him in the eye; her mother's words came to her: an unmarried female does not meet a gentleman's gaze. She took several shuddering breaths to compose herself. She was Eva, on the edge of the parapet.

But she had a life to live, books to write.

He planted his hands flat on his knees. There was a tear in the stocking where he might have fallen—that thumping she heard on

the stairs? She felt calmer then. He was decidedly off-balance. She had had experience with inebriates—how many nights she had lain on the threshold of her mother's door to keep her drunken father at bay! If only she were dressed... She realized the absurdity of her position; for a moment she choked back a laugh.

"It wasn' me at fault, I 'sure you," he said, leaning toward her. "Th' girl had a fanciful mind, making up stories y'know, urging th' girls to make up things, scribble 'em down—was why we dismissed her, hired her to teach facts—not scribbling. Next thing y'know they be writing novels—damnably unbecoming for a female. Your-sel', I'm sure..."

"I haven't yet penned a novel," she said, "but I do have one in mind."

And she had, yes. She had begun a novel in her head. One of the characters would be a lady who loved her dogs more than her daughters. A lord who hunted, womanized, pitchcapped unhappy peasants, and drank his way through life. She would begin it on the morrow, if not tonight—when she had this man out of her room.

He was unfazed by her declaration. He gave a crooked smile as though she were flirting with him. "We been quite, eh, pleased with your work," he said with a nod of his hairy chin. "Was telling Caroline jush last eve—th' girls like you. Carrie reciting dates, all the kings of England, begin' wi' Henry the First."

Mary was horrified; she had never assigned such a lesson. Dates without deeds were useless, a bore. And what about the queens? The ladies-in-waiting? The peasant women? Had she been in a less awkward position, and fully dressed, she might enjoy arguing the point with milord. But not now.

"Pray, leave," she said, tightlipped, "I need my rest. The house-hold rises early, I've lessons to prepare." She waved at the papers on the floor beside her bed, the volume of William Shakespeare at her pillow. A novel by the enlightened Madame de Genlis.

Suddenly he rose, like a genie out of a bottle of strong ale. In a step, he was at her bedside. A lurch and he was on it—on *her*, grinning foolishly, giggling, hirsutely, into her face. "Pray, leave," he mimicked, embracing her. His breath reeked of spirits, tobacco, horses. He was struggling to undo his buttons; his stocking gave a final rip at the knee.

"How dare you!" She pushed at him, jabbed her fingers into

his eyes. He grunted and pushed back. "Get out," she cried, "out or I will scream. I'll bring the servants. I'll send for Lady Kingsborough!"

She shoved with all her weight and he went sprawling on his back. He had one leg on the bed, one leg off; she shoved until both legs thudded on the floor. He lay still a moment. Had she rendered him unconscious? She leaned down to look. How ever would she get him out of here? Would she have to roll him to the door?

Now he was making little grunts and squeals that she interpreted as laughter. "You a feisty one. Thought you be pleased. But see I came th' wrong night. Worried you'd end like Eva, 'm I right? Well, she brought it on herself, always teasing." He pulled himself up on his knees. A ludicrous sight. She was tempted to knock him over again on his back. But she was in her shift. She could not get out of bed with impunity.

"A fool, that Eva," he mumbled on, staggering to his feet. "I offer her money, she shoulda taken it. That damned scribbling of hers makes her flighty, all 'motional. I come see her and she—" He paused, even in his stupor he realized he had said too much.

"It *was* you then." Mary sat up; clutched the blankets to her breast. She was not afraid now. She could take care of herself.

"Nay, nay, not me, not in June, I was in London, like I said. Look to James. James always hanging 'round her. Eva took a fancy—I saw 'em together."

"James is dead," Mary said coldly. "He cannot answer for himself. Now will you *go*."

She would ask Nora for a lock for her door. Did Eva have one? Evidently not. Was she hoping that Lord K would acknowledge the child—since they had, one time at least, been lovers? Had he come to her in the night and taken her? Had James got her pregnant and then left her, bitter and alone? Was Eva, in some way, responsible for James's death? Was that why she threw herself off the roof? Questions, questions...

She thought of Eva's last words: something about a journal. But where would she find such a document? And what else, Mary wondered while the man readjusted his clothing, might be in that document? What hints of James's antagonist? Her thoughts ran rampant. Oh dear, she had let the blankets slip; she yanked them back up to her chin.

Lord K was on his feet now, though unsteady; he slapped a hand against the wall. He wanted her to think it was James who got Eva pregnant. And precisely because he wanted her to think so, she disbelieved him. It was not Eva who killed James, was it? Or was it? Dear God. If not, who then? And for what reason? Her mind was teeming with possibilities. She would have to discover more about James's life. His interests, his acquaintances, lovers, relatives—in particular, his cousin (or half-brother if Nora and Cook were right), Lord Robert Kingsborough, future Earl of Kingston.

She sighed. But she would do it to save Liam.

"Leave at once, sir," she shouted. She bared her teeth and frowned her most awful frown. It had worked once on the father of a girl in her school; the man had caught her in front of her desk. It appeared to be working again. With a crooked bow, he picked up his candle and backed out the door.

His breeches were still half-unbuttoned. She prayed the servants were all in bed; she wanted no witness to this disarranged departure from her bedchamber.

He was gone. She shoved her writing table against the door. She was wide, wide awake. Her body was a harp; her nerves plucked like harp strings. She took up her pen and she wrote. She wrote until her wrist ached, and then she reread what she had written. She found it promising. She imagined the faces of her dumbfounded employers as they read her first novel. *Mary, a Fiction*, she would call it:

> *...the master, with brute, unconscious gaze sought amusement in country sports. He hunted in the morning, and after eating an immoderate dinner, generally fell asleep: this seasonable rest enabled him to digest the cumbrous load; he would then visit some of his pretty tenants; and when he compared their ruddy glow of health with his wife's countenance, which even rouge could not enliven, it is not necessary to say which a gourmand would give the preference to....*

She could not wait to see the manuscript in print. For the first time this entire grievous day, she laughed out loud.

Surprise Encounter at the Scene of the Crime

MARY SET a foot out of bed the next morning; then realized it was Sunday and there were no lessons. Ahh. She tucked the foot back into the warm hollow of her mattress. She would forgo the Anglican service the others attended—after all, her mentors back in England were the Dissenters Richard Price and Joseph Priestley. And though Milady might lift a sanctimonious eyebrow to find her absent, Mary wanted to avoid Lord K. She had survived a nightmare; she wanted to suppress it. She would insist on a door lock. For one thing, she did not want anyone coming into her bedchamber, reading her journal.

Eva's journal, though. Where would it be? Indeed, she had heard Eva Noonan tell Lord K that her mother had turned her out. If that were true, Mary could only conclude that the journal must be in this castle. But how was she to inspect every nook and cranny in this enormous place without some curious bystander seeing what she was up to?

Someone knocked and she clutched at her coverlet—then quieted. It was Annie, bearing a tray of fruit and bread in her freckled hands, a dish of tea. Breakfast in bed: the governess received it graciously, as though accustomed to it.

"Mrs Dillard sent it up, miss. She said she knew as how you'd be in shock still from yesterday's events." Annie crossed herself, as if Mary had some part in Eva's death and might pass a bad-luck omen on to her.

Mary sat up against the pillow. "It was a shock, yes. To you as well?"

"Ooh aye, miss, I couldna believe it. So full of life, Miss Noonan was, God rest her soul, always romping with the little ones, joking

with us maidservants. I could never imagine her jumping like that to her death." The horror of it replayed on the round face and Annie crossed herself again.

"You were here then, when she was governess?"

"Yes, miss. It were only three or four months ago now. I'd just started work here, miss. They don't stay long, them governesses. Pardon me, miss." She reddened: "I was referring to the past ones. You, miss, would be different surely."

Mary was certain she would *not* be an exception. But she said only, "Where did Miss Noonan sleep when she was here? Was it in this chamber?"

"Oh no, miss, she were above here in the tower, just above the library. Nearer the roof where she—" The girl clapped a hand to her mouth, unable to say the words. She crossed herself twice more. Mary rather envied her that gesture. A Protestant, she had no such sign to ward off the demons that daily plagued her mind.

"She give me half a crown once," Annie confided, "'twas when I brought *her* breakfast in bed. (*Should Mary offer a half crown? Did she have one?*) She told me to sit down and rest, for I'm looking tired, says she, and I were, miss. I been run off my feet by milady. She'd guests coming for tea, important ones says she, and I've ten orders at once! I were like a squirrel, miss, I'm after running this way and that, and never doing the right thing, you know, not once. So didn't I sit down with Miss Noonan then? And we talk a bit about milady and I tell her the only reason she took a gentleman into her bed now and then was to get back at his lordship, and Miss Noonan claps her hands and says good for her, and we get to giggling. It's like Miss Noonan was me very own friend, God bless her."

"Did you notice if she kept a journal?"

"A journal, miss? Well now, I couldn't say to that, no. I don't read myself, you see. I can write my name, though. I can! Me mother made sure I learned how, just as she did."

"Would you like to learn to write words, more than just your name?" Mary asked. "Read a little, too?"

The girl looked dubious. Her ruddy face went blank. "I don't know what I'd do with it if I learned, miss. You don't have to read to do a maid's work. And that's what I know to do, you see, don't I know that well enough. No, I think not, but thank you, miss, for saying you would teach me."

"If you change your mind, just ask," Mary said. Annie curtsied, and with one last sign of the cross that took her rough hand from her forehead to her navel, she left the governess to her breakfast.

Mary almost envied the simplicity of the maid's life. But she could not give up reading for the world. This morning she would take up her Shakespeare and slowly sip her tea. Then she would climb the stairs where only yesterday she had raced after Eva, and see what she could find, perhaps in a crevice of a wall or floor. Two hours of doing what she pleased lay deliciously before her. Precious liberty.

When a parlourmaid knocked with a summons from Lady K to come down and speak French with her, for a Parisian gentleman was coming for tea that afternoon and milady wanted to be prepared, Mary could not bear the thought.

"Pray tell her," she said as she chewed on a chocolate biscuit, "that I'm sorry, but my French sticks in my throat."

SHORTLY before noon Mary climbed the winding steps of the White Knight's Tower and entered the small room above the library. She could see that it had not been inhabited or cleaned in the several months since Eva Noonan left. The furniture was thick with dust, and spiders had hung their webs from ceiling to floor. It struck her as amazing how quickly things deteriorated: not only the human body, which had to be hastily dug into the ground, but buildings as well. The fire had long been extinguished in the grate; only a few drab ashes dotted the stone. One ancient wall had a long cracked seam from the weight of centuries. Something skittered under her feet and she cried out.

She pulled herself erect and took five deep breaths. "I think, therefore I am," she quoted from the philosopher Descartes. "No," she said, "I am, therefore I think. There are no ghosts, there are only mice." There was no reply but the sound of scrabbling in the thick walls.

Where, then, might a young woman hide her journal? She moved methodically about the narrow room, fingering the walls. There were many cracks, but none deep enough to hide a journal that would be pages thick at the least. Who could a lowly governess talk to in honesty, but to herself, her journal? Mary was on

hands and knees, rolling up the worn Turkish rug, probing the floor beneath for fissures when she heard footsteps in the hallway. She looked up to see a pair of knobby legs in white stockings and black buckled shoes. It was the butler, Dillard. He looked down on her, astonished, his whole face a frown. When he opened his mouth to speak, she spoke instead:

"What are *you* doing here, Dillard?" After all, the room was un-inhabited. She had as much right as he to be in this place. Though her posture, on hands and knees, might be conceived as decidedly odd. She stumbled to her feet to face him, her cheeks hot. But she would not dignify his curiosity with an excuse.

He was sufficiently taken aback by her question to respond at once. After several false starts he said, "Lord Kingsborough has asked that I examine the place where the young lady fell (*"fell," not "jumped," he said*). It might need repairs. I was on my way up."

It was perfectly natural, his jutting chin said, that he would have a look in this chamber, to see where the scrabbling noises were coming from. He waited for the governess to explain herself.

She was summoning up words when more footsteps resounded from the stairwell, and who should appear in the doorway but the poet, Mr Ogle. Here again as a guest? But why *here*? Blood flooded her face. She hung on to the bedpost. They were indeed an odd threesome.

"Why, dear madam, I did not expect to see you here." He bowed, as if they were in the drawing room, about to take tea. She tried unsuccessfully to quell a twitch in her cheek. He looked quite poetical in his black coat, gold waistcoat, and ecru-coloured, lace-edged sleeves. A slim red leather volume poked out of a pocket as though he intended to read a poem to the tower ghosts.

"Nor I you," she said, hearing her voice falter at the end. She pulled the bed curtain toward her, for she wore only a simple morning gown, and no cap. Her hair needed washing; she was not at all prepared for this encounter. The men seemed to await an explanation of her presence in this unoccupied chamber when she should be at church, but she could only stammer: "I, too, was on my way to the roof. I was upset by Miss Noonan's death. I wanted to relive the moment, to understand why...."

It was Mr Ogle's turn to flush a deep rose, but he said nothing.

Dillard jumped in, in a bass voice that reverberated in the empty

chamber: "I should think it quite obvious, madam. A young lady in a—" he cleared his throat "—delicate way and without husband." He wore that smug grimace she had often seen on self-righteous men. She had an urge to kick him—there was a vulnerable spot just above the buckle of his shoe that would do nicely.

But he was Nora's husband. Nora was her friend, one of the few here; she could not antagonize the husband—though she suspected that Nora, too, had occasion to want to kick the fellow.

"Well, then," said the poet, sounding quite jovial, "we will all go up together, shall we? And revisit the scene of the crime?" (*Crime?* she thought.) He thrust out an elbow and she took it, although the stair allowed foot room for only one abreast. She dropped back to follow him. Dillard made a distant third; she could hear his harsh breath from the steep climb.

She, too, was out of breath as they stumbled out on the roof; she could only stand a distance from the edge, chest heaving, before she could take in the landscape. But there was nothing special to see from this height except the River Funcheon, snaking its way through the grounds from the Galtees Mountains.

Below, although it quickened her heart to look, was the labyrinth of gardens, where a figure that resembled young George was scurrying through, en route, perhaps, to see his peasant sweetheart. Immediately below were the stables, where the grooms were readying a horse for Lord K. His lordship was standing by, looking smart in his leather riding breeches and buckskin boots, whip in hand. Finally she looked down again on the spot where Eva had landed. Not a drop of blood to be seen on the stone, nor in the grassy crevices. Grass, like water, quickly blotted out the dead.

"Oh!" She could see a shadow approaching hers. She turned; the poet was behind her. He took her elbow; his nails pinched her skin. "The height bothers you, sir?" She laughed to calm the tremor in her voice.

He didn't answer for a moment. Finally, as though he had caught an echo of her question, he nodded. The blood flowed back into his cheeks and he, too, tried to laugh. But it came out a cough.

"We could put a railing here, madam," practical Dillard said in his cavernous voice. "I will recommend it to the master."

"Excellent," she said, grateful now for the butler's presence. "In case *I* should be inclined to take the leap."

Mr Ogle stared at her as though she knew something he did not know, and she laughed again.

"But not today or tomorrow." Slipping out of his hold, she went back to the stairs. Holding up her skirts with one hand, the railing with the other, she spiralled, crazily, down and down until she reached her own floor. She ran to her bedchamber, shut the door, and shoved the writing table against it.

What had she learned from this expedition? She had not found a journal. But she had watched a poet turn ashen. Was it really the height that bothered him? Or had it to do with Miss Eva? Did he return, in a sense, to the scene of a *crime*?

Or was Mary Wollstonecraft too much the romancer, spinning facts out of flax?

AT tea, Mr Ogle made a point of seating himself beside Mary. She held herself distant at first. She sipped her tea until there was nothing left to sip; answered his questions in monosyllables. But he did look exceptionally well this afternoon: a crimson jabot added roses to his cheeks, and she soon found herself wanting to narrow the distance. When he handed her a copy of his latest poem, written in a flowing black script, she gave over wholly. She read aloud the opening lines: *Genius, 'tis th'ethereal Beam— / 'Tis sweet Willy Shakespeare's exotic dream*—and continued on in silence. She felt his breath on her cheek as he waited for her to finish.

He asked for her opinion. Oh! Well. She said, "I do not care for the word 'exotic.' I feel it is too 'exotic' a word to apply to Shakespeare, who speaks so eloquently yet plainly." When he nodded thoughtfully, she said, "Why not, sir, omit the word altogether so that the mind concentrates on that fanciful word, 'dream'?"

"Excellent!" he cried, clapping his hands. "You do have an eye—and ear, Miss Wollstonecraft. From now on I shall bring each new poem for you to consider."

Naturally, she was pleased. She quite liked the thought of being a poet's critic—or better, perhaps, his muse. Looking up, she saw Lady K tilt her head toward the doorway. Though if milady could see how the gesture aged her, wrinkling her neck, she would not make it. Mary remained another quarter of an hour past her signal. Only as she was about to leave, did she bring up the name of Eva Noonan:

"Pray, sir, do you happen to know where Miss Noonan's mother lives? I should like to pay her a short visit—that is, as one governess to the mother of another. You see, I did have a few moments to make the former governess's acquaintance. Mothers grasp at straws like that—they savour one's last words."

The poet blanched, oh just momentarily, but obviously. And what did this signify? Did Eva, too, critique his poems? Did she push first her opinions and then her self upon him? Mary wished to find out.

After a moment he "recalled" hearing Eva mention Fermoy, a town not far to the south of Mitchelstown. Ah, then. Mary would hire a hackney coach with the few coins she had saved: she would visit the mother. Someone had to tell the woman about her daughter's last moments. And she would enquire about the journal—it might be at the Noonan home, after all; she felt compelled to read it. Why else had Eva called out to her?

Was there a mention of Mr Ogle in it, Mary wondered. Or Lord K, or James King?

She rose, curtsied to the poet, and without looking at Lady K, picked up the skirts of her plain blue poplin and swept out of the room. Quite like a lady.

Not a lady for long though, for as she moved toward the main staircase, a pack of dogs dressed in caps, stockings, and on one, a lady's stays, hurtled through the outward room. Mary leapt aside just in time. Screams issued from the drawing room, then a series of crashes like overturned crockery, and shrills of childish laughter. The pack rushed out again, followed by three maids, two footmen, and an irate Lady K, along with Mrs Cutterby, her face a long turnip.

"Get out. Stay out. Every one of you!" Milady was enraged. "Out of this house at once. No, go to your rooms. Up, I said! Up to your rooms. And do not let me see you till morning, you young ruffians!"

The confused orders only created more pandemonium as dogs and children were swept out of doors and then herded back in again, heading for the staircase and the nursery. In self-defense Mary ran towards a rear hallway where she had seen staff enter. That part of the castle was foreign to her; she knocked on a door to ask directions.

A voice answered. She entered, and to her surprise, there was Major Cutterby. He was not making candles. He was bent over what appeared to be a map; he was making small, careful notations on it. Mary was about to enquire about the town of Fermoy when he sprang up, blocking her view. He told her that she was lost, which she already knew, and directed her to a back staircase that led to her wing. She had her own map of Ireland but was curious to see what he was doing with this one, and so she hesitated a moment in the doorway.

"I see you have a map, sir. I have relations in Dunmanway in Cork. I hope one day to visit them. How far would that be from here?"

Actually, her mother's relations were from Ballyshannon in the west of Ireland, but her friend Fanny Blood had family in Dunmanway, and the name had come to mind. She did not want to mention Fermoy; she did not want him to think she planned to enquire into Eva's life—or death.

"It—it just has to do with h-hunting," he stammered. "There is no Dunmanway here on this m-map. I have just marked off the p-places where the p-poachers hide out." His stuttering was worse than she had ever heard it. Nerves, she thought, and indeed, there was a moustache of perspiration under the man's nose. He did not wish her to see his map.

She admired a display of red-and-white candles, and he said he would give her a demonstration if she would visit his workshop at home. But for now he was occupied. As she turned to go her arm knocked a pot of ink, and while he rushed to save it from tipping, she was able to squint closely at his work. It appeared to be a map of caves, huts, and copses, each landmark underscored with a *D.* He had illustrated it with tiny trees and footpaths; he was a fine artist. But the sketch was not, she felt, for pleasure; he was drawing a chart, no doubt, of places where the Defenders might hide.

Where Liam himself might hide, she thought, and drew in a breath.

A Found Journal and a Failed Escape

MARY MADE two wrong turns on her way back to the south wing, and passed through a picture gallery she had not yet seen. It was damp and smelled of mould. Hearing footsteps behind, she moved quickly forward, then paused. Should she go left or right? The footsteps drew closer and she plunged blindly left— and banged into a locked door.

Someone laughed, and she cried out, although she knew now who it was. "You should not frighten me like that," she snapped, but Margaret only giggled.

"I've been behind you since you left Cutterby," the girl said. "I loved watching you make mistakes."

"Sly girl," Mary said, but had to smile—the girl looked so child-like and foolish standing there with a freshly killed chicken dangling by its scrawny leg in her left hand.

"It's for Liam," she explained. "I stole one from the kitchen when Cook turned her back. I was looking for you anyway, Miss Mary, to accompany me to the Donovans. I haven't been out of doors for ages and I need the air."

"But we don't know where Liam is. How would we get a chicken to him? Or do you—" This cunning girl was more sleuth than her teacher; Mary must not underestimate her.

"I don't," Margaret said, "but Fiona knows. She told Oona and Oona told George and he told me where. So come."

"Ah." Mary's heart leapt in her chest. She put aside the mystery of Eva and her journal and followed Margaret down the back stairs and out through the gardens. The girl was still coughing and Mary worried; the sky was overcast, the air chilly. "Go fetch a cloak then," the governess ordered. "Or you'll be back in bed with a fever and that fool physician will try to put leeches on your skin."

"Never," Margaret cried. "He shan't touch me!" She ran on ahead as a way of keeping warm, spinning about as she went. Mary sighed, and followed at a trot.

They found Fiona in the potato patch; she was bent over like a wilted weed in her black mourning shawl, her big belly sunk almost to the earth. Some of the potatoes had rotted and she flung them aside, keeping only a sackful that she slung over one shoulder.

"Fiona," Margaret called out, and the girl gave a shriek. "It's all right, it's only me with my governess. We've brought a chicken you can cook up for your uncle."

"Oh, it's you. I didn't know who, did I?" the girl said, for she was still a girl, sixteen years at most. At her age Mary's whole world had been made up of females; she hardly knew how babies were made. Nights, she would hear the grunts and groans her drunken father made in their bedchamber, but only a stoic silence from Mother.

"You're looking well," Mary lied. But Fiona nodded stiffly and peered at the dead chicken in Margaret's hand as if it were an object wholly foreign to her. How the Irish poor subsisted on a diet of little more than potatoes and milk, Mary could not fathom, for much of the harvest was traded in the town marketplace for rent to the castle. She glanced about for Liam, but there was no sign of him.

Fiona reached out for the chicken and carried it into the cottage in her free hand. She thanked Margaret, but seemed suspicious of Mary. When Margaret, in her impulsive way, questioned her about Liam, the girl was reluctant to answer. Her mother, on the other hand, ran at Mary to enquire about Lord K. Had he relented about Liam? Had he put in a word to the constable? Would he halt the search for Liam? Bridget's faded red hair hung wild and loose to her shoulders; she resembled a madwoman in a gothic romance— Mary might write her into one.

"Liam had naught to do with any murder," Bridget said, although no one present had accused him. "He loves his niece, he loves Fiona. He'd never have killed James, would he now, Fiona?" Her eyes bored into her daughter's face.

Fiona broke down at the mention of James; she howled in the Irish way of grief, tattie sack and chicken dropping out of her hands—Margaret caught them. Her mother grabbed the girl in a firm embrace whilst Mary and her charge stood awkwardly by.

Mary was sorry she had come along. She never knew what to do or say in the presence of tears. Now Fiona's words came in a torrent:

"Liam did not like James—you know that, Mam. He didn't trust him. He didn't understand, that was all. He was friends with Sean, who I never really loved—and he thought because James was gentry he'd hurt me. But James would not, no! James was all kindness. Why he never once came without bacon for you. He brought you daffodils on your birthday—once an armful of rare ferns. You remember that, do you? Do you, Mam? James loved me. He loved me!"

The girl reached out for her mother, but Bridget gave her a withering look, like a stroked cat that scratches you. "Och, and she won't hear a word against him." Bridget appealed to Mary. "The fellow was *everything* in her eyes when it should've been Sean Toomey she was waiting for."

Bridget glared back at Fiona as though the girl had betrayed Sean, and perhaps she had—Mary must not be quick to judge. "All the same," Bridget went on, "'twasn't Liam killed him. You know that, Fiona. Say it, say it now! 'Twas not Liam killed him."

"No, Mam, 'twas not Uncle Liam killed him," the girl repeated mechanically, though Mary could see the doubt in her eyes.

Oona came into the cottage and laid down a chunk of peat turf. She was a slender girl, a good four inches shorter than Mary, although Mary *was* tall for a female. She had enormous lake-blue eyes like her sister and Liam, and shiny hair, hanging to her waist; it was almost a bluish-black, like crow feathers. Her skin was pale white with a sprinkling of freckles about the nose and on the hands. Even though Oona wore the simplest of yellow flannel gowns, Mary felt an old maid beside her.

With the barest curtsy toward Mary that made the governess feel older still, Oona drew Margaret off into a corner, and the pair whispered. Mary heard the name George. She did not like the conspiratorial sound of it; she had already told George he must not consider a foolhardy elopement. She might speak to Oona herself when Margaret was absent. For the moment, though, she addressed Fiona:

"I want to help Liam. I hope, well—to find the murderer." Even as she spoke, she realized how unequal she was to the task. So, too, did the Donovans. Mother and daughter lifted sceptical eyebrows.

"What have you found then?" Fiona said, sticking her hands on her hips. "Who?"

"Very little," Mary admitted. She didn't know what else to say except that she was going to Fermoy the next afternoon to meet the mother of the suicidal governess. When Fiona's face took fire at the thought of a connection between James and Eva, Mary flushed, but it was too late. She blundered on. "Eva would have known James—that is, he was acquainted with her—well, only through the castle, you know. Oh, I know nothing—nothing at all! I'm just pulling at threads. Did you know her perhaps—that governess, Miss Noonan?"

There was a moment's silence. Fiona's eyes were fastened on Mary as though she would keep the governess stationary until she told everything she knew. Then Bridget spoke up. Eva Noonan's fatal leap was all the gossip. There was not a soul, she said, in the whole county who had not heard. "Didn't I know the girl well then; wasn't her mother second cousin to me? From Fermoy, aye. I was with Kathleen Noonan no more'n a fortnight ago. You 'member I walked there, Fiona? How upset she was with Eva, oh, in a fury, she was! You met Eva, did you, miss?"

Mary admitted she had, though briefly—but was again interrupted by Bridget:

"Kathleen wouldn't let Eva speak out. Didn't I tell her to have pity on the poor girl? A grand lord, I'm after telling her, is not to be countered. He'll take advantage; he thinks he owns us—body, soul, and tattie patch, aye. 'Twas not her fault, surely she fought back."

Fiona cried out and lifted a hand to her mother, then lowered it. "Not James, you mustn't think that James—"

"No, no, child, it's Lord Kingsborough I'm speaking of. He got to Eva early on, Nora told me that. She got Dillard to put a latch on the door but too late then, God rest her soul." She looked over at the cottage door and her face hardened as though someone she did not want to see was forcing an entrance. She began to call out orders: "Oona. Fiona. Fetch Pegeen. Go strip that chicken. Don't just stand about doing nothing. We don't have fifty servants here to do for us. Get to work now."

When Fiona started to pluck the chicken, Bridget took Mary aside to whisper, "And was it really milord who got her? Nora wasn't certain this time."

"He claimed to be away when she conceived," Mary said. "But we can't discount James. It's possible—"

"I heard that!" Fiona screeched. She had ears like a rabbit in the woods. "'Twas not James. James was true to me. He was going to marry me—he would've if he hadn't—" She sank, wailing, onto a stool, her hands full of chicken feathers. Oona knelt beside her, murmuring, stroking her hair.

Mary apologized. She had too loud a voice: it was always getting her in trouble. Fiona waved her off and Mary left her to Oona. Margaret was helping to pluck the chicken; she was clumsy at it, unused to such work—Mary could see the frustration in her face.

"James could do no wrong, miss," Bridget went on, drawing Mary out into the yard. "We're not to mention his name except in praise. And I cannot do that, I'm telling you. James was one of *them*—" She pointed toward the castle, her face twisted with anger. "There's a fortune there somewhere, don't you misdoubt it." She squeezed Mary's arm as if to drive home the idea of a fortune. "And none of it will go to Fiona and the child, no. They fling a few guineas at you, then leave you to the midwives. Would they send one of their doctors? No. He'll be tending to milady's cough." She had Mary's arms in her grip; her eyes were scorched with bitterness.

Mary was relieved to see Margaret on the threshold, feathers in her hair. She extracted Bridget Donovan's hands from her arms. They were hard hands, knotted and veined from picking rock and digging potatoes. Bridget offered to accompany the governess to Fermoy the next day: "You might want me along. She's a good woman but suspicious of foreigners—the English, that is. And since Eva's death—" She sighed.

When Mary looked back once more from the bend in the path, the woman had sunk onto a flat stone in the yard; her chin was in her hands. She had a brother-in-law sought for murder, a daughter about to give birth to a natural child, and no man to help with the outdoor work. Mary would not be in her shoes for all the world.

It was all she could do to stand up straight in her own.

MARY smelled the Fermoy house before she saw it. It was made of "earth mixed with bullock's blood," Bridget Donovan explained, seeing Mary's nose wrinkle. The Irishwoman's face was flushed from her first, ever, ride in a hackney coach.

Other than the somewhat disagreeable odour, the place was not unlike the Donovans', only a bit more commodious: the spinning wheel, threaded with green and black yarn, a flax comb, a smoky hearth, a table and two chairs, on which they were invited to sit after Mrs Noonan came hurrying into the room with a stool for herself. She seemed surprised, but pleased to receive company. "Don't I need it now, with my Eva gone."

Mary drew in a breath, for the mother was so like her daughter: the same marble-green eyes, the quivering mouth with its full, fleshy lips. But the brown hair was streaked with grey; it hung lankly beneath the white cap that sat squarely on top of her head, innocent of ribbons or lace. She turned her back to make tea and Mary noticed a small table, strewn with books—her daughter's legacy no doubt. Poor Eva, struggling to better herself. Mary felt an affinity with the dead young woman. She, too, constantly sought improvement.

Their hostess unlocked the tin tea caddy that was half-full of precious tea and sugar, then proceeded to fill their mugs. Mary's tea was hardly potable—it was full of dried leaves and tasted of dust. The milk was watered down, the hunk of bread she was offered tasted of bone ash and chalk. She choked it down to please her hostess.

But Mrs Noonan had come down from what she was born to. Mary saw this from the way she was stroking the flowered tin, like an artifact from an era of semi-affluence. She and Bridget spoke of the weather: too chilly, too windy, too wet for growing things; the worst harvest ever. The growing scarcity of potatoes, the rash of evictions; the problems of getting to places: "A coach? Such extravagance, Bridget, and uncomfortable I'd wager, bounces all about, eh? Though I rode to Dublin once, I did, too, in a coach-and-four. I told you of that excursion, Bridget, remember?"

"How can I not remember when you told me sixty-five times?" Bridget said.

"Not quite," said Mrs Noonan, unnettled.

Mary asked how Eva had come to acquire so many books, and Mrs Noonan pulled herself up. "Didn't I send her now to Mrs Keefe's school up the street, though it took everything I had in the world to do it?" Her face was grim, as though the books had brought on the pregnancy—the mother's reason to repudiate the

girl, Mary supposed, although the eviction was probably in a moment of anger. She seemed sorry enough for it now. "And then a fine lady in town took her on as governess; she were but eighteen years of age. Aye, she'd of stayed on more than the three years, too, but the pupils moved away and then Eva went to the Kingsboroughs and that was her undoing, God help us."

She made the sign of the cross, then shrank back into her stool and commenced to lightly beat her breast; she made a soft, grating noise in her throat. Bridget rose to comfort her; the pair spoke rapidly together in Irish. Mary sat rigidly on her hard wooden chair until Mrs Noonan turned to look full at her, as if for the first time. She ran a tongue around her dry lips. She waited for Mary to speak.

Mary murmured something about Eva's rise to scholarship, about how good her mother was to help her along the way. Though she saw the irony of it as she spoke. What rises must fall, she thought. Would something of the sort happen to her?

"Why have you come here, miss?" Kathleen Noonan's voice was flat, her eyes full of veiled tears; a vein swelled up in her forehead.

Mary stammered out an explanation about Eva's last words—the journal. "I thought you might want to hear. I felt there was some reason for her mentioning it. There might be something important inside that journal, something she wants people to know. I thought, perhaps—it might be here in this house."

There now, it was all out on the table. Still, there was a tightness in Mary's chest, a fist of heartburn. She would rather be back in the schoolroom, reading Shakespeare or singing with the girls—Margaret had a sweet, clear voice. She wondered how the three were managing without her.

But Mrs Noonan was on her feet; she crooked a finger and Mary followed her through a low door into a second room that was apparently her daughter's. An unpainted shelf had been nailed to the wall; it was crammed with books: Aristotle, Plato, Euripides. There were books in Italian—Mary didn't recognize the names except for Dante's *Inferno*, and a thin tome by the scientist Galileo. No wonder the King girls spoke such excellent Italian.

Mary was beginning to feel inferior now to this dead governess. She would have liked her for a friend, would have learned from her—and Eva from Mary, of course, for there was little English literature among the books. Not a single volume of Shakespeare.

Mrs Noonan lifted up a featherbed and there it was: EVA NOONAN, HER JOURNAL. It was filled with tiny, sprawling script, Mary saw when the mother opened it; she hoped it was not in Gaelic. Eva would have paid dearly for the quality paper in it—or did she take the book from a castle drawer?

"May I borrow it to read?" Mary asked, feeling her cheeks hot—after all, it was a daughter's life written inside, or part of it.

"I don't read," Mrs Noonan said, looking ashamed. "Eva wanted to teach me, but I said, what would I do now with learning at my age?" She took back the journal and shut her eyes a moment as though she would bless it; then she shoved it hard at Mary with both hands.

Mary carried it, like a glass ornament, back into the room where Bridget was already standing up, looking anxious, ready to depart. Liam might have come home; she would not want to miss him.

"But I'll want it back when you've done with it," said Mrs Noonan, sounding shrill. "And you can read to me—what you think Eva would want me to hear. I wouldn't care for—" Her voice faded out.

"Such an extravagance!" Bridget cried again as she and Mary made their farewells and walked to the village center to pick up the hackney coach—the tenant woman would not enjoy the ride for thinking of the expense. "'Twould keep us in tatties for five years!"

MARY ran directly up the castle stairs, clutching the journal under her shawl, wanting to read it at once. But as she made the turn before the gallery that led to the Kings' apartments, a hand on her shoulder spun her about. It was Lady K, with a pet bulldog in her arms, a nasty little creature that dared to growl at the governess.

"You are to pack," the mistress said. "We leave tomorrow for Dublin. The girls will want to keep up with their lessons." Seeing Mary's dismay, although she could not guess the reasons: "It will be for nine or ten days. We'll come back before the Christmas holidays and then return to Dublin, as usual, for the winter."

"Oh," Mary said, "but I do have other plans."

Milady pursed her lips to indicate that governesses do not *have* other plans. "We'll hear the Handel concert," she said, trying to

placate the governess, "and attend a theatrical performance—with professionals," she added, remembering, no doubt, the amateur *Macbeth.*

"Do the girls know about this?" Mary asked. Margaret had not mentioned Dublin to her.

"The girls are already packed. Carrie has been looking for you all afternoon and you were not here. I will not ask where you were. You can explain. Later."

Mary heard the exasperation in the way milady breathed: quick, shallow breaths in and out of her chest where she harboured her angers, her resentments at her lot in life, past and present. The toy bulldog wriggled out of her grasp; milady scooped it back into her arms, lisped an endearment in French, and scurried down the gallery toward her room. She paused a moment in front of a King ancestor, then held up a fist as though she would strike it.

Perhaps, Mary thought magnanimously, it is not Lady K's idea to go to Dublin at all. Perhaps she is as unhappy about leaving as I am. Perhaps she would like her husband to go and leave her here alone—nine or ten days of freedom from child-getting.

For a mad moment Mary wanted to call her back and tell her it was all right, she would be here to support her.

But when milady moved on down the gallery, unfurling a flowered fan over her shoulder in a dismissive gesture, Mary wanted nothing more than to be far away from all the arrogance that held her here in her *place.* She would not be closed up in a box. She would not.

She wished only to write away her frustrations, not to read. Back in her chamber with Eva Noonan's journal—she would save it like a reward of sweet chocolate—she settled into her chair, dipped her pen into the black ink, and wrote in her manuscript:

She had two most beautiful dogs, who shared her bed and reclined on cushions near her all the day. This fondness for animals was not that kind of attendrissement *which makes a person take pleasure in providing for the subsistence and comfort of a living creature; but it proceeded from vanity, it gave her an opportunity of lisping out the prettiest French expressions of ecstatic fondness, in accents that had never been attuned by tenderness.*

She wrote a few moments longer, meditated for a short time, then took up her pen once more:

> *She wondered why her husband did not stay at home. She was jealous—why did he not love her, sit by her side, squeeze her hand, and look unutterable things? Gentle reader, I will tell thee; they neither of them felt what they could not utter. I will not pretend to say that they always annexed an idea to a word; but they had none of those feelings which are not easily analyzed.*

When she had completed the paragraph, she was overcome with weariness. Her hand was too shaky to exercise it further. She lay back on the bed with Eva's journal, but discovered upon opening that it was written in *Italian*. Which meant that she would have to take an Italian grammar to Dublin with her. Oh! It was all too much to bear. Besides, the journal was too heavy to hold in bed, and already she felt overcome with sleep.

On the other hand, she thought as she closed her eyes, James King's estate was in Dublin. She might have an opportunity to visit his town house. Who knew what she might discover there?

MARY didn't know how long she had slept before she was woken by a loud knock at the door. Her first fear was that it was Lord K, and she held her tongue. Then the door banged open and Margaret barged in, her whole presence, it seemed, on fire.

"They have taken Liam!" she cried. "He's in the gaol now, right here in Mitchelstown. And Papa says we're to leave at high noon for Dublin and there is no getting out of it. I hate Papa! I hate the law! They'll hang Liam, that's what they're saying. And in three weeks' time. What are we to do then?"

She did not wait for a reply, but gushed on in that hoarse, passionate voice of hers, her broad face a hot pink with the thrill of her words: "We must go to see him, bring him cheese, Miss Mary—with a hidden knife to help him escape. You and I together. We must go soon—at dawn—tomorrow."

She flung herself onto the bed beside her governess; the large, hungry eyes implored. But what could Mary do to help Liam? She was on a frail vessel, headed out to sea, and with the lad in captivity, no one to carry her back to shore.

"Please, Miss Mary, we must help him. Say you will. Say it!"

Mary reached out a hot hand and the girl took it for an assent. "At daybreak," she cried, jumping up. "I'll see you out by the stables. I'll have horses." And she raced out into the hall before Mary could resist.

THEY tiptoed out a rear door at dawn and borrowed two bay mares with the assistance of a stable boy whom Margaret had bribed with bacon. Mary was not a practised rider; it took Margaret and the amused boy to hoist her up into the side-saddle. The horse took off with an upheaval of limbs that all but addled Mary's brain. Her thoughts were not for Liam but for her own mortality as the beast cantered down the muddy road past church, almshouses, and orphanage; past the town square where a temporary gaol was housed in an old stone building. When the animal came to a jolting halt, she offered it sugar and gratitude. They tethered the horses to a post, entered the gaol, and demanded to see Liam—at least Margaret did. Mary was speechless with something like shock. She had serious doubts that they could help Liam—two females? But here she was.

They claimed to be relatives: auntie and "brother," said Margaret, who had borrowed George's breeches to wear. But to no avail. The keeper knew a female when he saw one. He stared at them impassively, unimpressed that they had come from the castle. His arms crossed over his puffed-out chest like a drawbridge. He was perhaps the ugliest man Mary had ever seen; one would think him perpetually off-balance with his gross upper body and stick legs clad in tight blue breeches and dirty white stockings. But if he pitched forward on his scuffed boots, the two shiny pistols stuck in his waistband might discharge. So Mary was careful to keep her distance.

"No visitors," he growled, squinting his bulgy yellow eyes. He relented a little to see Margaret's disappointed face and softened his voice, but not his denial. "It can't be done, miss," he said when the girl clasped her hands. "I've orders to admit no one. Not a single blessed soul. Would you want a murderer riding about the country-side, would you now?"

He evidently imagined himself a ladies' man from the way he leered at the two females, like a garden snake about to swallow

a pair of mice. Whilst all Mary wanted was to leave. At once. She turned on her heel.

"But Liam's not a murderer!" Margaret insisted. "He's a good man, a kind man, he's one of our tenants. We just want to give him this." She held out a packet of cheese and meat. Ham—the odour was unmistakable.

He stood firm: there were to be no visitors. Nevertheless, he could smell the ham. He ran a tongue over his dry lips. He reached for the packet. Then he crowded the women out the door with his big chest.

"It'll never reach Liam now," Margaret mourned. "And Cook came in when I picked up the knife, so I had to put it back." Her frustration pooled in her eyes.

"Miss Margaret," a young man called out; he ran up to hand her down the steps of the gaol. It was Devin, a bony, yellow-haired fellow who had once worked for the Kings as a footboy, Margaret explained, as she introduced her governess. One day, the girl said, laughing through her defeat, Devin had fallen on his face delivering a platter of oysters. "And we had to scoop them up before the grown-ups saw. Have you ever tried to scoop oysters? They keep escaping, as though alive."

"She saved me life," Devin said with a grin. "And what can I do for you, miss? You were looking a bit upset when you left the gaol." He made an awkward bow.

Margaret rushed out the story of Liam. "We want to get word to him, that we're trying to prove his innocence. That we won't let him hang."

Mary watched the lad's face to see if he could be trusted, but he looked harmless enough with his big rustic grin. "Liam must not hang," Mary agreed, picturing that high-spirited fellow dangling from a nearby oak. She squeezed her eyes shut against the awful image but could not wholly dismiss it.

"And why then am I here meself?" said Devin with a slight swagger. He patted his pocket as though he kept something important there: a pistol or a dagger. "Didn't I follow the devils here when they took him?"

He gazed open-mouthed at the pair as if awaiting a bit of praise for his loyalty. But they only stared at him, unspeaking. The wind blew his greasy hair in his face; he slicked it back with a hand but it

whipped in his eyes again. There was an unpleasant odour of horses, leeks, and sweat about him. But this Devin was a Defender, Mary gathered—though he would not use the word in front of them.

"Where is Liam then?" Margaret asked. "In what part of the gaol?"

Of course he could not get them past the gaoler, Devin allowed, but he had discovered the cell where Liam was held; it had a high, grated window. His swagger said he had a use for that window. Mary's spirit of adventure returned with the thought of seeing Liam's window, perhaps even his face. Perhaps close enough to speak to him. Her heartbeat quickened. At least he would know they were here for him.

The cell was at the back of the stone building, in an upper storey. Luckily there was a tree nearby; they watched as Devin climbed nimbly up. He grinned down at them, a young man pleased with his prowess in front of a pair of females. He pushed a bent nail through the grate. "To unlock the padlock—eventually," Margaret whispered. Mary nodded; she was still in a bit of a fog.

"His leg irons are linked by a chain—to a staple in the floor, see?" Devin hissed down. "But he's dragging toward me."

Before Mary could stop her, Margaret had clambered up the tree behind Devin; she might have been a jaybird in her blue cloak and borrowed breeches. Herself, Mary could never manage the tree with her full skirts. One stocking was already ripped at the ankle; her nerves were equally frayed. But she managed a smile at Liam, whose face had just appeared a short distance from the window. Margaret, who had withheld another small packet of meat from the gaoler, thrust it through.

Liam flashed a grim smile. But despair clouded his blue eyes; she saw the drawn brows, the growth of reddish beard, the sunken cheeks. He spoke briefly with Devin in Irish, then waved them all away. "You could only make things worse," he said. Then, acknowledging their protests: "Well, and if you really want to help, Devin can tell you what to do. And my thanks to you."

"Donovan!" a gravelly voice shouted from inside the building, and Liam's head disappeared from the window. Mary worried that someone would find the nail Devin had thrown in, or Margaret's packet. And that Liam would be confined in even more miserable quarters, or moved to an unknown place. He might even be the

gaoler's only prisoner, and hence more valuable to the man for whom a hanging would be a coup—not to mention a few more guineas if he were to take part.

Devin and Margaret swung down from the tree and almost simultaneously the gaoler came barreling around the corner; Devin ran off into the woods behind the building.

"I've never been so close to a gaol," Mary stammered, lifting her chin to meet the keeper. "I was curious to see what it looks like. That young man—whoever he was—offered to show us. Now you've frightened him away! He meant no harm."

For a moment the keeper stood still, as if uncertain what to do with these two castle females. Finally he shook his head as though utterly disgusted and motioned them off. He peered into the woods where Devin had disappeared, but not a leaf stirred.

They rode back to the castle at a slow trot; there was no word from Devin as to what they could do to help Liam escape. "And now," Mary told her pupil as they broke into a canter, "we're to go to Dublin and your Devin will never find us."

When Margaret uttered an oath, Mary did not upbraid her.

Dublin: No Cure for a Broken Heart

D UBLIN WAS an attractive city, although in Mary's view it
could not compare to London; it was like a small opal be-
side London's ruby. Like London, of course, it was full of rogues,
wretches, prostitutes, and beggars. The latter sprawled on the street
corners with their rented babies; one was immediately aware of
vice, poverty, disease. The air stank of coal fire, onions, and burnt
potatoes; of rancid perfume, refuse, and excrement.

The people, though, were pleasant and welcoming, more so
than the reserved Londoners. And for her short stay Mary was at
least able to lead something of a metropolitan life: by walking, or
using a public hackney cab. She was glad, after all, that they had
come. The gaol adventure seemed foolish and far away. And yet
she saw Liam in every blue-eyed young man she encountered on
the street, though none could compare with her renegade. In his
absence he became more and more desirable.

The town house on Henrietta Street, owned by Lord K's father,
the Earl of Kingston, was situated on the outskirts of Dublin. There
Mary had her own upstairs chamber with a fireplace, an escritoire, a
canopied bed, and two large windows that opened out onto a quiet
street. She had a small drawing room that contained a harpsichord
that she did not know how to play—her education in the arts was
pitiably lacking. Lady K was surprisingly attentive—though Mary
could see that the attention cost her a modicum of pride. When
Mary swooned one morning in church (from the combination of a
dull sermon and tight stays—she had gained weight from the rich
castle food), milady insisted upon taking Mary to her own physi-
cian, who offered a diagnosis of "nervous fever, to which sensitive
souls, especially women, are prone."

His words were discomforting, and Mary knew that the nostrum he prescribed would be of little use. "My disordered nerves," she wrote to her sisters, "are injured beyond a *possibility* of receiving *any* aid from medicine. There is no cure for a broken heart."

Perversely, and to identify further with Liam in his prison exile, she determined to spend much of the time in her chamber, writing the book that would take her back to London. But, alas, in the rush of departure, she had left Eva Noonan's journal behind.

She had small interest in the round of card games, masquerades, and dances that Lady K delighted in and spent three hours dressing for. But when Mrs FitzGerald sent an invitation to accompany her to the late James King's town house, she was thrilled—had she not hoped for such an opportunity? They were to depart at five o'clock. She might find something there of interest. Until that time she would rest and reread the first half of Rousseau's *Emile*—but not the second part where he denigrated females!

<div align="center">❀❧❀</div>

CAROLINE'S father-in-law, a pompous ramrod of a fellow, was to be in the drawing room at half-past four; he wished to meet this governess who had written a book. So Caroline sent a parlour-maid upstairs to bring the governess down. Mr Ogle, too, would attend, and at least the earl would keep the governess at bay and leave the poet for Caroline. She needed Mr Ogle; she was lonely without James. Besides, she knew things about the poet—things he had confided to her that others, in particular Miss Wollstonecraft, ought not to know.

"Well?" she asked the maid when the apple-cheeked girl entered the drawing room.

"The governess sends her regrets, madam."

"What? Governesses have no *regrets*! Go back and tell her she is to come down at once."

"Yes, madam." The girl made an awkward curtsy and backed out of the room.

Five minutes later she returned.

"And?"

"She won't come, madam. Says she has an appointment with Mrs FitzGerald to see Mr James's town house."

"*Aughh*! Foolish girl." Caroline waved her away.

Now there was nothing for it but to go up and bring down the female herself.

She traipsed up two flights—and there was the governess: seated in a wing chair, wholly unoccupied—just reading a book.

"I might remind you," Caroline told the governess, "that you are a guest in my father-in-law's house. It is not an option to remain in your room when summoned by the earl."

She did not wait for a reply. She wheeled about, out of breath, and clumped back down to the drawing room. She shrugged a satin shoulder at her father-in-law, then seated herself beside an elderly cousin. Anyone, even a parlourmaid, was preferable to the Earl of Kingston, who smiled at her only, it seemed, when she was pregnant. If the governess did not appear—let him go after her himself.

But there at last was the governess, and in her old blue poplin. The earl rose to meet her. He was all smiles, this time, and bad breath. "Do tell about this scribbling of yours," he shouted at the governess (he was hard of hearing and assumed everyone else was, too).

Caroline smiled at the governess, and was rewarded with a frown that matched her old blue dress. It was not at all becoming.

But oh, here was her darling poet! Caroline ran to greet him and at the same moment Mr Ogle crossed over to the governess and flung himself down on the settee beside her. The earl got up. He caught Caroline's eye and winked—she was piqued. She fanned her way over to the settee to address the irritating female. "Pity you cannot stay long, my dear. I understand you plan to visit James's town house? Am I correct?"

"You are indeed," Miss Wollstonecraft said, and smiled as if there were no reason at all for Caroline's disapproval.

The poet looked surprised at the mention of James's town house. He had a folded paper in his hand, no doubt one of those tedious poems—he had read them aloud to that other one, Miss Noonan—and see where that got her. Ignoring Caroline, he inched closer to the governess. "Why, madam, would you visit there?" he asked. "The house is sparsely furnished, and the gardens have been let go—they crawl with weeds. I was there just the other day— didn't stay long. It's no place for a lady."

The governess, Caroline thought, is a *lady*?

"You did not care for James?" Miss Wollstonecraft asked, sounding interested. Caroline did not like her speaking of James—it was enough that she wanted to visit that house.

Caroline picked up an almond biscuit and moved behind the settee where a bowl of flowers needed rearranging.

"Nay," Mr Ogle said. "That is, James King was not my favorite."

Not his favorite? Caroline smiled. She knew why, but had promised not to tell. She knew how to keep secrets, Caroline did.

"We did not share the same politics," the poet was saying. And that, Caroline thought, is true as well.

Caroline pulled out a pink rose, and breathed in the scent. Now the governess was asking about the poet's life as a privy councillor—about the new Irish parliament. "If indeed, sir, it is a democratic one. If it would work on behalf of the Catholic peasants as well as the Anglo-Irish lords?"

He laughed, and Caroline smiled. "*Why*, my dear Miss Wollstonecraft," the poet said, "should you concern yourself with Catholic peasants? Give them a bag of potatoes, a fiddle, and a barrel of whiskey and they'll be content as cats curled by the hearth fire."

He had gone too far. Caroline could see the governess bristle. The poet helped himself to a biscuit and laughed again with his mouth full. He leaned into the governess's neck and planted a chocolate kiss on the pink flesh. Oh!

It was time to move in. Caroline tipped the porcelain vase forward and the water dribbled down the back of the poet's neck, a yellow aster with it.

"Oh my," she said, and heard Miss Wollstonecraft gasp, and then laugh. For once she and the authoress were in accord about the peasants, whom Caroline cared for in principle if not in the flesh.

Mrs FitzGerald was in the doorway; the governess jumped up. She must be on her way, she said gaily. "I'm anxious to see his garden, even in a state of decay. James was a fine gardener, do you not think so, Mr Ogle? He knew everything there is to know about ferns and ornamental grasses."

Caroline smiled. She slid down beside the poet and dabbed at his neck with a hanky. "Such a shame," she said, "on your pretty ruffles. Now tell me, dear man, did you discover who it was cleared

out James's stables as Robert asked—and what he found? Oh, and look at that bruise on your poor neck. Another run-in with those nasty rebels, was it?"

JAMES King's town house was on the north side of Dublin. It was smaller and far less grand than the earl's; after all, Mary thought, James is probably not a legitimate heir. But the putative father, out of guilt, perhaps, had given him a house and servants. And the place was impressive: ten rooms, with stables out back, and in front, a large terrace. The gardens were, indeed, largely untended as the poet had said (what business had *he* here?).

A servant welcomed the party of three—for Margaret, as usual, had insisted on coming along—into an immaculate but small drawing room. It was quintessentially a man's room: black leather chairs, dark framed portraits, a horsehair sofa that shouted, Don't sit on me or I'll scratch.

They did not sit. It was James's private quarters Mary wanted to see—Mrs FitzGerald understood this without being told. She asked the maid to take Mary upstairs whilst she inspected the gardens. She herself had contributed a species of rose and wanted to be sure it was covered to keep out the frost. Mary thanked her with a squeeze of the hand, and she squeezed back. Mrs FitzGerald had known James since childhood; she, too, wanted the murderer brought to justice—but had "nothing of the sleuth" in her. "A hard thing it is," she had observed in the carriage that brought them there, "to overcome the conditioning of one's youth, to be the proper lady at all times." She mimed the embroidery needle. A proper lady would not go looking for a killer.

But as governess, Mary could virtually do what she liked—at least, unobserved. She and Margaret entered a bedroom even barer than the drawing room. There was not even an escritoire. Already the girl was dancing down the corridor to open other doors. Three successive chambers yielded little of interest beyond the conventional beds and armoires, a portrait of Madonna and Child above one of the canopied beds. (He *was* Catholic then!) The fourth chamber—ah!—was James's study: bookcases filled with volumes that Margaret swooped to examine, and on the walls, portraits of voluptuous actresses, their bosoms gleaming white above colourful gowns, their velvet eyes narrowed at the invisible artist as if to

promise a carnal reward. A riding cloak was thrown over a black leather chair as though the master of the house would shortly ride to hounds, and in the top drawer of the polished writing desk lay a crumpled letter beside an envelope addressed to a man called Dennis. Mary sat down at once to smooth it out, whilst Margaret hovered like a twittery bird; the girl's breath filled the governess's ear as she read aloud:

Sir,
I will meet the man you designate on the pier at one of the clock this Friday, then deliver the articles to your contact that same afternoon. Should anything happen to deter a safe delivery I will keep the cargo in my stables. Rest assured it will be safe there. You can count on my servants to be discreet.

"Cargo? How exciting!" Margaret cried. And then pouted: "James never spoke of any cargo to me."

There was a blotch of ink at the bottom where something had spilled, or leaked, and the original letter, Mary surmised, had been copied over and dispatched to the unknown Dennis.

What, Mary wondered aloud, was this cargo he spoke of?

"Guns, of course," said Margaret, running over to the window to look down on the stables. "They have to have guns—muskets. They cannot fight the English with kitchen knives."

Mary sat back in the desk chair and stared at the girl. She felt as though something had wrapped itself around her brain, stifling rational thought. James, an Anglo-Irish aristocrat (legitimate or not), was running guns for a patriotic peasantry?

She thought, for some reason, of Mr Ogle's political opposition to James, but could not find a place for it in the scheme of things. It was her time of month, that female scourge: her abdomen was bloated, her brain refusing to make connections.

"I can't tell you why he would do this," said Margaret, as though the governess had asked, "but there was a Dennis who came to visit Liam. I saw him at the Donovans' six months ago when I went to see Oona. I remember him because I had never seen such eyebrows in all my life: they curled straight across his face and over his eyes like a black hood. I wondered how he could see where he was going! But he smiled at us girls and I liked him. Then Liam hurried

him off. And Mrs Donovan didn't want Dennis there either. She worried, I think, that I might go home and tell Papa about him, when of course I would not. Then Oona said he was one of the Defenders. And soon after that, she told me, Dennis was shot and wounded."

"Oh," was all Mary could say, though she wondered, in that case, why Liam would have been so angry with James's courting Fiona. A question of class again? James was rising higher in her opinion; he was more than the womanizer she had earlier taken him for. She was truly sorry that he was dead.

Had that letter something to do with his death? If for some reason, he had not provided the guns—if Margaret were correct and guns were truly the "cargo." Did some jealous member of the Defenders murder James? Want him out of the group because of his birthright, and James would not withdraw? Or did James deliver the guns, but someone, a servant perhaps, reported him to the English authorities and the guns were confiscated and James was duly murdered?

Yet, in that case, would not the English have taken him to court and made a spectacle of him? Or perhaps the murder had nothing whatsoever to do with the Defenders and Mary's brain was blundering through a slough of mud.

There were only two other items of interest in the desk: a sheaf of scribbled IOUs from James to various individuals, mostly noted by their initials—P.P. or R.S.N. or G.D.O. And an unsent, undated letter to Eva Noonan, saying he could no longer see her. Mary was stunned. But she hoped to find something about that relationship in the journal—if indeed she could translate the Italian correctly (too humiliating to ask Margaret to help).

The only full name among the IOUs concerned a debt of five hundred and fifty pounds to Lord Robert Kingsborough, no doubt borrowed from his kinsman. Unpaid debts were not likely to improve relations. Mary would keep this in mind. For one thing, she still owed her friend Mrs Burgh for the poplin for her blue dress and for other sundries.

She put the IOUs back in the drawer but kept the letter to Eva. She did not want some officious person to read it, although undoubtedly the few literate servants had already had a heyday with it. She did not mention the letter to Margaret—the girl needn't

know everything! But she would offer a slim packet of letters from Fiona, tied with a red ribbon to Margaret, to return to the tenant girl. They were probably romantic, even sentimental, and Mary had vowed to absent herself from such passions. It was not Liam's person, she told herself, but his predicament that mattered.

"So. Fiona is literate then," she said as she handed over the letters that smelled slightly of buttered potatoes.

"James taught her. And George is teaching Oona. So you see, we aristocrats aren't all bad. If we can't always keep the peasants fed, some of us can educate them a little. And education, as *you* keep telling us, Miss Mary, is a necessary tool for a woman."

Mary laughed. She had taught the girl well. Margaret was the light that kept her moving through the dark tunnel of the King household.

When she and Margaret left the room, a female servant scurried past and on down the hall. Had she been listening?

While Margaret was having tea and scones in the drawing room with Mrs FitzGerald, Mary strolled out to the stables. The area was all but empty: the horses had been removed since James's death; she saw only a few mounds of mouldy hay and hardened manure on the floor. The rafters were hung with spiderwebs and wisps of old straw; a rat scurried past and she cried out—her courage did not extend to rats. She glanced about for a stable boy but saw none. Indeed, most of the servants had been dismissed, an aged gardener told her, there were only a few left. She mentioned the name Dennis to him, but he stared back blankly.

There was no evidence of guns anywhere, inside or out. Perhaps Margaret was wrong and the so-called "cargo" was simply one of English linens or fine wines. Dennis was an English name as well as an Irish one. And didn't Margaret say that the Dennis she knew was wounded, possibly dead? One more fruitless quest.

THE remainder of the Dublin stay was uneventful except for a visit to the crowded Rotunda gardens after the Handel concert, where Mary encountered, of all people, her former beau, the feckless Joshua Waterhouse. Seeing her in such elevated company, he came hustling over: "Egad, Miss Wollstonecraft, what a delightful surprise to meet *you* here!" His grin virtually split his face in half; and though her heart was an orchestra of drumbeats and whistles,

she threw him a look of contempt and turned away. Reaching a safe place behind a group of ladies, she peered back and there he stood, crestfallen, like a man who had missed the last coach to London. *He* knew now what it was to be put aside.

She was not a bit sorry.

But she did allow herself to be distracted by Henry Gabell, whom she had met on the packet boat. He looked quite handsome in his black broadcloth coat and silk waistcoat, and she was turning on all her charm when a rather large young woman, who reminded Mary of a Doric pillar, hurled her plumed self between them. "Allow me to introduce my, um, my—" Mr Gabell began, looking like a man with a rabbit in each hand—both of them illegally caught.

"His fiancée," the young woman finished, tucking an arm intimately under his. He smirked—his cheek matched the abundance of pink feathers in her hair. After five minutes of small talk he allowed himself to be dragged off by his scented companion. So that mystery is solved, Mary thought: the feathered woman on the pier was no sister. The fellow never mentioned during their voyage across the Irish Sea that he was engaged to be married.

Men. She would henceforth be wary of all—repeat, all!—*gentle*men.

Afterward she went out into the Dublin streets, into the smoke and fog and the earsplitting clatter of horses' hooves and waggon wheels that loosened the very cobbles she walked on. A gaunt woman hawking apples and smelly Irish cheeses attached herself to Mary's elbow and would not let her go without the purchase of one of her rotting apples. Mary gave up a hard-earned tuppence and escaped to a hackney cab. She handed the apple to the coachman's boy, who tossed it into the street, where it splattered at the foot of a statue of St. Patrick.

NEAR the end of the journey back to Mitchelstown with the girls—the Kings were to stay on another week or more in Dublin—their coach passed by the prison where Liam was being held. His cell was dark behind the iron grate. She had a panicky thought that whilst she was drinking tea with the idle rich, he had been hanged. Margaret, too, was squinting out the window; they shared the same apprehension.

For a moment she wondered if her pupil was half in love with Liam—but then dismissed the thought. Why, anyway, should it matter?

When they reached the castle gates it was almost twilight, and the young people were hustled upstairs by the nursemaids. Nora came running out to greet Mary. She handed over a note that Liam's cohort Devin had brought the day before, but was to be read in private. "Not by another soul, Devin said, but yourself," Nora whispered.

Seeing the Cutterby's frown as she reached for the note, Mary said, "Oh yes, that Dante translation for the girls"—as though the message were of academic interest, with Nora a disinterested courier. Her curiosity piqued, she ran two steps at a time up to her chamber to read it, leaving her portmanteau for a footboy to bear. *Liam has escaped*, her imagination warned. *He wants you to know where he is; he needs food, needs guns.* Good lord, and where would she get those? Should she pull up the boards in James's stable?

Or *Liam lies wounded.... He needs medicine, bandages, water....* Or *He is yet in prison and you are to be a part of his escape and then ride off with him.* For that (his moist eyes pleading inside her mind), she would climb a tree. She would learn to shoot a musket. She would give up the creature comforts of the castle.

Would she? She did not know. She had become a stranger to herself.

CHAPTER XIII.

A Most Compromising Posture

D EVIN'S NOTE was a summons to meet him: I BE AT
THE BRIGE BY THE FALLS AT NINE THURRSDAY NIGHT COME
ALONE.

She was disappointed, even annoyed. She did not know where
the falls were, let alone a bridge across the river—which she as-
sumed was the River Funcheon. Why, there might be a dozen or
two bridges in the area. And if she were to come alone, whom
could she consult for directions? Why had he sent this to her, and
not to Margaret, with whom he was better acquainted?

Nor did she feel comfortable, as a woman, going alone at night
to meet a young man. Should any of the adults in the Kingsbor-
ough household see her, she would be greatly compromised. She
did not want to give Mrs Cutterby any more ammunition than the
woman already had.

But Thursday was three days off, and meanwhile, she had les-
sons to prepare and letters to write to her younger siblings; they
could not seem to cope without Mary to advise them. And of more
immediate concern, she had Eva Noonan's journal to read. In
Italian.

Then, too, there was her novel. But all else must take priority
over that. Such, she thought, is the dilemma of the writer.

For the moment, the journal took precedence. As Mary leafed
through she saw that although it began in Italian, mercifully, it
turned after three or four pages, into English. The English part was
hurriedly written—it could do with a little editing. Of course it was
not for publication, so one could excuse the dashes, blottings, ab-
breviations, and here and there a turnip or beetroot stain. Or was
it blood?

She and Eva Noonan, she discovered, were in full agreement about the King household. "A den of iniquitty," Eva wrote, misspelling the word (and raising Mary's self-esteem). The former governess satirized the drawing room ladies—in particular, the Cutterby, whom she called "Missus Flutter-by." The dogs—or was it the children?—were Lady Caroline's "bower of little bitches."

Then there was Lord K, described in an entry dated April fifth, in a mix of Italian, Gaelic, and English. In Mary's translation of the Italian, milord tried to seduce Eva several times with no success, until one night after she'd had three glasses of wine at table and then two more while playing cards, he visited her chamber with a bottle of her favorite claret. Here the handwriting disintegrated into a series of exclamation points; the final one, Mary was certain, stabbed with blood. Then there were words she recognized from the sailor's letter as Gaelic: *Amadan! Tha mi 'g innse dhut gu robh....Agus de tha a' tachairt a nis?*

"Ask Nora to translate," Mary wrote in the margin. Then, thankfully, English again:

> *Next morning I was ashamed of myself, angry at him, worried I might be pregnant, a thousand thoughts chilled my mind. Anything anyone said to me had me in tears. I fainted on the stairs, right under* The Rape of Proserpine *and Lady K told me to go to bed for the day—she would summon a physician. I wanted none of that!*

But she wasn't pregnant—not then. She was wooed by a second gentleman. But Mary learned it was not James, although, as Mary judged by the unsent letter in his chamber, he, too, had pursued her. "Soul" she called this unknown man, *for we were soulmates. I lived and breathed for my Soul. S,* as she finally designated him, met her nights at an undisclosed place and consummated their love. She had written simply, *Tout*—all. *For the first time in my life I am utterly, completely in love. I would do anything for him, anything at all.*

Mary read and reread that phrase, intrigued to know whom. Evidently this *S* was a rival of James and of another man labeled *X*—the rivalry was described in two entries:

S does not like X or J's flirting with me. In vain I told him—
James flirts with all the females. I know about his wooing of the
Donovan girl, I tried to warn her but she was blinded by his
attentions. Moreover, J and S had once fought a duel, I discov-
ered—S would not tell me what it was about. S was wounded in
the palm of his hand but one can see only a small crooked scar
there in the very center. How often I kissed it!

Mary returned once more to the phrase *I would do anything for*
him. Did this mysterious Soul prevail upon a lovelorn governess to
kill for him?

She flipped hastily through the journal to find an entry for
James's death. It would most likely be November first or second.
But the November first entry merely read: *So now he is dead. And S*
can claim full satisfaction.

The rest of the journal up to her death was heartbreaking to
read; it reinforced Mary's anger at the plight of woman. This Soul,
Eva had earlier discovered after two months, had another female in
his life. When Eva told him about her pregnancy, *He backed away*
with a hundred excuses. Money was all I could expect to receive when
what I wanted and what I needed was affection, a home for our
child.

She did not, however, have marital expectations from S. And so
the relationship broke off. Eva was dismissed from the castle and
given an annuity of fifty pounds *to stay quiet.* Stay quiet about what,
Mary wondered. Lord K's involvement? For she had evidently ac-
cused *him* of the pregnancy, even before Mary's time; and he was
vulnerable at that point, not knowing when she conceived.

"Oh, our female biology," Mary wailed to the walls, "we are
defeated by it. Unfair, unfair!"

When she had calmed down with a tiny glass of claret saved
from dinner, she tucked the journal under her mattress. But it
made a telltale bulge so she put it in her wardrobe under a blanket.
Eventually she would return it to Mrs Noonan and enquire about
the mysterious S. Perhaps Eva had given her mother the identity of
this Soul. But then, mother and daughter did not appear to have a
close relationship. Mary could understand that.

A knock on the door and Margaret rushed in. She had heard—
through a servant perhaps—of a certain note passed on to her gov-

erness. "What was it? From whom? Liam? Tell me!" She flung herself onto the bed; her big white hands begged.

For a moment Mary was torn. But her sensible self said, "Oh, a poem in translation, that's all—something you'll see in tomorrow's lesson. Now run along. I'm exhausted from that long journey. Go, go! We'll meet in the morning."

When the girl had gone, Mary vowed to discover the identity of this Soul, and his relationship with James. But must she examine every gentleman's palm for a tiny scar? And how important, really, was Eva Noonan's love life to Liam's predicament?

EXERCISE, Mary reminded herself, invariably served to enliven the brain and to solve problems, so shortly after dawn the next morning she took a brisk walk-think about the grounds. But as she rounded the path into the herb garden, she came upon George and Oona in a most compromising posture. The girl was spread out on the ground. The boy's hands were burrowing into her small clothes; he was pouring honey into her ear and she, to make matters worse, was allowing it to flow.

Suppose a gardener were to see the pair... Mary stepped on a twig and Oona looked up. George jumped to a standing position, his face and neck turning the colour of a painted sunset. Mary did not need *this* on her mind right then, but there they were. She clapped her hands on her hips and considered the pair whilst they stared at her in shocked silence.

"You might have chosen a less public place," she said, and George offered a faint smile. "No one comes here," he replied, defending his choice of venue, and Mary retorted, "Well, I am here."

"Aye." "Yes," they admitted with one voice.

His defenses down, George went on the offensive. He held out his open palms. "Then help us, miss, whilst my parents are in Dublin. We want to get married. We need a little money, is all—till I'm eighteen—it's only a year and a half from now."

Mary was aghast that he should ask such a thing. He knew she was only a governess, a family minion. "If you marry," she said, "you will have to procure a position somewhere and earn yourself a living. Two livings." That statement, she thought, should shock him: a gentleman having to earn his living?

"I could," he cried. "I could do it, could I not?" He blinked at

Oona, and she gazed soulfully into his eyes as though he could fly, if he were to try. "But as the eldest son, I do not think I would have to." He smiled self-righteously at Mary.

She stood firm. "I will not prevent you from marrying, but I cannot help you."

The girl burst into tears; Mary frowned. Did she detect a slight fullness in the belly?

"But I want to do what's right by her," George wailed. "If we marry, my parents will have to help us. I'm the eldest, I said—father won't abandon me." He spoke with conviction. But in truth Mary had known of aristocrats who would disown before they would suffer a child to marry beneath his or her station.

So what was she to do? She could not let this girl go the way of her sister. But she did not want to lose her post. Not yet. She needed the money.

On the other hand: what if she *were* dismissed? She might be glad of it. She required no recommendation—she would never again, she determined, be a governess. When her term was up (if she weren't dismissed first), she would visit her publisher in London and prevail upon him for a monetary advance for her novel.

The novel on which she had written only a page.

"I can lead you to the bridge by the falls this Thursday," said George. He softened his voice. "To meet Devin. It's not safe for a female to go there alone."

What! How did he know? But he held up a hand to give pause to her flood of words. "Oona was with Nora when Devin came to the cottage. Nora left to chase a runaway pig and well, Oona saw the message." He glanced at the girl for verification.

"The pig is always running off," Oona said in her high, sweet voice. "'Tis a naughty thing. But it's our only pig. Mam would swoon, she would, if it went missing."

George put an arm around her shoulders as if to compensate for the pig. "So you see, Oona read the note."

"'Twas writ in big letters. Nora had just unfolded it—I couldn't help but see it, could I now?" The girl looked wide-eyed and close to tears. She swept back a sheaf of black hair that had fallen across her face.

"Of course not," George soothed. "And I won't tell. But Devin

is fond of the girls, miss. He's come often enough to hang about Fiona, and Oona doesn't like it."

"Not a bit," Oona cried, "you should smell his breath. He's terrible fond of leeks."

George gazed down at Oona lovingly: She *was* a young beauty with her milky skin and luxurious hair. "You should not go alone," he persisted, holding Mary with his eyes. "I can wait at a distance whilst you talk to Devin, if you prefer."

Defeated, she accepted his offer. They made plans for Thursday at half-eight—it would take half an hour, he said, to walk to the falls. She would meet George in the herb garden; he would give a warning whistle. Oona would join them—and then stay out of sight.

He brought up the elopement again and Mary said she would consider it carefully—what else could she say? She knew it to be utter folly. "We'll discuss it after the meeting with Devin," she told him, and that would be the end of it for today. He smiled at her so engagingly then that she had to smile back.

UNFORTUNATELY—or in one sense, fortunately—Margaret was back in bed with a painful throat on Thursday and Mary was able to meet George by herself in the herb garden. The boy was late by a quarter of an hour and she was displeased: she did not care to be lurking about in a garden as though she had a rendezvous with one of the King household. When she heard voices coming through the hedge, she crouched beside a wheelbarrow, her heart a rising kite. She did not recognize the voice—it might belong to one of the many guests who stopped for a night or two, whether the Kingsboroughs were in residence or not.

She had interrupted a tryst. The man was encouraging a female—perhaps one of the maidservants—to follow him into the gardener's shed, and the female was giggling. Then "No, no, sir, really, I shouldn't," she cried. And ho! Mary knew the female voice to be Mrs Cutterby's.

"You know you love it, you do, you little tease," boomed the male voice.

Mary was in a game of war in this castle, and this tryst could be ammunition. She might speak up at once to embarrass the pair, except for the fact that she, too, was in the garden for an unexplained rendezvous.

She felt a sneeze coming on and stifled it. There was a silence. She held her breath. If the pair should detect her, she would say she was taking a walk.

But if the Cutterby discovered the governess with George, what would *she* tell the world? Mary prostrated herself on the ground until the lecherous pair had passed (men were so laughable when they tried to seduce). Soon more footsteps came padding along, and then the agreed-upon whistle. George started to speak and she shushed him.

"Company," she whispered, not wanting to tell him *who*, and he quietly made his way through the hedgerows and out to the familiar path that led to the Donovan cottage where they were joined by Oona. From there it was a rocky trudge alongside the River Funcheon. Oona and George walked ahead, hand in hand, with a light. Oona squealed occasionally as she tripped on a rock or root, and Mary struggled to keep apace, holding up her burdensome skirts.

Moments later her ears picked up a kind of hollow, roaring sound; it rumbled louder and louder until she was deafened. At first she panicked, imagining it a hundred voices in pitched battle, and she hung back. But George said it was only the falls. It was a primal sound, so like earth and heaven coming together to make celestial music that her heart responded by beating arrhythmically, the way it had in Dublin when she heard Handel's "Hallelujah Chorus."

George whispered that she should go on, alone, to where another path intersected with this one: that would be the head of the falls and the bridge where Devin awaited. He gave her his lanthorn to carry and a penny whistle to blow into should she require help. He seemed distrustful of Devin, and that, too, escalated the governess's heartbeat.

She stumbled forward; she had the sensation that she was walking *into* the falls: at any moment the water would thunder down on her head and hurtle her over and into a maelstrom. George had left her too soon. The meeting place seemed miles away, although she did not know exactly where it was. But finally she came upon the intersecting path and halted. The earth was wet where the falls had sprayed it; droplets of water struck her face like pebbles. The bridge was a narrow strip of logs across the river; she did not want to step out on it. If Devin did not come soon she would be drenched, she would catch an ague. And then how was she to cope?

Soon, though, she heard a crunching of leaves and a tall, thin figure glided ghostlike out of an alternate path. It was Devin; the light caught his yellow tangle of hair, the pallid skin. He had been waiting for her, he said; he looked impatient—he knew she was not alone. "Who is with you then? Where is he?"

He had a stick at his side, gleaming in her lanthorn light. But with George behind her, young though he was, Mary was brave.

"How was I to find this place without help? Did you really expect me to come by myself?"

When he lifted his stick, she said, "It's a friend of Liam's, with Liam's niece. They're back there on the path. Now tell me what this is all about." She took a bold stance. She was a Dissenter, a female Defender; an Amazon. Her fingernails dug into her hips; her heart was racing the falls.

"Fiona?" he called out loud.

"It's Oona," she said, "and they can't hear you. All right then, I'll go back and summon them—you can see for yourself."

"Never you mind," he said. "Come down the path a ways and we can talk." He motioned her on with a thumb. She did not want to go any farther; she did not want George to be out of earshot of the penny whistle. This fellow could be a spy for the enemies of the Defenders. A double agent—she had heard of such people.

But she wanted to help Liam. She had to hear the fellow out. So she followed.

He halted by an ancient oak; the air was drier there. "We're planning to free Liam," he announced. "He has the bent nail I gave him to unlock from the chain. We might saw loose the window bars. He said you offered to help."

"But how can you be sure it will work this time? They would have all the more cause to hang Liam."

"They'll hang him if he don't get out," Devin argued, running two fingers across his pale throat and then up into his greasy hair. "Do you want to help or not, I'm asking?"

"I want to discover who killed James," Mary said. "Then they'll have to release Liam. Without any sawing of window bars."

"Och." He looked scornfully at her as if to say, How can a female like you find a killer? Irish males were an imperious lot, she was discovering—more so even than the English. In a show of bravado Devin pulled out a knife and stroked its blade as if he were

in love with it. Mary's lanthorn was dimming; she did not entirely trust this Devin and his shiny knife.

"All right then," she said with a sigh. "What exactly do you want me to do? I must get back. I can't promise anything. I'm not from these parts. Isn't there someone else who can help, who knows the neighbourhood?"

"It's not that," Devin said, his voice thick with purpose, his breath thick with something more than leeks—she could not define it. He put away the knife and held her eyes as if to say, *Trust me*. And she had to; she was virtually alone with this knifeman by a waterfall that could swallow her in a trice.

"Och, we'll get him out all right," Devin went on. "We're just needing you to keep the old man occupied, you know, the gaoler, so Liam can slip by him if need be. You can keep him talking. You can flirt with him. Surely you know how it's done." He smiled.

Mary froze. She had tried once, and failed. She would rather climb the tree to Liam's cell and saw at the bars whilst someone else kept the lecher occupied. "There are others can do it better. I'm certain you know someone who—"

He waved away her words; his voice overrode hers. "'Tis a new gaoler, I know him—that's why we waited till now to free Liam. But Joseph knows the local girls. He'd suspect something. Aye, they're all lusting after Liam." He laughed. "Joseph needs an older woman, I'm telling you."

"Is that so?" Mary said coldly (Older woman indeed). "Well, I cannot do it. I will not degrade myself." Her arms hugged her chest. She turned to go.

"Take him some cheese and wine," Devin said, as if she had already agreed. "Tell him it's for Liam. If he says no, why then uncork the wine and offer to share with him, you can do it. It's set for Wednesday night when the new gaoler comes in. At the peal of nine. We'll be waiting in the woods. We'll watch to see you go in, aye. We'll give you twenty minutes to seduce—" When she whistled her indignation, he softened his tone: "That is, keep him occupied. 'Tis Liam's life. Surely you're not wanting to see him hang?" His voice grew louder, more passionate. "He's our leader, God knows we need him! It's for Ireland, for liberty...."

She fell back against the oak and pressed her body into the ungiving bark. For Ireland she was doing this? For liberty? The thought

appealed. She must sacrifice her pride, yes, for a larger cause than a single man. Her heart echoed the cries of her Celtic ancestors in their mud huts. *Remember us, redeem us: the squalor, the hunger, the oppression.*

"I'm Protestant," she said, her final stance.

"And what do you think we are, we Defenders?" he cried in that feverish voice of his. His face went blotchy red in the lanthorn light. "We're Catholic *and* Protestant. Working for a single cause, are we not? To free Ireland!"

"I'll do it." She was overcome. "Wednesday? I'll have to steal the food. I'm only the governess, I don't have access to things. I'm not meant even to enter the kitchen."

"Nine o'clock. We'll be waiting," he said, "and blessings on you." He was on his way then: a streak of yellow hair, a glint of knife. The air freshened around her. "Blessings" he had said? Hmm.

"Wait," she called after him—a pressing question had come to mind. "What do you know about James King? Did he supply arms for your comrades? I must know. It might be important to Liam's life."

Devin turned back. His face was skull-like when she lifted her light to it, yet he could not be much older than nineteen or twenty. "The man never delivered what we paid him for. He seduced Liam's niece." He spat on the ground to show his disgust.

"Did you kill him? Did Liam?" But he was running off into the dark, slashing twigs and branches as he went. She had no answers.

She trudged back down the muddy path with her dim lanthorn, and stumbled twice, hurting her knees on jutting rocks and stumps. Devin need not have worried about George and Oona. She found them locked in an embrace that shut out the entire world, herself included. She was glad of the roar of the falls so she would not have to hear their lovemaking.

She gave a shriek on the penny whistle to warn them of her presence, and stumbled forward.

MARGARET waylaid her governess on the castle stairs—she had slipped out of her room when the nurse fell asleep; she demanded to know what had happened; George had told her about the meeting. "What did Devin say? What can we do to get Liam out of that gaol?"

"Not here," Miss Mary whispered, looking dismayed and a bit disheveled. So Margaret followed the governess up to her chamber—tiptoeing, of course, for the castle eyes and ears, even at this baleful hour, were watching and listening. The governess fumbled with the new lock on her door and Margaret followed her in.

"Tell me now. Everything," Margaret ordered. Her cheeks heated up with the thrill of what might happen. She hopped onto the bed in her night shift and squatted cross-legged. Her watery eyes stared into her tutor's—she sniffled back the phlegm. She would not let this cold take over, would not!

Miss Mary sighed into her chair, and then it spilled out—she did love to talk. She was full of George and Oona, the waterfall, and then Devin with his knife. She frowned when she spoke of it.

"It's all right, Miss Mary, I've seen him with it. He wouldn't hurt you." The governess looked sceptical and Margaret laughed. "Well, go on, tell me the rest! The important part. What are we to do?" She settled back into the bed.

"*We*," said Miss Mary, pulling herself upright the way she did in the schoolroom, "that is, you and I, are to do nothing. *I* am to go in there alone—this is a job for a grown woman." She gushed out the whole of it: feeding the gaoler, getting him drunk, entertaining him so he would not hear Devin sawing the bars. "A dangerous job," she went on, her eyes flashing, "for, well…" Her nose glowed pink with what the gaoler might do when he had drunk his fill.

Margaret had to be part of it, had to! "If the fellow assaults either one of us I will threaten him with hanging by Papa and stage a screaming fit. Devin can saw all he likes and the gaoler won't hear a thing."

She peered sidelong at the governess. Miss Mary was quiet, thinking. Margaret dropped down off the bed and sank onto her knees. Begged with her two hands. All at once she had a better plan. A more practical plan than sawing the bars. One that would involve *herself*. "Listen, please! If you could get the key to Liam's cell from the gaoler after he has drunk the wine, why then I could unlock it and Liam could slip out—*quietly*!"

The governess was interested. She was considering: Margaret could see it in the half-shut eyes. She did not want to go alone, Margaret could see that. The job was easier with two; the fellow

could not take on two females at once, no! And her plan *was* more sensible. She would relay it somehow to Devin.

"All right then, you can come along," the governess said and Margaret's heart leapt.

"Ha!"

"But. You will have to remain outside the gaol until I am ready with the keys. If I call out sooner—if I summon you—you will come in. Otherwise, emphatically, no. This, as I made eminently clear, is a task for a mature woman. Which you are not—yet. With two of us, the project might fail altogether. You do want Liam freed, do you not?"

Margaret threw herself flat on the floor. She *was* mature for her age. Why, she was as tall as her teacher—and growing! Her breasts were swelling. She was bleeding monthly—well, trickling.

"Get up, Margaret, and stop acting like a baby. *I* will go in and *you* will wait outside until summoned. Or would you rather not come at all?"

"No, no, I'm coming. I'll wait outside. I'll watch through a keyhole. If he makes a single move towards you whilst you're stealing the keys, I will—"

"Yes," said the governess. "I can imagine what you will do and I may be glad of it. Now, pray leave so I can have some rest. Tomorrow we will finish reading *A Midsummer Night's Dream*. What is—is not. What's not—is. A theme for all of us to consider here in the castle. And you can help your younger sisters with the story. Now go, foolish girl, and don't get caught in the hall."

"If so, I'll tell them I'm sleepwalking. I'll say I am not myself. If they want Margaret they must look in her bed."

The governess laughed. "Exactly," she said. "Now good night, sweet—"

"Rebel," said Margaret with a curtsy, and then stood on her hands, bare as a newborn under her white shift.

CHAPTER XIV.

A Seduction and a Crooked Scar

T HE "GREAT ESCAPE," as Margaret named it (in a whis-
per) Monday morning, was still two days away and the young-
er girls must have no inkling of it. So when Carrie suggested that
they put on a few scenes from the Shakespeare comedy, and Polly
cried, "Let me play Puck," Mary agreed. She found Puck the most
delightful of all the characters, for he was the one to pour the love
potion into the lovers' eyes and make them fall headlong in love
with the wrong partner. "Puck," she told them, thinking of the
devious Pucks in her life, "represents cruel fate."

They spent the rest of the lesson choosing parts for the others
in the castle and then copying out lines for a presentation the fol-
lowing evening. At first Mary was less than enthusiastic, as she had
heavier things on her mind—like how to play the coquette to a
drunken gaoler. But when the girls prevailed upon Mrs FitzGerald
and George to perform, she warmed to the idea.

"You will wear masks," she decreed, thinking of the secrets that
might come to light through such disguises. George would play
the lover Lysander, who planned to run off with Hermia, a girl
destined to marry a man she did not love. As Hermia, they would
bring in Oona, disguised in Margaret's white gown; they would
fasten a veil over her face—the Cutterby would not recognize her
(or so Mary hoped).

Margaret would play Helena, and invite Mr Ogle, who had
come riding in this morning for breakfast, to take on the role of
Demetrius. Although Mary did not care for his politics—according
to Mrs FitzGerald he would allow Catholics no rights—he was, af-
ter all, a published poet: he might be useful to Mary in her literary
endeavours. Mary herself would direct and narrate between scenes

since she was the one most familiar with the play—and for reasons of her own, most anxious about the outcome.

"And Major Cutterby will play the actor Bottom, of course," said Margaret, "and wear the ass's head that I will happily construct." The girls giggled and Mary shushed them as a pair of whispering housemaids passed by the schoolroom.

"And Mrs Cutterby?" Carrie asked with a grimace.

"Why, the queen fairy, Titania, whose quarrel with her king created this whole world of mistaken identity, and who falls in love with an ass."

Ah, but Mary relished that thought!

The afternoon was taken up with the creation of makeshift costumes, with which the servants were asked to help, and the absent Lady K's wardrobe was invaded.

"Mama won't know. We'll put it back the way we find it," Carrie promised, and Mary vowed to hold the girl to it: no rips, smudges, or stains. The girls did have difficulty convincing Major Cutterby to wear an ass's head, but Mr Ogle told him to "be a good sport, sir. I myself am to be accused of murdering Hermia's lover."

"Something *you* would never think of doing, eh?" said the agent; and the poet, colouring, replied, "I think not, sir! And why, pray, would you make such a remark?"

Indeed, Mary wondered why herself. She was *so* looking forward to the revelation of secrets.

ALREADY the secrets had begun—and not all welcome ones. They were rehearsing in the ornamental grasses garden Tuesday afternoon when Oona came running to whisper a message in George's ear and the latter in turn whispered it to Mary. Liam's escape was to be moved up a day—no explanation given—which meant it was destined for this very night. The night of the play! Panic crawled up Mary's spine and exploded in her head. Now what to do?

There was but one answer, she told herself. She could not postpone the escape. The disclosure of secrets would, regretfully, have to wait another night. Luckily, only the young people were at the rehearsal, including the smaller King children who were to portray Peaseblossom, Cobweb, Moth, and several other mischievous fairies. And the rehearsal was in such a state of disarray that no one was surprised when she announced that they would have to postpone

the performance to Wednesday evening. Today they would work on lines, costumes, and properties.

After that, events moved so swiftly that she had scarcely time to be anxious about her own role in the escape.

Margaret purloined the bacon, cheese, and wine from the kitchen. She knew when Cook was out; she had a pact with a lame scullery maid named Doreen, who would let her into the pantries. Rules were considerably relaxed in the absence of the elder Kings; even the Cutterbys seemed more at ease. Without the lord and lady present, Mary could loosen her stays, so to speak, with impunity.

The escape from the castle was easy enough. George helped to pad Margaret's bed to avoid suspicion by the half-blind Kara, and in the end the lad insisted on accompanying them to the gaol—Margaret had outlined the revised plan to him. Mary was to get the turnkey drunk, obtain his keys to Liam's cell, and Margaret would unlock it. Too many cooks spoil the broth, Mary thought; the old saying, but there was no going back at this point. And so they set off after supper on two horses: Margaret and Mary on one, George on the other. Mary thought she saw a curtain pull back as they rode off, but told herself it was only the flash of a candle passing a window.

They left their horses at a public house, which George boldly entered (the boy seemed quite at home there), whilst Mary, who had already prepared herself with a glass of wine, marched up to the gaol and demanded to see Liam. Margaret was at her back: "I'm ready to jump in any time, oh yes," Margaret hissed, but Mary waved her aside.

When the gaoler—Joseph this time, as Devin said—looked at Mary sceptically, she announced, "Lord Kingsborough sends cheese and bacon for the prisoner." The keeper did not know, she prayed, that milord was in Dublin. "And for you," she said, smiling her most winning smile: "a bottle of his lordship's finest claret."

The wine drew the expected results. The gaoler gave her a searching look—the wine had encouraged her to loosen her muslin neckerchief to make her frock's bosom slightly revealing—and apparently satisfied she could do him no harm and offer, perhaps, some greater reward, he invited her to join him.

Mary warmed to her role; she eyed the key ring on its chain: "Nay, sir," she protested. "I am here to give victuals to Liam. I can-

not return without fulfilling my errand. And wine? Why, sir, I am
not used to wine. I would roll off my horse, quite!"

He laughed heartily at that notion and opened the bottle with
a pop. He took a deep swallow, and wiping off the neck with a
dirty sleeve, passed it on. Mary turned her head and pretended to
drink—she did not want to touch where his mouth had been. When
"they" had finished off half the bottle, the gaoler looked Mary up
and down through squinted eyes and advanced in her direction.
She backed up to the door and tightened her neckerchief—after
all, she could not let go her principles. With his scraggy whiskers,
small pig eyes, and protruding belly, he was the personification of
the word *lecher*.

"Are you a married man, sir?" she asked, hoping to keep him at
bay with words.

"Why, three times o'er," he said with a coarse laugh that suggest-
ed it was his exuberant lovemaking had killed off the first two. She
grimaced to picture the wine-belly lying atop his wife, the woman
all but smothered beneath him. No doubt he beat her when he was
done, making her the scapegoat of his daily frustrations. Mary had
lived, as daughter, with such a man.

Her timepiece told her that Devin was already outside waiting
with two horses. Liam, she hoped, had been able to free himself
with the bent nail Devin had earlier given him. And now she must
steal Joseph's keys. Yet the man was holding his liquor altogether
too well. She must pour more into him. But she had brought only
one bottle of wine, and the contents were rapidly shrinking. What
was she to do?

She spotted a small keg in a corner. "Might that be porter, sir?
I've a terrible thirst for it," she said, and inched back into the cold
room. The door was open on the crack; a cool draught was blow-
ing in, although the gaoler didn't seem to notice, his face pink with
the wine.

But she would brace herself and go through with it. It might
one day serve for a scene in a book. A writer must be always pre-
pared.

"You've a thirst, have ye," he said, pouring out a pewter mug of
the ale. "Aye! I can take care o' that all right." He was already quite
intoxicated, the ale slopping over the edge of the mug as he thrust
it at her. He stumbled back to pour one for himself. She took a seat

on a hard wooden bench and sipped the thick drink. Ugh—a pewter mug soured the taste. She preferred fine china or glass to drink from. Thoughts of dining off fine china kept her from focusing on the gaoler; the man was gulping the ale, his eyes fixed on her, contemplating, no doubt, some unthinkable act.

"You've hardly made a dent in that jug," she said, "I'm disappointed in you, sir. I thought you could handle more than that little taste. Why, my own sainted father could empty that keg in moments and call for more!"

Guffawing, nay, braying loudly, he rose to the challenge. Margaret was at the door now and Mary put a finger to her lips. Together they watched as he swilled down two, three, and four mugfuls—and then rolling his eyes, collapsed to the floor.

"Oh sir," she cried, "you need help. I can scarce hear you breathe…" She bent to unhook the key ring from its chain, then tossed the keys to Margaret, who ran with them up the prison stairs.

When Joseph blinked drunkenly up at her she dropped her mug. It clattered on the floor. "Oh sir, look what I've gone and done!" she cried at the top of her voice to keep him occupied whilst Margaret unlocked Liam's cell. "Have you a cloth, and I'll mop it up?" She forced a peal of laughter, all the while despising what she had to do—yet pleased with herself for doing it so well.

The man took her laughter for provocation. He pulled himself up and sidled toward her; he was a crab shifting in its ooze. He yanked at her skirt and it ripped. "Here's a cloth for cleaning," he bellowed, and giggling, he hauled her hard into his hairy arms. She felt that she was thrown into a sty, a dozen pigs oinking, sucking, biting her flesh. "Wench," he murmured, and she cried out and shoved him off.

But the pig giggled and belched and pulled her back into his smelly embrace.

"Get off me, you brute," she screamed. "Off!" She wanted out of there at once—Liam would have to fend for himself, she could not. Where was he? Where was Margaret? She sucked in a deep breath—and heaved the villain away. He lost his balance and rolled over on his back.

Footsteps sounded on the stairs, and Liam hobbled past, followed by a triumphant Margaret. But Mary's relief was short-lived. Springing up with a roar, the keeper flew at her again, landing half in her lap, knocking them both on their backs.

There was a a bang and the outer door opened wide. "George! Margaret!" she cried. "Come quick!"

But God help her, it was not the young Kings: it was the Cutterbys. Mrs Cutterby shrieked to see the governess on the floor, in a terrible embrace. Struggling to her feet, Mary saw with horror that the lecherous fellow had unbuttoned his breeches.

The sight of the agent and his wife brought the gaoler to his knees. The Cutterby's eyes were hot coals; her irises gleamed with the scandal of it.

The governess cringed, at her mercy. "I wasn't…I'm not," Mary began—but the woman did not let her finish. She was to come home at once, the young people with her.

"They ran when they saw me, the naughty pair of them," the woman squealed. "Oh, yes, I saw the three of you leave—up to no good, I said to myself. I sent a boy to follow—never dreaming of—this!" Her tongue licked her lips. She appealed to Major Cutterby, who was staring at Mary, pink with amazement. He had not yet been able to make a full assessment of the situation.

There was a gust of wind, a rattle of keys thrown in through the open door, and then mercifully, the clatter of hooves.

"Prisoner escaping!" Major Cutterby shouted when he came to his senses. He and Joseph stumbled out of the gaol, knocking over the last of the wine; it flowed like the Red Sea to the door and leaked into the cracks of the stone walk. The hem of Mary's dress, torn by the gaoler, was wet with it. Liam had escaped, but at what cost to the governess? She was too absorbed in her own catastrophe to even care what was happening outside.

When George and Margaret appeared in the doorway, laughing and shouting, "He's gone, Liam's free!" Mary could only stare at them, blankly.

"And I have lost my reputation." She recalled the line from *Othello,* when Cassio's superior caught him drunk, and fighting. The reek of that awful keeper was still in her nostrils. She wanted only to go home and bury herself in blankets. Finally, after a spate of pseudo-explanations that Mrs Cutterby received in a stony silence, Mary and the young people left—on horseback, as they had come.

THE Cutterby threw a withering look each time she and Mary chanced to meet the next morning. In fact, she deliberately thrust herself in the governess's path, as if to reduce Mary to the fallen

woman she appeared to be. At dinner, Major Cutterby glared at the governess through slitted eyes, as though he suspected she had something to do with Liam's escape.

She stared back in all innocence. "I was bringing a bit of bacon," she said, "and the man took advantage. I was lucky to escape with my life! You heard my screams, did you? It was most fortunate that you arrived just then."

And still he frowned. She loathed her hypocrisy.

Though she owed no apology, did she? "It was before his lordship left for Dublin," she continued, seeing the agent's lifted eyebrow, but unable to halt her prevarication. "I asked if I might bring food at the family's request, and he agreed." She stared straight in his eyes, daring him to disbelieve.

He blinked back at her.

"Margaret has created a donkey's head for our play," she said. "It will look charming on you." And she swept as grandly as she was able in her worn skirts, out of the dining hall.

THE performance went on the boards at half-after eight in the grand ballroom. The hour was late for the younger children, but governess and housekeeper pronounced this a special occasion. The nursemaids would never tell; the little ones could sleep late the next morning. If the makeshift set and costumes were still not ready and the lines only half-learned, it was all right. The spirit was there, and the audience, consisting mostly of servants, along with three or four guests, appeared full of anticipation.

She had divided the play into four scenes, with her narrated summary in between. It began with the fairy king Oberon, played in a monotone by Dillard, whom Nora had draped in a scarlet robe. Embarrassed, his eyes focused on the floor, he squeezed the flowery love potion onto Queen Titania's eyelids. The queen glanced into the wings to see if Mr Ogle was watching, and then collapsed with a squeak onto a flower-strewn couch. "Wake," mumbled Oberon, "when some vile thing is near."

Mary thought again of the gaoler who had given her fresh nightmares, but he no doubt was at the public house, drinking away his disgrace at having let a prisoner escape.

Next Polly, as the impish Puck, tripped out in her white shift and flicked drops of water into the sleeping Lysander's eyes. In her

puckish voice she warbled: "When thou wakest, let love forbid... Sleep his seat on thy eyelid." She did a series of twirls that evoked a burst of applause from the spectators. Overwhelmed, she ran off behind the Japanese screen.

The play went smoothly through the scene where the separated lovers fell in love with the wrong person. An arrow of jealousy shot through Mary to see Mr Ogle, as Demetrius, emote over Oona as Hermia. But offstage he slipped a new poem to her, and she could not help but be flattered. She was restored to good humour to see Major Cutterby's donkey head bobbing over the Cutterby's beehive, and whooped with laughter as the fairies tripped into the drawing room and Puck fed figs and currants into the donkey's mouth.

Shakespeare, she thought, would writhe in his grave to hear his lines bobbled, but they were, she allowed, uttered with verve. She could scarcely keep track of who was whom, but wasn't that the whole point? One never really knows who the other person is, she thought, and so she fixed her eyes on Mr Ogle when, as Demetrius, he lay down to sleep on the Persian carpet before Puck came to restore his true love to him.

But dust rising from the fairies' frenetic dances made the poet cough. He coughed and coughed, and she signaled for a glass of water. A maidservant rushed it to him. And as he lifted his right hand to take it, she saw the crooked scar precisely in the center of his palm.

"MAN is but an ass if he go about to expound this dream," Bottom's voice echoed in Mary's head as she tossed in and out of sleep that night. "Methought I was—there is no man can tell what!" Half-awake, she wondered if she had dreamt that scar, or mistook a crease in his palm. Or if it truly was Mr Ogle, the poet, who was party to a duel, who despised James King for his rebel sympathies, and later killed the man for them. And before that, as Eva Noonan's soulmate, made love to the young woman and got her with child. Chills raced up and down Mary's spine at the wonder—the horror of it all.

But it was not yet time for accusations.

Nothing was as it seemed, no. Liam was free—but with a bounty on his head. And who *was* Liam? The scars on the young man's face

were obvious enough, but what invisible scars inside? How was she to know who was where on the evening of Samhain when James's life was so abruptly interrupted? Must she plan an assignation with Mr Ogle and wheedle a confession out of him?

Thank you, but I have had enough of assignations, she warned herself as she turned over on the soft mattress. And why, why must women seduce in order to gain favours? That gaoler deserved to have a prisoner escape!

"Men, men, men, men," she muttered aloud. "Would I could live in a society made up of women only...."

But how wearisome, her heart spoke back, how dull to live without men.

This, her body told her, was Mary Wollstonecraft's dilemma.

Well then, she would mull it all over tomorrow. The "tomorrow...and tomorrow that creeps..." or however Macbeth's soliloquy went... For now she could not think; her brain was atrophied.

CHAPTER XV.

An Interrupted Rendezvous

TWO DAYS later, Mary was rudely awakened at six o'clock. It was Margaret, banging on the door, demanding entrance. It was getting to be a habit; Mary was not pleased—but she opened. "Don't you think a governess needs her sleep—if she's to cope with the likes of you every day?"

"It's George," Margaret said, her breath coming fast. "He's gone. He woke me an hour ago to tell me. He took his horse. He was to meet Oona and take her to Doneraile—that's five, six miles from here. A cousin of hers has persuaded some half-blind priest, her relation, to marry them; she told him George was eighteen—she'd helped him get a license, and signed his parents' names. And the old man believed it all! George does look eighteen, don't you think? Then they plan to take ship to America—can you imagine?"

"Why are you telling me this?" Mary was only half-awake; she had sat up late writing. "If George wants to elope then he'll have to take the consequences. What can I do? I can't bring down the moon."

"He wants me to come and be a witness." The girl moved up behind Mary. "And of course I must be there. But Oona is worried about Liam."

"What does Liam have to do with it?" Mary dipped her face into the blue bowl, trying to clear her head with the icy water.

"He came to the cottage yesterday to do chores and George and Oona were there, making plans. Mrs Donovan was away visiting a sick friend so she doesn't know. Liam was not pleased, you can well imagine."

"I can imagine, yes." Mary recalled his animosity toward George

at the Samhain feast. "The whole scheme is mad, they have no money. His father will disinherit him; George has no work skills. Though I suppose he could take up boxing, or raise pigs."

Margaret was not amused; her mind was on one track only. "So we had best go at once. I'm afraid Liam will try to stop the wedding."

"What?"

"Kara was there in the corner when George told me. She comes into my chamber, you know, like a little mouse, and curls up in that old wing chair. You never know when she's there, the monkey. She hears things she shouldn't."

Now Mary was fully awake. She pulled a blanket over her shift. The castle walls held the cold and expelled it out into the room like an icy breath. The fire, too, had gone out. Mary raked the coals but there was only dead ash. "Would Kara tell on George?"

"That's why I'm here!" The girl was a cloud, raining over the room. "Kara usually stands up for us. But now—"

"Now George has gone too far." When Margaret nodded, Mary thought of the old nurse telling the Cutterbys. Worse, she thought of Liam, galloping off to halt the marriage. She thought of a constable, alerted to recapture Liam. She thought, too, of the time she had rescued her sister from her abusive husband. They had been in a state of high anxiety, and had to keep changing carriages, knowing the fellow to be in pursuit. They stayed a whole week in a dingy rented room, jumping at the sound of each carriage stopping outside in the street, at each knock on a nearby door.

It would end in disaster, this elopement. How long before George discovered that Oona did not know how to curtsy? Or which fork to use at dinner?

"All right. I don't know what I can do, but I'll come. Meet me by the stable door in a quarter of an hour," she said. "Get us a fast horse. Not to ride, though—I can't do that again. Hitch it to that little red post-chaise of your mother's. And bribe a stable boy to accompany us. Oh, and bring some bread and bacon. I cannot go without a bite of breakfast."

Wild horses were galloping in Mary's temples. She wanted to go back to bed and shut out the world, but now Liam was involved. She was furious at George for going against her advice. It was not her place to stop the marriage, but she would fill his ears when she

saw him. And she would keep a lookout for Liam. If they were not too late for—well, everything.

THE lovers were in the small stone village church when Mary and her pupil arrived. It was a pitiful little party: George in a ruffled white shirt and pale blue waistcoat; Oona in yellow flannel with a blue sash and holding a limp bouquet of orange and yellow chrysanthemums. Fiona wrapped in a black mantle that in no way diminished her enormous belly; a plump, pink-cheeked, laughing woman whom Mary assumed was the matchmaking cousin. The priest was a virtual dwarf in his wrinkled black cassock; he was glancing from one girl to the other, confused and already full of toddy—Mary could smell it from yards away.

Seeing them, George broke away from the altar and kissed his sister. "I knew you'd come." He grinned at Mary like a small boy who had put a frog in his teacher's desk drawer and knew that, under the circumstances, she could do little about it. And now all Mary could say was, "You must not go through with this, George. You are too young to understand the consequences. You will be very, very sorry, I'm warning you."

But George only shrugged.

"Hurry, Father, and marry them at once," the cousin cried, peering about as though at any moment someone would rush in and shout, *Stop the wedding!* And well he might, Mary thought, watching for Liam. He would halt the proceedings, yes. But at what cost?

"Nay, this one, this one," the cousin cried when the old man tried to put the pregnant Fiona's hand in George's. Oona was looking tearful, and George laid a protective arm around her shoulders. Fiona was openly weeping, no doubt picturing herself at the altar with James, had he lived to marry her. All the females were emotional, even Margaret, who was gazing glassy-eyed at the couple. Mary felt a moist pressure at the back of her own eyelids but blinked to stifle the sentiment. She would not be held responsible for George's actions, she would not! She was publishing a book on how to educate *females*. And now one of them had dragged her to an illicit wedding.

She was being swept away again by that waterfall—there was no stopping it. She wanted Liam to come, and at the same time she

wanted him to stay away. She stood close by the entrance, watching for him. The church was cold and dimly lit by torches on the side walls. But there was a rear staircase to the left of the altar, descending into some inner sanctum—and she hoped, to an outside door—in case.

"We are ready," the cousin told the priest, and he nodded his stubbly chin. "Dearly beloved…" he began, then went into a fit of coughing. He mumbled something inaudible, cleared his throat, and continued: "We are here to join, um, George with, um—"

"Oona," the cousin cried, and gave a little giggle. Mary could see how thrilled she was to be engineering this wedding; there was no ring on the cousin's left hand. She was living the union vicariously.

"Oona," he mumbled, and fell into a second paroxysm of coughing. George's forehead was beaded with perspiration; he was wringing his hands—had he second thoughts? Had he just fully realized that he might be disinherited? (Mary hoped so.) Oona's bouquet was a shaft of golden arrows in her two hands; a loose flower shot onto the priest's prayer book. He peered at it closely as if it were a sign of an approaching Armageddon.

"Hurry, Father, please," the cousin squealed.

The priest mumbled and coughed through the pages of ritual. Mary determined anew never to wed; she did not need this nonsense mumbled over her, Catholic nor Anglican. Only a marriage of true minds, as the Bard said, would do for her—at sea or on hilltop. Would it ever happen?

She was in a reverie of her own when the church door swung open behind her and there was Liam. She ran to him and grabbed his sleeve. "Do what you have to, Liam, and then leave. The Cutterbys have been warned." She didn't know this for truth, but it was highly probable if the old nurse had her way.

He glanced blankly at her; his cheeks were red as crab apples. She might as well be a squirrel dashing across his path.

"Christ, let's go then, Liam," a voice barked—and there was Devin; she was grateful for his presence of mind. But Liam was bounding up front, dropping a hand on Oona's shoulder. She looked up, wide-eyed, and tried to hold him but his shoulders were braced. He spoke urgently in a voice Mary could not comprehend—perhaps in Irish. For a mad moment she wanted to run

up and tell him to let the ceremony go on; the girl had a right to choose for herself.

"What's this? What's this interruption, hey? Hey?" sputtered the priest, squinting up at the intruder. George was staring huge-eyed, speechless, at Liam, whilst Liam went on whispering. Devin stood by the rear stairs; he was beckoning to his fellow rebel, his breath almost audible.

She moved closer to listen, then spun about when the oak door squealed open and in rushed two burly men. "Stop the ceremony," they bawled, "stop it at once!"

Devin and Liam raced to the stairwell and down the crumbling steps.

"Leave us be," George shouted. "You've no right! Get away, damn you."

"Sanctuary!" Mary cried, "you cannot come in here. These young people are safe." The ancient ritual of sanctuary was sacred—where else could a body in trouble go? But the constables cared little for sanctuary. One of them, a bulky fellow with a nose the colour of a sunset was galloping down the stairs after the rebels, his stick raised. Shouts echoed from the bottom of the steps; there was a scuffling and a crashing sound—her heart all but ceased.

The second constable grabbed George by the arm. "We're to take you home," he shouted. He waved a paper in the boy's face.

"I won't go, I shan't!" George bellowed. The females yanked at the officer's massive elbows but the man had the boy in too strong a grip. He hustled him up the aisle. When George's ankles failed, he was dragged along on his woolen knees. Fiona stood on a pew, wailing—Mary worried she would slip and produce the baby. The stable boy dove under a pew. The cousin was running behind the constable, shrieking in Irish. Oona and Margaret raced out, screaming, whilst the priest sank motionless into a front pew, as though struck by lightning.

Mary watched in the doorway as George was shoved like a rag doll into a carriage. Major Cutterby held up a finger and the carriage jounced off. It might be a prologue, Mary reminded herself, to her own departure from Mitchelstown Castle. Back in the church, she listened at the stairwell: there was an eerie quiet below; the other constable had not yet emerged. She would go down to see, but her feet felt fastened to the floor.

Then footsteps slapped the stone stairs and Liam and Devin emerged, white-faced and grim; Devin wiped his knife on his trousers—Mary saw the blood. The rebels hugged the walls as they crept toward the front—there was evidently no exit in the cellar. She heard a groaning below stairs, but no one ascended. The front door opened just before the fugitives could reach it, and they crouched between two pews.

"Down there in the crypt—I heard a noise," she told the first constable, and he plunged down the steps—she did not want his partner dead. Liam and Devin snatched the moment to race through the oak door—without a nod at their saviour.

The old story.

There had been no marriage, but the priest had tried. Mary put a silver coin in his hand. He stared at it as though it had fallen like manna from heaven and sequestered it under his cassock. She handed the weeping Donovan girls into the coach that George had reserved for his flight with Oona. She and Margaret returned to the castle in the post-chaise—Margaret in glum silence; Mary pleased, on the whole, at the way things had turned out—except, of course, for the constable, for whom she offered a short prayer.

Mrs Cutterby met them in the entrance hall. In her black ribbons and scarlet neckerchief she resembled one of the three Fates—the one who would cut away the thread of the governess's *future*.

"I am too shocked to speak," the woman said, though she spoke anyway: "That poor innocent George! Too young to know what he was doing." She glared at Mary as if it were the governess who had seduced George and planned to elope with him.

The image of a disrobed Cutterby flashed into Mary's mind. "Did I not see you in the garden with a gentleman guest? Should we inform Major Cutterby? I am sure Lady Kingsborough would love to hear."

The words were magical; Mary might have waved a wand. The Cutterby was struck dumb. "Don't" was all she could think of to say; she held up a hand with five rings crammed onto the pudgy fingers. Mary smiled, then sailed, head high like a figurehead on a ship's bow, up the two flights to her room.

GEORGE was inconsolable. Oona had been forbidden to see him, so they must plan a second elopement, he said when the next day

he poked his shaggy head through the library doorway. After all, he complained, he had already booked passage for two on a ship to America.

"Cancel it," Mary said. She reminded him that his parents would be home through the Christmas holidays, and that afterward he was to return to Eton. "You will be of age soon enough," she told him. She thought of Mr Ogle's poem: "*Carpe diem*—enjoy your liberty."

The boy pointed a finger at his temples as if he would shoot himself.

Mary had one burning question. "*Is* the girl with child?"

He flushed, then shook his head. "She thought perhaps—but no, she—"

"Well, then." She dismissed him with a wave of the hand. He would not shoot himself, she was certain of that; the life force was too strong in the young eyes. He would finish Eton, she predicted, inherit the castle, take over the leadership of his father's cruel militia, and marry a woman of beauty, wealth, and stupidity.

Poor George. He would never again be what he was now.

But what if she were wrong? Perhaps she should encourage him to take flight to America.... For her judgment *had* been wrong on occasion.

Quite often wrong, in fact, an inner voice told her. But she banished the voice.

When he left, head hanging, disconsolate, she jumped up from her chair. She could not concentrate on her studies. There was a nagging feeling of disappointment for her as well as for George. Her future was no more roseate than the boy's. Her mother was dead; the males in her life had abandoned her. Even her sisters complained of her—though they never failed to accept the money she sent. She was in a period of spiritual trial. She pulled down a volume of *Hamlet*: she might find sustenance there. The prince, too, had lost a parent—his father murdered, the man's ghost there to confirm it. "Do something about it!" she heard the ghost saying.

Or was it just Mary Wollstonecraft crying out in her head?

She came slowly back to life and its conflicts. She thought of Eva Noonan again, and of Mr Ogle, who had doubtless fathered her dead foetus and who was, in a sense, Eva's assassin. She thought of Liam: the law in pursuit, anxious to hang him for James's death.

Liam had seen the governess as he raced out of that church, surely he had—he probably blamed her for Oona's elopement. She must find him, assure him it was not her doing.

It was the poet, Mr Ogle, she now decided, who had killed James. She was quite certain that the GDO to whom he owed a considerable sum of money was George D. Ogle. She must ask what the *D* stood for. Did he sometimes reverse the letters to spell out GOD, as in a monogram? Words could kill, she knew, as well as actions. But how to prove his guilt? She did not want to be the victim of his wily phrases. But for Liam's sake, she must confront him.

The sight of Liam running from the church; the tail of his homespun shirt flying behind like his ginger hair, grown halfway now to his waist; the muscles working in the backs of his strong legs—carried her through the hour until she returned to the prosaic schoolroom.

And when the lesson was over, she would seek out G.D. Ogle, poet extraordinaire.

AT half-after four Mr Ogle came to her as if by magnet. She smiled a nervous smile; he took it as pleasure. He invited her for a turn about the dying rose garden and she accepted. Mrs Cutterby paused at the far end of the hall as they made their plans; her face was a mug of sour milk. She was obviously filled with vitriol against Mary but could not expel it because of what she knew that the governess knew. But the officious woman might try to follow, and so Mary asked Nora to distract her. The housekeeper glanced quizzically at the governess, then grimaced to see her leave on the poet's arm.

"La, sir," Mary said, playing the coquette (She had had practice, had she not?), "I wonder how many ladies you have entertained here in the rose garden?"

He was startled; then he laughed—a man liked to be known as a lady's pet. "Oh, too many to count," he retorted, playing the game, and his words matched Mary's thoughts. "Now let me see: there was the upstairs maid and the downstairs kitchen wench...."

"And the governess?" she said in her tiniest voice.

He gave a faint laugh; she observed him carefully. He licked his dry upper lip—he resembled a snake surprised in the garden and curling up in defense. "Who, pray?" he said.

"Miss Noonan, perhaps? You saw where she made her leap, though not the leap itself. She did not come to you in her distress?"

"Distress?" he repeated numbly, as if he had no notion what that might be. He went on smiling, although the effort distorted his face.

She glanced away, as though embarrassed, and in truth, she was somewhat—for Mr Ogle did look prepossessing today in his ruffled shirt and violet silk waistcoat with his hair elegantly powdered—sometimes his charm outweighed his hypocrisy.

He changed the subject; he asked if she had read the poem he had slipped her the night of the performance. It was called "Mary Astore." He smiled seductively as though the poem was written for Mary Wollstonecraft alone. But she knew that "Mary Astore" was some other Mary, in an old Irish song—he had merely written new lyrics.

She had not yet had the opportunity, she replied: she was called away on an unexpected errand; she did not tell him the nature of that errand. But she was certain he knew why Eva Noonan had destroyed herself, and since his liaison with the former governess might well be irrelevant to James's death, she did not pursue it.

Their eyes met, their faces flushed. But she could not let him have the upper hand.

"You made an admirable Demetrius," she said, and he laughed out loud. He liked to be praised. "It is interesting how things are not what they seem," she continued, stooping to smell a late damask rose. The petals fell as she touched it. "It happens so often in real life. Surely Shakespeare made that observation. He was using the midsummer confusion as a metaphor for all our lives, don't you think?"

The poet smiled indulgently. "The Bard was borrowing from Ovid, from Chaucer and Plutarch. From Montemayor. I do not think he was trying to instruct us; he was merely playing with the notion of identity, a sort of entertainment. You cannot read too much into that comedy."

He had missed her allusion to his own hypocrisy. It is interesting, she thought, how differently we perceive ourselves from the way others see us. How easily we misconstrue. She would have to try another avenue.

"I noticed, sir, when you took the glass of water at the play's end, a small, crooked scar." She put on her innocent face: concern, sisterhood. She took his hand; she wanted to re-examine his palm, confirm what she saw. Or thought she saw.

It was indeed a scar.

At first he appeared reluctant to speak of the scar; he shook his head as though it were nothing: a scrape, a surface scratch. "It looks deep," Mary said, "more like a wound."

He gave a deprecating laugh.

"A knife wound. A sword cut?" Her eyes burned into his.

His eyes reflected her heat. What does she know? they asked.

"One would think you had been in a duel," she pressed on. "How romantic, really. Was it over a woman?"

"No, no, not that at all. I would never fight over a woman." He, too, picked a faded blossom from its stem, then crushed it in his hand and threw it on the ground. So much for his wife, she thought, remembering the gentle little woman in the drawing room—whom he had somewhat recently married, according to Mrs FitzGerald.

So much for Eva Noonan with all her book learning.

"A man then," she persisted. Now she was a dog with a meaty bone. "You had a quarrel. Over what—money? Honour? James King once mentioned—" Once more she was on unstable ground, but she gazed at him knowingly.

"James? What did James have to say?" Visibly upset, he grabbed for her hands. She pulled away. James had said no such thing—at least, to her. She could not admit that she saw James's papers, that she was certain he owed a substantial sum of money to one GDO. She could not mention the Defenders. Whom might the anti-Catholic poet alert?

"Oh, very little," she said. "Only that he owed you money and did not pay and you challenged him to a duel."

He stalked off towards a far corner of the garden; then veered about. "If you knew about the duel, why did you ask about the scar?" His eyes flashed fire. She had lost her connection with him. They were playing a verbal game of chess; she had just taken his queen and he did *not* like it. It is time, she thought, to open up.

"I read Eva Noonan's journal. I know about her relationship with you. I know you would not acknowledge her child as yours." She did not know, exactly, but she strongly suspected his paternity.

"She was a governess, like myself." There, now. She had justified her reading of Miss Noonan's diary.

He threw a scathing glance at her as if to say she need not worry about his getting *her* pregnant. He pulled himself up to his full height (he was barely an inch taller than she), and said, "Madam, I have a wife"—as though that would excuse the shirking of responsibility. Though he was not married in Eva Noonan's time, was he? Only betrothed, perhaps? The wife had a small fortune, she had heard. He turned abruptly on his heel. His white stockings were splashed with mud from the morning puddles.

Halfway down the path he called back, "Eva was a romantic girl. There were others involved with her. She was a flirt! Don't think I was the only one. Look to James. Look to Lord Robert." He waved at the castle where a pack of children and dogs were frolicking.

"You must have been angry," she cried, "when James stabbed you in the hand. It must have hurt. He was Catholic, was he not—a convert? And you never did get the money he owed, did you? You took your revenge?"

He looked surprised, even bewildered. She had thrust home. She felt the thrill and tension of the duel—although she did not care for the violence. Slowly he came back to her, lowering his voice, speaking through his teeth. "I sought no revenge, madam, if that is what you imply. Why, for God's sake, would I avenge a man over a few thousand pounds? What is this all about anyway? Have not you and I been friends? Have we not shared poems?" He held out his hands; he wanted a truce.

Blackmail, she thought. He wanted her to hold her tongue. He did not know how hard that was for Mary Wollstonecraft.

She held out her hands and he reached for them. Ah, she had him, curled up in her palms. His head jerked forward, seeking her lips, as though he would try to seduce her, make her his. For a moment she wanted to yield: he was manly, nicely limbed—a fine sensibility, but—

She retreated a step. "What was this money *for* that you lent him?" She didn't know that it mattered, but it was something to break the spell between them.

"Just money. A matter of two thousand pounds."

"Two thousand pounds is a very great deal for a man trying to make a living from his poems."

"It is," he admitted. "You can understand why I wanted it back."

"Why couldn't James repay it? He spent it on other things?"

"It was gone. *Poof!* Spent on a nasty cause."

"The Defenders?" she whispered. "Revolutionaries fighting our British crown?"

"You understand, don't you?" he whispered back. "We cannot have that here in Ireland. It would undermine our safety, our society. Speak to Lord Kingsborough, he will tell you. Speak to his father, the earl. They are banding together, you see, those Catholics. With some of our Protestants. Our own class! It's terrifying. The next you know, we'll have an insurrection—like the Colonies. Then what will happen to our way of life?"

Mary loathed the class division. And yet, in her heart, she, too, was afraid of what would happen if someone tried to tear it down. What would they have in its place? Tyrants coming to power? She thought of Alexander the Great, of Oliver Cromwell; King John and the kings Henry and Charles.

"Eva was part of it," he said, his face so close to hers that she could see the coarse black hairs on his chin and cheeks, the wrinkles at the pinkish corners of his eyes. "Eva was helping James. Indeed, she was," he said when Mary drew back, surprised—she had seen no mention of this in her journal. "It was a confidence to me. I was shocked. It was another reason I ended the liaison. A pity, for she was not that way before—" He gave a delicate cough, stroked his prickly chin.

She was beginning to understand. "James came between you and Eva, did he not. It must have been upsetting. After there was so much trust between you."

"He used the girl for his own pleasures," Ogle said. "She told me the whole of it when she and I met for the last time. But by then—" He wiped his damp brow with an embroidered handkerchief. It bore his initials: GDO.

D for devious, she thought. "You were angry with her. You hated what she was doing. You felt betrayed, of course you did. You left her. Even though you knew what she was carrying."

He looked away, shamefaced. His fingers coiled into fists. "I hated James. I loathed the man. I wanted to—"

"Kill him?" she whispered.

Children exploded into the garden, followed by a crowd of excited dogs. The animals trampled the plants, goaded on by the small boys. The plants were dying anyway; Ireland was on the brink of winter, but there was no need to hasten the season, to crush the blooms. Mary hallooed and waved her arms. She was a scarecrow; she chased the children away, naughty little boys and dogs who had interrupted her confrontation. "Shoo, you scamps! Out! Away from these plants. Don't you think they can feel?" It was James who told her that.

The children looked up at her, startled; they tumbled off in a hurly-burly pack.

Mr Ogle went with them. He attempted a shortcut through a hedgerow and encountered a pile of stone; she heard him stumble. He glanced woefully back, as if it were Mary who had tripped him up.

And it was, was it not? She was quite pleased with herself.

On the other hand, she was disappointed to see a man of genius sink into sensuality—and worse. She could not help but think that it was herself, Mary Wollstonecraft, whom he had betrayed.

Revelations of a Cutterby Cousin

T HE KINGSBOROUGHS were back. The servants, in livery or white caps and aprons lined the front steps to greet them, while Mrs Cutterby and the maids rushed at Lady K with welcome wreaths of artificial roses that all the servants—including the governess—had been made to construct. Mary stood in their wake with Margaret and George; the boy was still sulking. If his parents caught word of the foiled elopement—who knew what might happen to the young lover *or* to the governess. Mary had silenced the Cutterbys, yes, but the servants were prone to gossip.

Lord and Lady K paraded ceremoniously up the steps, nodding and smiling like any king and queen; the footmen hurried behind, picking up a dropped handkerchief, plucking a leaf off an embroidered coat. Mary was not happy to have them back; life had been almost tolerable in their absence. Even the younger children had behaved—well, more or less. A ball bounced off her foot; a child cried, "Boo!" in her ear; a longhaired cat clung to Mary's ankle for refuge from a pesky toddler. Then, as the parents approached, there was a sudden, tense silence. Fear of God and Parent was bred in the bones of the young Kings.

"Give your mama a kiss," old Kara shrilled, but the children would not budge.

The day brought more than the Kings; it brought two copies of Mary's book in the post: *Thoughts on the Education of Daughters*. She was thrilled to be holding the book in her hand, morocco-bound and smelling of fresh paper and print. Lady K was in the drawing room just before tea time, decorating for the holiday, and Mary planned to present her with one of the copies. Milady still wore the wreath of flowers they had made for the homecoming;

Mary smiled to think of someone mistakenly hanging *her* up for a Christmas decoration.

The lame kitchen maid was on an ancient ladder tying pink angels to the gold frame of a painting; Lady K had not considered the condition of maid or ladder. A weak rung gave way and Doreen lost her footing. She screamed and a footman rushed to catch her, then whisked away the faulty ladder for repair. The painting fell to the floor and a bit of gold leaf chipped off.

"Clumsy girl," milady cried, "now look what you've done." She stroked the painting as though it were the sole victim. The girl ran sobbing out of the room; Mary's heart followed. But then a young footman came to comfort the maid, and it was the governess who felt displaced. And uncomfortable, for she had laced her bodice too tightly—even her heavy breathing could not loosen the whalebone.

Mary tucked the book back into her handbag—this was not the time to approach her employer. Lady K had not once addressed the governess since her arrival, and Mary wondered if the Cutterbys had got to her after all. But then Mary saw Marion FitzGerald walk in, and like a naïve schoolgirl, she thrust the book at her and received a spontaneous embrace.

"So this is it," cried the loyal Mrs FitzGerald in her low, throaty voice. "Well! And here stands the authoress. My stars, aren't you the clever one."

"Sniff," Mary said. Mrs FitzGerald held the book to her nose, and they both laughed. In case the latter (to whom Mary owed a few guineas) thought the governess was wealthy as a result, Mary hastened to confess that she had received only ten pounds for the writing of it, and had already given away that small sum.

By now the authoress had drawn a small crowd of ladies about her, who pretended to admire the book. Lady K's head turned, but Mary affected not to notice her. An overdressed female introduced to the ladies as Mrs Thorndike, English cousin to Major Cutterby and wife of a British parliamentarian, was impressed: "Oh la," she gurgled, "whatever made you decide to write a book?"

Mary told her that it grew out of her experiences of running a school for girls. (She did not say that the school was ultimately a failure.) "It is my belief," she said, given an audience, "that children—girls, in particular—should be brought up and educated by

their *parents* rather than servants. Children must be shown affection—" she raised her voice because Lady K was tinkling a string of ribboned bells "—not punishment or constraint."

She had their attention now and she held forth. "And most important of all, young girls should be taught to *think*. They should not only be seen, but *heard*."

As she spoke half a dozen children and dogs screeched past in the great hall, followed by a protesting servant whose newly washed floor they had muddied.

"Well, usually, if not always," Mary wound down, and the ladies fluttered their fans. Major Cutterby's cousin had the book in her hands now; she opened it at random and peered into it.

"The authoress says a teacher in a school is only a kind of upper servant," Mrs Thorndike announced to the party. "She says to be a governess to young ladies is equally disagreeable." She glanced at Lady K. "If you knew the trouble we had with two of our governesses! They might have tried to teach the children to *think*— though I would worry *what* thoughts—but never to sew or draw."

Mary did not respond to that innuendo, but she did want to make use of the agent's cousin. No one had yet introduced her as the governess, so she seated herself on a settee to the woman's left. "You grew up, madam, with Major Cutterby?"

"With Willard? Oh no," the cousin said with a giggle; she seemed thrilled to be addressed by an authoress, despite her veiled criticism of the book. "I never laid eyes on him, my dear, until he was fifteen years of age. I lived in London, he grew up in Ireland. He was monstrous provincial until they sent him to stay with my family and then he got a bit of an education at a public school, don't you know." She fanned herself vigourously and smiled a yellow smile. She could do with a tooth cleansing.

"But you and he became friends?" Mary asked. "He was somewhat...modest about his situation? Being a relative, I mean, though not an Englishman?" She was aware how pompous she sounded, how prejudicial. But then she was talking to Mistress Bias herself.

"Oh, he was pleasant enough, my dear, that is, as much as a male adolescent can be. But then when he was older, much, much older—well, three and a half years ago, to be precise—the situation altered." Her lips pressed hard together as though she would eliminate an unhappy memory.

"Altered—in what way?" Mary asked in a bland voice as if this alteration in his conduct was not of any particular interest—though she *was* anxious to find out.

"Why, his brother died, did he not?"

"His brother? He died in Ireland? Or—"

"Of course in Ireland." The cousin fanned rapidly to add drama to her words. "It was monstrous sad. Willard and Richard were twins, you know. It was one of those uprisings the peasants are always forcing on the English—they are never content with their lot, no. We British try to bring about change in Ireland, and the people do not appreciate! They have their own parliament now, should not that be enough?"

The puppet parliament, Mary understood, was only formed when the war began with the Colonies and England needed Ireland's help. But the Irish were still ruled by the English, and poor Liam was risking his life to take Ireland back.

"The brother died?" she asked. "Or was he killed?"

"Of course he was killed!" The fan was moving at high speed. "Richard was not an officer or anything. He just happened to be crossing the street in Dublin when a man ran up and struck him on the head with a club. Struck him again and again! With no provocation! It was monstrous. It was an outrage! Our Willard was grief-stricken. He and his papa and his younger brother put on a huge funeral."

"He had a younger brother, too?"

Mrs Thorndike's attention was fragmented by a maid passing a tray of chocolates. And Lady K was lifting her habitual eyebrow. But Mary wanted to hear more about this agent's disputatious family.

"Major Cutterby was working here at that time?" she encouraged.

"He was," the cousin said, helping herself to a chocolate angel. "His wife was the one brought him to the castle. She is a relative, you know, of Caroline's. A *distant* relative. He had a perfectly good position in Dublin, but she did not think it worthy of him. Never mind that *he* liked it, and had time for his candles. Have you seen his candles? He is so *clever* at it. But he jumps whenever *that one* speaks."

She indicated Mrs Cutterby, who was seated at a card table across

the room. Her hair had been freshly dressed; today it resembled an ark, something animals might have marched into two-by-two during the biblical flood. Mary was quite certain she saw something crawl into it—and ho! She was right. The Cutterby lifted a small jewelled stick to probe its depths; then squeezed the creature between her fingers and let it fall to the Turkish carpet.

"And then—" Mrs Thorndike whispered.

"Then?"

"Then *she* took over, quite led him by the nose, don't you know; she's a monstrous controlling woman. I don't know why he dotes on her so."

Mary nodded. Her thoughts exactly. She smiled at the cousin.

Lady K was circling the room like a lady hawk, bent on its prey: the governess. She swooped down in front of her stepmother: "Do you like the pink angels around that frame, Stepmama? I thought we might have a large angel made of white silk and float it from the ceiling. What *do* you think?"

"Very nice, Caroline. I am fond of angels," Mrs FitzGerald said. She grimaced slightly in Mary's direction as Lady K paused directly in front of Mrs Thorndike. Mary noted the strong scent of lilacs, although it was already December.

"You have met our *governess*, I see," Lady K said with a little smile of triumph.

"Governess? Oh, but I thought—But this—" Mrs Thorndike held up Mary's book. Mary could see the shock on her face. She had been seated beside a *governess*. And she, the wife of a parliamentarian!

Mary snatched away the book. "It's for you, Mrs FitzGerald, I'll inscribe it for you. I'm anxious to see what you think of it." Her friend's face wavered in her vision; she felt quite ill, in fact—the room had grown hot and fetid from bodies and strong scent. The tight stays were squeezing her organs together; she could scarcely breathe. The room darkened in her blurred vision; she thrust the book at her friend, then toppled sideways into her arms.

When she regained consciousness, she was lying on the lemon-coloured settee, her feet elevated on a cushion. The blood was rushing to her head. Someone was holding smelling salts to her nose; she waved them away. The ladies were gathered on the far side of the room as though afraid of contracting something nasty.

Mrs Thorndike shielded her face with her fan, still in shock, no doubt, from her conversation with a humble governess.

Lady K's personal physician came in with spirits of hartshorn. Mary's swooning, he declaimed, stemmed from "an efflux of noxious vapours upon nerves of unusual sensibility." Mary admired the sound of those nerves. She refused the ammoniac spirits, and taking deep breaths, staggered up on her own to exit the room with some semblance of dignity.

Mrs Cutterby followed Mary out, alternately fanning and whacking the back of the governess's head. "You must lie down, my dear," she rasped. "Teaching girls to think, is it? The authoress might *think* a little herself before she *acts*."

The "authoress" wheeled about to confront the Cutterby. "I think, madam, you should look to your own actions. Where were you, dear lady, on the evening of James King's death?"

"How dare you—" the woman screeched. But just then Margaret came running up to claim her teacher before the Ark could shoot another volley.

"Oona has a fever," Margaret cried in Mary's ear after the Ark had floated past. "And George is distraught. He's there now, at the Donovans'. He says if anything happens to her he'll throw himself over the falls. And he just might. What are we to do, Miss Mary?"

Mary didn't know. She was no physician—although she could probably do as well as most: what fool could not stir up a potion of frog legs and urine? "We must bring Oona some tea and biscuits," she said, trying to cool Margaret's panic. "*You* must pilfer the tea," she added, not wanting to be caught up in that occupation. Who knew what kitchen maid might be in league with the Cutterby?

"Give me time to freshen up," she said to Margaret, "and we'll go to the Donovans' together."

MARY watched as Margaret pulled back the curtain of the tiny rear chamber to reveal Oona lying on a featherbed. Her illness, Mary thought, is all in her head—a result of the failed elopement. Fiona sat on a nearby stool, sewing something yellow. She had had false labour pains the night before, but they had subsided. "I told her to stay abed but would she listen to me? Nay, nay," her mother complained.

It was nothing, Fiona said, "Only the babe rolling low in me

belly, putting me off balance. And no need to summon Nora." But the cloth trembled in her hands.

George was on a stool beside Oona, holding her hand, crooning endearments, as the girl lay still as a sunning turtle on a rock, her blue eyes focused on his face. "There is naught wrong with her a marriage can't cure," said Bridget, whilst Margaret made Oona a dish of tea. "But God knows it won't do with that one." She pointed at George and wiped her hands on her stained apron—she had been cutting up potatoes for a stew or soup. Her grimace said she would like to stir the boy into the stew.

Was the girl pregnant? Was that the implication? It did put things in a new perspective. How ironic, Mary thought, that only a marriage could cure that affliction. She eyed the young aristocrat coolly.

"If Father finds me he'll lock me in my room," the boy said, appealing to the governess. "He said I was not to come here again. He doesn't care that Oona is ill. I despise him for that."

"You look rather ill yourself," Mary said, and he did: his cheeks were fever red, his forehead pale. She told him to go home; she could not help him should someone from the castle arrive—with the exception, of course, of Nora, who had left her birthing stool here—a strange-looking piece of furniture with a hole in the center.

Mary vowed once again to remain a spinster. Babies and books were not a good mix.

Margaret led her out of doors and into the potato patch. "It's not because of the failed elopement," she told Mary. "It's because she lost the baby. Her mother was ashamed to have you know. It happened, thank heaven, when Nora was here last night to see to Fiona. And Nora ended up taking care of Oona."

"But then she needn't marry George after all."

"That's what *she* said," Margaret confided. "She's aware of their differences—afraid of them, to tell the truth. But you don't know George. When he desires something, he won't stop until he gets it. And he desires Oona more than ever. He wants *her*, he says, not any child—he's quite relieved about that, I must say. But he's sick with love. Literally! His forehead is burning up. I know he has a fever." The girl lowered her voice. "It's quite disgusting to see him this way. It's not the first time either. Last year there was the daughter of one of Mama's friends—but the girl rejected George!"

"Oh?" Mary did not want to hear about rejections. "Love is a disease," she said. She should know. She had been afflicted three times in her life so far. Besides Joshua Waterhouse and an earlier rake, William Ashworth, there was Neptune Blood who had reduced her heart to a pile of ashes. But she had preserved her virginity through them all; she was proud of that. (And at twenty-seven years of age, a bit dismayed. Had Queen Elizabeth ever had such feelings?)

They were about to re-enter the cottage when a whistle pierced the woods. It sounded familiar, but it was no bird. They waited and it came again.

"Devin," Margaret said, and so it was. He came bumbling out of the woods, his face blackened with coal—a fearsome sight. He held up a limp and bleeding arm; his hair under the green cap was a nest of leaves and burrs. Margaret ran to him and for a moment Mary worried he might fall into her arms. But the girl only peered closely at the arm and removed a heavy sack from his shoulder.

"Attacked," he said. "Christ, but it were close, somebody must've told where we was hiding. But we had the pikes and pistols, we held 'em off by the grace of God—wounded two or three. I got hit." He looked pleased with himself, especially when Fiona lumbered out of the cottage and gasped to see him. He let her examine the wound.

"Liam," Mary said, "is Liam all right?" Her heart did a somersault in the cave of her chest. Why had he not come himself? She was afraid to think.

Devin started to answer but Fiona was pulling him into the cottage. She was tearing up an old shirt for a dressing when they entered, making him sip the brandy Margaret had brought. Devin was gazing soulfully at Fiona. When she had done bandaging the arm, he accepted a second glass of brandy, and told his story. They pulled their stools close to listen. Bridget hovered above Devin as he spoke:

"We was hiding out in the hills," he began, waving his good arm in a northerly direction, "when up come a dozen and more men from Lord K's militia—yelling and banging off their pistols in the air. They come riding down on us, God help us, calling us out to surrender. When we won't, they fire! Aye, the bastards—oh, sorry, miss. They hit Brendan Riley in the chest—we got him to

his mam's—I don't know if he'll live, God save him. They hit Tom Quohane in the neck; he'll be paralyzed for life, I wager. Liam got a bullet in the ankle—"

Bridget gasped and Devin waved away her concern. "Och, he'll be all right, he's just limping about a bit, that's all. We got two of *them* down—not dead, just down. Would they'd all died, the ba—, the rats. And us thinking we're safe! How'd they find out our cave, I'm asking?"

Bridget wailed to think of Liam's wound, and Fiona scolded. "Devin says he'll be all right, Mam, God bless him. Now stop that noise, will you?" She turned back to Devin. "That arm'll be right again soon enough. Just so you don't use it for a time." She smoothed out the bandage though it didn't need smoothing.

The bulge in Fiona's belly twitched, and Devin reached out a finger to touch. "You got a live one there all right." Did he know about James's paternity? He must, Mary thought. Bridget Donovan had broadcast news of that to all the world.

"How did they know where to find you?" Margaret leaned over Bridget's shoulder; she wanted more news of Liam.

Devin's face went grim. "One of *us* has to be the betrayer, the sneak," he hissed. "Liam suspects, but he won't tell, says he, in case he's wrong. They hate us, you know, the bloody Brits. The Kingsboroughs and that lot. They don't like it—some of us together now, Catholic fighting alongside Protestant—though the Proddies, I'm thinking, ain't the easiest to deal with. I could do without 'em, you want the truth now. But the English want us divided. They can keep us in thrall that way, aye. In thr-rall," he repeated, rolling the *r*, pleased to be using that prickly word.

Mary did not like to think of a spy in Liam's camp. Nor did Fiona: "If Liam even suspects someone, he'd best get him out of the way," she said. "Or next time it could go worse for you."

Devin nodded, gazing at Fiona. She *was* a lovely young woman. The claret-coloured hair—more gold in it than Liam's, the white skin with the tint of wild rose deep in the cheeks, the swan neck. Pregnancy became her.

Mary rose from her stool. She had to get back to the castle; someone would miss her. Polly had a habit of asking folk for her governess's whereabouts, asking even her mother, and that bred jealousy. She sent Margaret into the rear chamber to summon

George, who was still hanging over Oona, as though she might expire without his surveillance. However, she seemed a strong girl, stronger perhaps than young George, so vulnerable in his state of agitation, his rift with parents, his inner conflicts. Even he must know that his life most likely would not turn out as he desired. But for the moment he clung to the illusion.

She heard a dull, hollow, clomping sound—it might be one of the females mashing potatoes, or perhaps her own heart. But it came louder and she realized it was hoofbeats outside in the grass. Devin raced for the back door; Fiona snatched up dressings and salve, and bundled them into a corner cupboard. George vanished behind a curtain.

Margaret poured tea. They were seated quietly: Margaret, Fiona, Bridget, and Mary, when Major Cutterby stomped into the cottage in his old fashioned jackboots.

He made it obvious that he was surprised to see the governess. "I did not know you were ac-q-quainted with—" He waved his hand at the walls.

"We're here to see to Fiona," Mary said. "She is unwell, as you can see. We were bringing her a spot of brandy." The jug Fiona had brought out for Devin was still there on the floor. "For her lying-in."

The agent nodded. Though he obviously did not trust the governess's presence; she had been turning up of late in strange places. He had come, he said, addressing his attention to Bridget Donovan, about the rent.

"I know, I know," he said, throwing up his arms when she opened her mouth to protest. "Your man has passed on, your brother-in-law has ab-bandoned you." He had heard all the excuses; he appealed to the governess but her face was a stone. (Medusa, Mary thought, keeping the straight face.)

"Never," Bridget cried. "Never for the love of God would Liam abandon us. He'll be back, Liam will. You'll see he's done nothing wrong. He'll see to the spring planting. You'll not be turning us out." Her cheeks flamed; she crossed herself.

"Oh no, no, not that at all," the agent said, friendly now, taking in Fiona's belly, then flushing, and turning back to the mother. "Lord Kingsborough in his m-munificence has promised you should stay in the house. But there is a certain r-rent now in arrears.

Due *me*, that is, as agent." He gave a courtesy bow; Mary would have liked to push him onto his broad, bland face.

"You had the pork and half the tatties," Fiona snapped, taking over for her mother who was sitting with her chin in hands, overwhelmed, her lank hair falling into her eyes. "Blessed saints, and that's rent enough, is it not, Mister Cutterby?" Fiona's cheeks were full and flushed; Mary silently applauded her feistiness. The girl would probably make her way in life, even as an unmarried mother.

Major Cutterby sat down, uninvited, on a round three-legged stool. He squirmed a little. Uncomfortable, he stood up again to remove a pair of errant scissors, then rubbed a hand over his bottom to be sure there was no tear. He would make a bargain. "If you can send Liam to us. As the h-head of the household, so to speak. We would w-work something out with him. Take something out in, um, l-labour, you know."

No one spoke. Mary could feel the outrage in the air. Bridget had begun peeling potatoes with a vengeance; the skins were slapping against the walls. A peel struck Mary's cheek, increasing her fury at this honey-tongued man. "You know that's impossible," she said, rising to direct her gaze at him. "Liam will hang if he comes out of hiding."

"No, no," said the agent, with an ingratiating laugh, "why would I t-tell the authorities? Nay, that is not my business. We can have a p-private meeting. Right here, if you will. We can w-work things out, aye, he can save you from eviction. For it might, just might, I say, c-come to that. His lordship's patience will not continue forever. No indeed. You c-can trust me," he added, looking shrunken and earnest, squatting back down on his stool, holding out his hands, palms up, like a truce.

Bridget was hesitant. She wanted to trust him; one could see the desperation in the watery eyes. Finally she nodded.

"She doesn't know where Liam is," Mary said. "How can she summon him? You'll have to wait for your rent. You'll have to," she repeated slowly, glaring at him, and he flushed. He might, she thought, be a little afraid of the governess. She could intrigue, could she not, as well as the rest of the castle spies and gossipmongers?

But the man stood his ground; there was more steel in him than one might think. "If he should c-come to you, well, for any reason,

tell him I'll be here Friday next, at half after three. I'll come alone; we can meet outside the c-cottage if he prefers. Then he can go his way, s-safe."

With that he took his leave, doffing his hat, a small man with badly powdered hair and a round bald spot on the back of his oblong head.

In truth, it was not Major Cutterby whom Mary worried about; he seemed on the whole to be an ineffectual little man: mostly posturing, trying to live up to his wife's expectations as his cousin, Mrs Thorndike, had said—although that, too, could be dangerous. Cutterby wanted his rent—but was that all? It was whoever else might be waiting behind the trees, when and if the meeting occurred, that concerned Mary. Someone to run out and clap Liam in irons; take him to a Dublin gaol and hang him at once.

Again, she imagined the pale neck bent forward, the ginger hair fallen over his eyes, the tongue lolling between the full, ripe lips, the fine-boned body dangling from a tree. She wanted to run after the agent and push him down, stamp his greedy face into the mud.

But Bridget Donovan wanted the rent concerns over and done with—Mary could see the resolve in her set lips. Friday, Bridget had agreed. Friday, the agent could come alone to meet with her and Liam. Lord Kingsborough, the agent had called back to her as he took his leave, would let Liam finish the harvesting with impunity and pay the rent—which seemed to be all the man cared about.

"Don't let him do it," Mary warned the Donovans. She worried that Liam would be so desperate to do his avuncular duty, that he would appear. But Bridget's face was expressionless. And Fiona was listening only to what was inside of her. She cried out and clasped her belly. Her water had broken, soaking her dress.

Mary sent Margaret off on the run to the castle. She did not want to have to assist a woman in childbirth—she had seen enough blood and mucus at the births of her siblings. And the shouting. The screaming. One would have thought her mother was being slowly strangled by a dozen villains.

"Get Nora," Mary ordered. "She'll know what to do."

Dead as a Doorstop

M ARY'S HOPE of escape was cut off when Nora came running up the path with a sack full of birthing equipment. "Sheets, blankets, clean rags," she called out: "Rum, sugar, and tea." She grabbed the governess by the arm and pivoted her about. "Stay. The child is coming breech, God help us—I saw it this morning just. Lady K has got Margaret locked in her room—she wants the girl away from this. And won't Bridget be all thumbs and hysteria? So stay. Stay."

What could Mary do? She stayed. She heard Fiona before she saw her; the girl was shouting in Irish—all curse words, according to Nora. "She'd've picked them up from her da. My soul, but that man had a foul mouth—me own brother, but what could I do?"

The pains were coming five minutes apart. It was unlucky, Bridget wailed, this coming out feet first—"'Tis God's punishment—I knew it from the first!"

Nora shoved the birthing stool aside; it would not do, she said, for a breech. Besides, Fiona was not one to sit for long. She was stumbling about the room as if to accelerate the process. A yellow cat, great with kittens (the whole cottage seemed to be pregnant), mewed pitifully at Mary's feet; the room became crowded and fetid as women shuffled in to offer support—though in Mary's opinion they were more hindrance than help. They had come in part, according to Nora, to hear the new mother's confession: "Who sired this child? Do tell!" For it was the custom for the mother to tell all at the moment of birth.

But Fiona had nothing new to declare; it was only "James, James" she was moaning—where was James? Though she knew perfectly well where James was.

The birth was slow; the pains came further apart and Nora sent

Mary back to the castle: "'Twill take longer than I expected. And there's others to help—I hadn't thought to see them so soon. Curiosity is what it is."

Mary was quick to leave. She wanted a proper meal, time to work on her novel. The arrival of her first book had spurred her on to complete the second—she liked the heft and smell of a book in her hands. Mrs Thorndike's disdain made her want to return post-haste to England. Only the image of Liam's poor hanged body, the tortured blue eyes, had given her cause to stay on. What did it matter who killed James? One could never bring back the lover for Fiona.

For this reason she was glad to see Devin; he surprised her by leaping out from behind a tree. "Don't frighten me like that!" she cried, for in truth her nerves were jumping like crickets.

"How is she?" he asked, and she told what she could, which was not a great deal.

"It's coming the wrong way round," she explained.

He grimaced, and she thought: Devin is sweet on Fiona. But he just said: "Liam would want to know."

"Tell him she's doing as well as can be expected," Mary said, gritting her teeth when an outcry came from inside, followed by the wailing of a half dozen women who were experiencing the birth vicariously. She wanted to be far away now in case the labour had speeded up again. She was about to take her leave when for some reason Major Cutterby's brother came to mind, the one who was killed—mistaken perhaps for one of the Defenders. Her mind *was* a leaping cricket these days!

She no sooner asked the question of Devin when twigs crackled and out of the trees hobbled Liam Donovan, like a wounded owl, come to see for himself how his niece was faring. His ankle was bound in what looked like the cloth of a woman's petticoat. Who might that woman be, Mary wondered, with a twinge of envy. She caught his eye—like a blue sky after a rain shower—and described Fiona's travail, what she saw of it. Then she told him about Major Cutterby's proposition. "Don't come," she warned.

She saw the hesitation in his clouding eyes. "The agent belongs to the castle," she reminded him. "He can't be trusted." She thought of the maps in Cutterby's office, the rebel hiding places they most likely represented. "I'll help your niece, I will."

But she could not help Fiona, could she? She had promised away

her wages. She now owed Mrs FitzGerald four guineas—should she sell her blue hat? She could offer labour, but what did she know about working with her hands? She could not even sew a straight seam. She blinked into Liam's eyes; he must see how hopeless it was for them both.

He held up his hands, palms out, to show he would not be bothered by agents or worried relations. Nor did he need a governess's help, although he gave her a crooked smile. "I can take care of meself, God bless you, miss." She saw fresh bruises on his cheek, the bandage on his ankle. She was suddenly aware of how sheltered a life she led as a female, how vapid it was.

His uplifted hands were placing a wall between them. She nodded, and turned back onto her path. She moved slowly ahead, thinking he might call her back to renew the dialogue. But he was whispering now with Devin. He did not need her help.

An outcast, she trudged on toward the castle. "All right," she told the trees that were threading roots—deliberately it seemed, across her path, "you can patch up your own problems. See if I care." Nor did they, for she tripped head-over-hands into the rooty path, got up, fell again, crawled a few feet, rose once more, and finally entered the castle.

"Holy Mother of God," cried one of the maids. "Whatever've you been doing, miss?"

She waved her arm as though it were nothing at all—just a quiet walk in the woods. She limped up to her room, dropped her outer clothing on the chaise longue, and took up her pen. The writing was her physician, an outlet for her anxieties: *Her understanding was strong and clear*, she described Mary, her protagonist, *when not clouded by her feelings; but she was too much the creature of impulse, and the slave of compassion.*

She resolved henceforth to look at humankind rationally, objectively. She would withdraw into herself, like a mole into the earth; she would distance her feelings.

Let them resolve their murders and birthings and suicides without her. She banged a fist on the writing table and the ink leapt in its pot and spilled. It blotted out the word *impulse*.

WHEN an anxious Margaret begged Mary to accompany her to the cottage before breakfast the next morning, she, albeit reluc-

tantly, complied. The birthing would surely be done, the family at peace.

Wrong. She could hear Fiona bellowing, even yards away; she entreated Margaret to turn back but the girl clung to Mary's arm, pulling her forward. "I hate him. I hate James for doing this to me!" Fiona was shouting. "Hate him, hate…" the neighbour women echoed. The words rang clear and Mary hated him, too.

"Push, push!" Nora was shouting. Fiona gave a terrible shriek that brought Liam out of the woods and barging into the cottage that was filled with turf smoke and scented herbs. Mary and her pupil followed to the door, and stood behind the fellow. Mary breathed him in: the damp wool, the caked blood, the earth, sweat, and grass stains. She saw him freeze, terrified, against the inner wall and was sorry for him, after all. Men were so helpless. Fiona squatted in the center of the room, held up by her mother and Nora. The encouraging cries of the neighbour women were enough to shake the thatch off the roof.

Mary could not watch any more, but Margaret was pressing close behind, holding her captive. Another shriek brought her eyes back to Fiona and she saw the babe bowl out feet first, wrinkled and red, into Nora's arms. Instead of placing it on the exhausted mother's breast, Nora wrapped it in a blanket and carried it at once behind a curtain. Mary thought she heard it cry, but the women were making such a racket, shouting and shrieking as though they, too, had given birth, that no other sound was audible.

Nudging Margaret aside, she went outside. No babies. I shall have no babies of my own, she told herself over and over as she hurried back to the castle.

SHE awakened that night, bathed in perspiration from nightmares of birthing. Once it was her own lie-in: the midwife could not get out the afterbirth and her insides were slowly turning to rot. Outside the wind was howling and a heavy rain was battering the windows. It was an hour before she could fall back to sleep.

It was still windy as she woke, but she was alive, and she had missed breakfast—she had only an apple to eat; she was still savouring it as she entered the schoolroom. The girls arrived for a geography lesson in Italian and mumbled the tedious text: *L'Italia e una penisola dell'Europa meridionale, situata nella parte centrale del*

Mare Mediterraneo. The lesson was dull, the governess too weary, too hungry to brighten it up. But she forced herself to concentrate.

She blocked out Fiona and her ill-begotten child until at the end of the lesson a maidservant screeched, for all the world to hear, "It's got drown-ded!" The girls rushed past Mary's frown and out the schoolroom door to hear the latest news.

Then back they came, like a retreating tide, when the Cutterby appeared and shut them in with the governess. "A kitten, that's what it was," Carrie said in her positive way, "I saw Cook with it yesterday. It got born with two heads and Major Cutterby drowned it."

Holding back her nausea, Mary set them to writing a passage of Italian fifty times. When they complained: "Just do it, I said. Now write, write!" She sat at her desk, head in hands, grateful for a short respite from teaching. The kitten struggled in the water behind her half-closed lids.

<center>❧❦❧</center>

"WHAT—who's drowned? Speak sense, girl." Caroline went into the hall in her dressing gown to quell the disturbance. She had a headache: something like a fist was squeezing her brain, letting go, and squeezing again. She hoped it was not a tumour—though that, too, might get her away from this place. Anywhere, just away.

"Answer me. Who was it drowned?" Her hands clutched the maid's bony shoulders; the girl reared back.

"Why, the baby, madam, the one that Fiona Donovan, the tenant's girl what was got in a fambly way by poor Mister James, God rest his soul, what got stabbed after being—"

"What? Stop stammering and sit down!" She shoved the maid down onto the bottom step of the staircase and planted her legs on either side of the terrified girl's feet to keep her in place. "Now start at the beginning, girl. What of the baby?" She recalled a baby—yes, the Donovan girl's baby. But what was this nonsense about a drowning? What did it have to do with the castle? Oh! James, yes. She held on to the bannister; she was feeling faint. "Gladys!" she shouted at Mrs Cutterby. "Find out what this drowning is all about. And then have someone bring a pot of chocolate to my bedchamber."

The agent's wife stepped up to question the maid; the woman loved a confrontation. Caroline only kept her on because Robert needed the agent for his dirty work. The woman buttonholed the

frightened girl: "How is the mother? Where did they find the child? Who would have drowned it?"

The maid stared at both women, open-mouthed. Too many questions. She was struck quite dumb.

"Speak up," said Mrs Cutterby, shaking the girl. "Answer your mistress."

Slowly, the girl found her tongue and then it came out in a torrent of words. "Oh, Fiona is well enough; sure, and she's lost a deal of blood. But she's beside herself now, I'm saying, for the babe is got itself drown-ded. I'm a neighbour, I heard the news this morning just." She made the sign of the cross. "Me mam was there at the birth. 'Twas a terrible hard one, says she, and now nothing to show for it at all, at all."

The girl started to cry. There was no getting any more out of her. Caroline was desperate for her chocolate. "It did not drown itself," she told the agent's wife. "Find out who did it and then come up and tell me. No, never mind—I'll speak to Robert. I can't take any more death leaps or stabbings or—*aughh*!"

Caroline left the girl weeping on the steps, the agent's wife slapping the girl's face to make her "stop whining," and went in search of Robert. When the footboy came sliding down the bannister, she battered him on the wrist with the key to her rooms.

The door of her bedchamber was wide open. Her husband, in his riding coat, was leaning in the doorway. He was holding a manservant by the sleeve; he was giving him orders.

"You are not to bring a constable, Seamus," he was saying. "The child was probably stillborn. They drown them sometimes, those peasants, it's not unusual. I've seen it happen."

"What is it, Robert—who drowned it? Was it the mother?" Oh, why was Caroline the last to know what went on around here!

Robert was not in a good mood. A late night, she expected, and a morning hangover. His eyes were rimmed with red; his face was unshaven—he was most unappealing with all that dark fuzz on his face.

"If you would get up in the morning and see to the household," Robert said, "you might find out."

"I woke up with a headache. And not from wine. Or *ale*." She shoved past him and into the chamber.

He waved away her headache. "How the deuce do I know who

drowned it? I wasn't there, was I? It was an accident, I'm telling you, and that's final."

"How could a newborn have an accident?" Caroline shouted back. "Did it crawl to the river?"

The servant cleared his throat; he was still waiting for his order. A constable, her husband had said? Caroline's head was suddenly clear. Of course Fiona would not drown her own child. Did he think a peasant girl was little more than a pig—incapable of love? She wheeled about to confront him. She was suddenly furious; she heard Mitzi growl, her loyal Mitzi.

"Damn you, Robert, it could be one of ours and you'd say it was 'just an accident.' If it was drowned, why then it was deliberate. You don't know it was stillborn, you just assume that. Seamus, fetch the constable at once. It has something to do with James's death, oh I know it. It was his brat, we all know *that*. I warned him to stay away but he would not, he was too hot-blooded. Now look at the mess he's made. Someone has to find his killer or we'll all be murdered in our beds!" She glanced, huge-eyed, at her rumpled bed where two dogs lay peacefully snoring. She longed to be there among them, away from these awful deaths.

"No constable, Seamus," her husband said. "So leave us please. And that is the final word." Robert was scowling—very apelike, yes. Obtuse.

She snatched up a slipper the colour of her anger and hurled it at his face. He ducked; the servant caught the shoe and stared at it. She was convinced now that the child was killed—did not Margaret hear it cry? Yes! It all came back to her now. It was born and Margaret heard it cry, the girl said—she had deliberately disobeyed and gone to that cottage. Where was the girl, anyway? Not at her lesson, for outside in the hall the governess was sneaking past, with George in her wake. Now what had that female heard?

Caroline lowered her voice, but spoke firmly: "Seamus," she said, bringing her hot face near his. "Send a constable at once to the Donovan place." When he didn't move: "Do what I say, Seamus. Go, damn you! And what are you doing with my red slipper?"

<center>❧❦❧</center>

MARY found Margaret at the library window, her face pressed to the glass. The girl had sent George to summon her teacher after the lesson broke up, but seemed unaware of her teacher's presence. Be-

hind her, looking down, Mary noticed how geometrically the gardens were laid out. The hedgerows of barberry, privet, and juniper divided herbs from roses, roses from asters, asters from the ferns and ornamental grasses, her favorites.

Order was the word in nature, something Mary craved in her life now. Not drowned babies, but order.

Margaret turned, her eyes wet. "He was alive and crying, Oona said, when she went to sleep. And I heard him, too. Then sometime around dawn Fiona woke to find her baby gone! She won't stop weeping, Oona says."

The girl could add little else except that the small body had floated up against a log. "He had a stick tied to his leg, they said, to keep him down in the water. But the log forestalled him."

"Who found him?" Mary asked.

"One of the grooms," George said, coming into the room. "He was breaking in a new colt down on the river path. He saw what he thought was a turtle trying to climb on a log and save itself, but it was the baby. It was floating—"

"He, it was a *he*, not an *it*," Margaret cried.

"*He* was floating back and forth in the current but got stuck there. Dead as a doorstop. All bloated. All purplish."

"Oh, George."

"But it was. You asked for details and I'm giving them; you're too soft. It was—"

"Enough!" Mary said. "The poor girl must be in a terrible state. To go through the torture of childbirth and then find the fruits of her labours, spoilt. But we must go and comfort the family."

"We've already been there. Just this morning, before breakfast." George fanned away the suggestion with a broad hand. "There's nothing anyone can say, Fiona won't hear it. The house is full of wailing women—you can't imagine how awful it is—all that popish praying. I tried to get Oona out of there but she won't budge. She won't even look at me. So I left. I'm not going back. Not for a while, anyway." He crossed his arms and sighed.

Mary was relieved, actually. She did not want to hear the uncontrollable weeping. When her mother died she had held her tears, even though they were welling up at the gates. Her father made a fuss and then went on courting his second wife—the one he had begun seeing while her mother lived.

She picked up her sack of books and prepared to leave the library. She was not sure why she had been summoned here, except to hear a few sordid details about the dead baby. She did not know why he had drowned, but conjectured that he died in the night and they did not want Fiona to find him dead.

She was at the door when Margaret said, "I saw Liam. He had slept in the woods, he and Devin, but heard nothing unusual—no baby crying, no one running off with the child to the river. He was on his way back to the mountains. He only came out of the woods when he saw it was me. He wanted to give me a message for you."

A message from Liam? Mary clasped the books to her chest.

Margaret gave that sly smile of hers. She read the governess's interest all too well. She let Mary wait a moment. Then she said, "He'll be there Friday. To speak to Major Cutterby—Mrs Donovan persuaded him to. He wants you to see that the agent comes alone. He doesn't want any ambush. We'll help, George and I," she said when she saw Mary's dismay.

"I have no influence with Major Cutterby," Mary said, irritated now. "I cannot keep him from summoning the entire militia. They could be waiting in the woods, for all I know. I warned Liam. I told him not to come."

"It's for Mrs Donovan," Margaret said. "Liam *is* the only male in the family."

"Then he's taking family duty too far. Why, it isn't fair of her to ask this of him—he's not her husband! If Liam is recaptured she won't have a brother-in-law. Has she thought of that?"

"If he doesn't help they won't be able to pay Cutterby's rent. And then the family will have to beg in the streets." The girl sighed and Mary held out her empty palms. She could neither deter Liam nor keep the land agent from bringing others.

She thought again of Major Cutterby's brother. The dead man simmered at the edge of her mind, as though that killing might have a bearing on one of the castle deaths—she would ask Devin when he reappeared. Or on the drownings. For the hundredth time she pictured Sean Toomey's body plummeting into the sea. Three deaths now. No, four. Although Eva's suicide had been resolved in her mind, had it not? It was the poet, G.D. Ogle, who ultimately caused that tragic leap from the roof?

Ah, the poet. She had questioned and questioned him and he

remained as elusive as a fly one tries to swat in flight. But Mr Ogle, she reasoned, was a privy councillor: she ought to ask him about the agent's dead brother—how it happened, and why. Yet what dead brothers or suicide leaps or fallen sailors had to do with Major Cutterby's mission against Liam she could not fathom. Certainly the agent did not really want to *help* the Donovan family.

So. She would have to go, after all, to the Donovan cottage—if only to find Liam and Devin. To see if they were still close by in the woods, although that, too, was sheer folly. Lady K might prevail in the argument with her husband that Mary had just overheard, and send a constable.

Unless, she conjectured, they were so concerned with Fiona and the drowned baby that they wouldn't leave the grounds—not until they were certain no harm would come to whoever *did* drown the child. But who? She could not think of anyone who would want to drown an innocent babe.

"I'll do what I can," she said, feeling herself a martyr—after all, the young Kings could not expect the governess to bring down the stars for them. She shrugged as she took her leave.

MARY ventured a short way into the woods behind the Donovans' cottage, humming out loud; the bushes parted and Devin's bean-pole body emerged. She plucked a late wildflower, something brilliantly blue like butterwort, and breathed in its earthy fragrance. The air was clean and fresh after last evening's shower; the aroma of turf smoke rose from the cottage chimney.

"How is Fiona now?" she asked, though the question was pointless. One could hear the primal keening inside, Fiona's voice rising above the rest.

He shook his head. What could anyone do? Mary had warned him about the meeting with Major Cutterby; she urged him to change Liam's resolve. Then she explained why she had really come: "To ask you and Liam a question."

He glanced sideways at her; his mouth hung open, revealing a chipped tooth. He was tense, like a hunted rabbit, ready to leap.

"I wish to know about Major Cutterby's brother. The one who was killed in the street. Was it some kind of mistaken identity? Or was he one of you?" The breath she drew in stabbed at her lungs.

Devin retreated a few steps. She breathed in the greenwood again, although the copse was more yellow and brown than green, and the new trees not yet full grown since the ravaging of forests by the English—to build their ships and warm their houses.

"How would you know about that?" Devin asked. He sounded breathless as though he had taken a hit in the chest. He leaned back against an oak tree, trying to look casual.

"He was a Defender? A patriot? Or a spy?" Mary was still guessing—she didn't know where she was heading. She felt a bit light-headed, to tell the truth. Back in the castle, she thought, tea is at this moment arriving on its flowered tray, along with a biscuit or two. An Englishwoman had no place here in this Irish copse of intrigue. A pox on her ungovernable curiosity! Yet her feet were rooted to the spot; her head craned forward for his response.

"Aye," he said with a shrug, "wasn't he a spy then? The fellow had one of our leaders killed with his nasty tricks. So we—we bid him farewell." He let go a nervous giggle. "Ah no, miss, no, it were no mistake, surely, no mistake he were killed." He picked up a loose stick, as though he would like to strike the traitor all over again. Although he was too young at the time, Mary thought, and had doubtless only heard about it from his elders.

"He was Willard Cutterby's twin brother. Richard, I believe."

"So?" Devin rose to his full height, defiant; Mary had to look up. His yellow hair had a cowlick right in front, dividing the hair into a central parting that was quite unattractive. Where, she wondered, was Liam?

"Twins are close to one another," she said. "Killing the brother could make the living twin do something he might otherwise not do." She thought of how quiet the land agent appeared, how unassuming. Though it was often the quiet ones, she had discovered, who would brood for months in their chambers, and then one day...

But why would the agent kill James? Major Cutterby had less reason, as far as she could see, than Liam. Liam, who hated James for what he did to his niece.

"'Twas James King killed Richard Cutterby." It was Liam now, limping out from a grove of young ash trees. The blue eyes narrowed as though Mary had voiced her thoughts.

"Aye, King wanted us to think he was on our side," Devin said. He was still holding the stick, whacking a pile of leaves with it.

"But he wasn't really?" Mary was confused. Neither man answered, and she guessed they didn't know either.

She stared back at Liam, who was smiling now, a bitter smile. "Let the bloody agent come," he said. "I'm not afeared of him. Don't I owe it to me family?"

He swaggered a little as he spoke; he looked for approval at Devin, who grinned back. Mary was reminded of her youngest brother, Charles, when he was small, and determined to bring a bullying neighbour lad to heel.

"Go then and meet him," she said to Liam, as she had said to her brother. She added, "And then let them hang you. *I* cannot keep the enemy off."

Masquerade:
Don Quixote Meets his Match

THERE WAS to be a masked ball that evening. Lady K insisted that the governess join the guests, but Mary had no appetite for it; she was too consumed with the thought of a meeting between Liam and Major Cutterby. She had lain awake nights dreaming up Machiavellian scenarios. So she told Lady K that she was indisposed. But milady was like an ant you brush off, yet it crawls back on your shoe. This time it was the loan of a black domino, a loose cloak with a mask for the eyes; never mind it drained all colour from Mary's complexion.

"You've been too serious lately," Lady K said, filling the governess's doorway with her scented self. She was in one of her charitable moods. "All this thinking is not good for the nerves—believe me, I know! Have a care now for yourself and eat stewed prunes. My physician recommends them. I've put an order into the kitchen for them."

Mary eschewed prunes, as they turned her bowels to liquid. But the mistress was trying to be pleasant. In all likelihood, she had noticed how cool the governess had become with Mr Ogle; she felt, perhaps, that Mary was doing it for her sake. And Mary had learned how to play the game: she promised to try the prunes. She would wear the unsightly costume, though she had never been good at disguises. She took it from Lady K's extended hands and curtsied slightly whilst milady fluttered a Chinese fan and smiled her superior smile.

An independent woman, Mary told herself, turns adversity into fortune. A masquerade might, after all, prove useful. Mr Ogle would be there, and the Cutterbys. And so would Lord Kingsborough. Mary had been trying her best to avoid her employer, yet he was torturing her mind more and more of late. He, like Major

Cutterby, feared a peasant uprising—had he not invented that cruel device to spill tar and gunpowder on the rebel heads? James was milord's blood relation, yes, but James was a turncoat, a rebel himself. And a Catholic.

Or was he a duplicitous rebel who worked both sides, according to whim? Lord K had seduced Eva Noonan—that was a fact, whether he *caught* her or not. He was, it appeared from her journal, her first seducer: a malefactor who, in Mary's opinion, scarred the girl for life.

Or as it turned out, for death.

As for Fiona's drowned babe, one could not connect milord with that—except that James was the father. His lordship would not want any natural offspring demanding money, would he? He had barely escaped Eva Noonan's needy arms. Had he given orders to one of his men to drown the newborn?

So the governess attended the castle masquerade. The ballroom was crowded with sultans and sultana queens, milkmaids and gypsies, chimney sweeps and shepherdesses. It reeked of perfume, scented shaving soap, tobacco, wine, and sour breath. There were tall men dressed as ladies, silly and awkward with fans; tiny, plump women crowned as knights, with paper swords stuck under their fleshy arms. *Do I know you? Do you know me? Who are you?* Bland salutations, foolish banalities uttered in squeaky voices.

Ridiculous. All of it. For the Kings and their aristocratic cohorts, Mary thought, all life is a masquerade.

She squeezed through the throng in her hooded domino. A masked Quixote approached: on his head an iron pot that made him hold his neck rigid. He wore a shiny sword at his side—it gleamed sharp in the torchlight. He was both ridiculous and dangerous. It was Major Cutterby; she knew him when he spoke. She liked the fact that she knew him and he did not know her. She stared at him through the slanted eyeholes of her mask.

"How are you tonight, madam?"

"I am well, aye, sir," she dutifully replied in her false voice, swaying a little on her feet. "Are you looking for an evening's conquest, sir? If so, sir, you might try yon milkmaid there." She pointed to a robust middle-aged woman with a coiffure that might pass for an outsized jug of milk. It was Mrs Cutterby, of course; there was no mistaking that lusty, over-age wench.

Don Quixote frowned. The masked milkmaid appeared to be flirting with a round-bellied Falstaff.

Mary tapped his arm to bring him back to her black-cloaked Dulcinea. She would ask questions without revealing her identity.

"A child has drowned," she said, lisping a little. "Is Don Quixote going to avenge it? To discover the villain perhaps? Don Quixote is out to save the world, is he not?"

He gave a little gasp, as though she had stepped hard on his foot. Then, "Ah," he said, "a terrible thing, m-monstrous. Aye, surely I must investigate. M-my windmills—"

"Are still spinning, aye, sir." She was not going to let him distract her. "But this child. 'Twas James King's child, I believe. Was it not, sir?"

"Um, *sí, sí,*" he said, remembering he was supposed to be a Spaniard, "most unc-conscionable, aye, uh, yes, um, *sí*. I am sorry for that poor m-mother."

"So am I, sir. So are we all. James would not have liked it. Do you think it was drowned by the one who killed James?"

He drew back, startled. A red-masked Lucifer danced past and brushed her thigh. "Why, as to that, m-madam, why, I've no idea. Who could know?"

"The one who drowned it, I suppose."

"Oh. Why yes, a logical thought, aye. Um, *sí.*"

"It is only right, sir, that James King should have been removed from the scene, is it not?"

"Hmm? What? What do you mean by that?" Don Quixote was fidgeting now, twisting, in an effort to avoid his partner. She placed a firm hand on his wrist and pressed down.

"I mean, sir, that James was a killer himself. They say he hit a man with a club. From the back, in cold blood. It was, um, oh dear, what was his name? Um, Richard, I think, yes. I cannot bring the surname to mind. Though I do recall it began with a *C*—something like your own name. Could it be—your relation, sir?"

He stood perfectly still, his body slightly angled, one arm lifted, the fingers of his hand like a rake, as though he'd had an apoplexy and could not straighten them out. Mary waited. She was sorry for him, but she required answers. And they came, though not in words. The lower, unmasked part of his face turned slowly pink, then bluish, then blue-black. He was virtually baring his teeth,

the fingers curling into fists. She saw the shiny knucklebones; saw his body, under the foolish costume, begin to shudder. The pot tilted on his head. Then, as the head shook more violently, it clattered to the floor and he crashed down on top of it. People turned to stare; there was an audible "Oo-oooh..." Mrs Cutterby hurried to him.

"Get up, Willard. Up, I said, at once!... It is so unlike him," she told the masqueraders who had circled about his prostrate form. "Water!" she shouted at a footman. The footman rushed the iron pot into the kitchen. A few minutes later he was back with it; he flung water on the agent's face.

Mary stood by, contrite. She had not expected such a violent reaction. Saliva dripped from the major's tongue, which his wife had pulled out of his mouth to keep him from swallowing it. Undoubtedly this type of seizure had happened before. Yet Mary felt it was her words that had brought it on. Twins were indeed soulmates. She tried to imagine how she would feel had someone murdered her twin, had she had one: her other self, her other sensibility. Or even one of her sisters, different though they were, and her nails dug into her palms. She would want to strangle, shoot, disembowel, drown the enemy.

Slowly the man came to consciousness and was carried to a settee. Already his humiliated wife had gone back to her Falstaff. What little appetite Mary had for the masquerade was gone. She started out of the ballroom, but was stopped by the masked Lucifer. Garbed in red, pitchfork in hand, he loomed large, arrogant, dangerous. He blocked her passage.

"Surely you're not leaving, madam. The festivities have barely begun." He smiled seductively under the mask; black hairs prickled on his chin. He would make the evening interesting for her, the smile said.

Mary tried to brush past him. Up in her chamber she had a new book to read: Mrs FitzGerald had lent volume one of "a wonderfully clever novel," *Caroline de Lichtfield*. Besides, she did not need to talk to this man; she might have found her killer, Major C—she had only to verify his guilt. This was not so simple, but somehow she would extract a confession from him and be done with it. She would finish her term here, and ah! return home to her beloved London.

But the devil had her wrist; his fingernails bit into her flesh. "Madam," he whispered, "I was nearby when you interrogated the agent. Zounds, here's the devil's own soulmate, I thought. I could not have done better myself. I didn't know it was James who killed the man's brother. That does paint a new picture, does it not?"

Mary tried to pull away, but his fingers held.

"It would give Cutterby a motive for killing James," he went on in his baritone. "But then how do you explain the fact that he and I were at the game table the night James died?" Now he dropped the false voice, for of course she knew the man. The role of Lucifer was no disguise for Lord Robert Kingsborough.

"All evening long, milord? There was not a half hour when one of you left the table to—well, there are many reasons for leaving a table," she allowed, trying to be discreet, though discretion, she knew, was not one of her talents. "And if it please you, sir, I would like my wrist back. Your nails are boring holes in my flesh."

"Ah," he said, blinking coyly at her: "And you've already holes enough in your flesh, have you not, Miss Wollstonecraft?"

She disliked the sexual innuendo; she pulled away—then took a stance. "You did not answer my question, *sir*, about the half hour away from the game table. I returned from the Samhain festival, and saw only ladies at a card table. You yourself, *sir*, might have been on the path to join the celebration. Or to eliminate one who was enjoying himself?" (She heard her voice rising shrill.) "To whitewash the family name? Keep an overt affair from being broadcast about the countryside? Avoid an offspring of this illicit union whose mother might, like your former governess, come one day to—"

The hand was back on her wrist, twisting hard. She cried out. He was still smiling. "You were hired to teach my daughters," he said, all business now. "Not to act as constable. After the holidays I think, we will reconsider your contract with us. Already we have had letters from a French governess. A young Parisienne, with an immaculate tongue."

He let go her hand and she stumbled up the staircase. Standing under *The Rape of Proserpine*, she wanted to scream but held back. She reached her bedchamber without mishap, and dropped down on the bed. She lay back, stunned; rubbed her wrist that had swollen to a pulpy red. The man could kill to save the family name, she felt, with little remorse. She understood, too, that sooner or later

she would be dismissed from her post, despite what she knew about the family—what she would tell others.

But she would leave, she vowed, *before* she was dismissed.

FRIDAY came, with the promised meeting between Liam and Major Cutterby, and she had devised no plan. She could only set Margaret and George to spying on the agent. It would be easier for them than for her, as the agent had assiduously avoided her since their masked encounter. Through his wife, she supposed, he had discovered it was she in the black domino. He would be aware that she had certain information on him—information that could endanger her own life. When they accidentally met in the outward room after breakfast the next day, he veered about and ran straight into the arms of the incoming Mrs FitzGerald. The latter was stunned—Mary smiled at her friend.

He did not suspect Margaret and George, however; he seemed merely annoyed when they continued to bump into him in their amateur spy game. At last Margaret reported that the agent was preparing to leave the castle. From an upstairs window Mary watched him stalk off in his brown cloak and jackboots. He cut a sinister figure from her point of view, although she could see the balding pate when the wind blew off his hat. He had only recently adopted the new wigless fashion.

When the agent disappeared into the herb garden and George and Margaret followed him at a cautious distance, she worried. She slipped down the stairs herself and out into the chill December air. She could not trust their immature judgement—and she was anxious for Liam. It was half-past three, with the smell of rain in the air; a snowflake drifted past. So much the worse, she thought, since any number of militiamen could be hiding in the shadows, alerted by the agent. Something sour settled in the pit of her stomach and made her footsteps heavy.

Near the cottage her hopes rose for a moment when she spotted Major Cutterby. He was alone, and glancing about with annoyance. She thought, ah, Liam has had second thoughts—he won't come after all. Bridget Donovan peered out the door but popped her head back in when she saw the frown on the agent's face. He took off his cocked hat, then slapped it back on again, hard, as though that gesture would seal it to his head against the wind. He was an

impatient man, Willard Cutterby. Perhaps—Mary hoped—he just wanted to get back to his quiet candlemaking.

All at once—oh! The bushes parted and Liam stepped out of the copse. Mary looked about for an invisible enemy, but saw no one. She would not rest easy until the interview was over. Hidden behind a growth of oak leaves, she exchanged glances with Margaret and George, who were crouching nearby. Wild berry vines crept around Mary's ankles, as if trying to hold her fast; she stamped on them, then held her breath when the agent peered in her direction.

Snatches of the quiet colloquy between agent and outlaw blew toward her on the wind: "Defenders...hiding place...rebel names... America..." The agent, no doubt, was demanding that Liam and his men cease their activities. It is a threat, she thought; it suggests that unless he conforms, the Donovan family will be evicted. The word *America* came again to her ears, and she wondered if the agent was offering the family a reward, an escape—a passage to that new world in exchange for information. Of course Major Cutterby could not say how the family would sustain itself in the wilds of that land. And Mary had heard stories of kidnappings and scalpings. She could not wholly believe in Rousseau's noble savage. Nor could she blame the American Indians, with the white man appropriating their lands.

No, she did not trust this Willard Cutterby. His lips smiled, but his eyes were cold. His hands clawed at the cloth of his breeches; the man was agitated. Did she see him glance off into the woods? Were Lord Kingsborough's men hidden there? Margaret was looking about, twitching at each crackle of leaves. George, too, was on the alert: he had a pocket knife in his hands; he was nervously pulling it in and out of its sheath. Mary wanted to embrace him for his loyalty. But what help could a boy with a pocket knife give Liam in the face of an armed enemy? Then, too, George wanted to *join* that militia. He was only helping Liam out of loyalty to Oona.

It was hard to tell what Liam was feeling. He glanced once or twice at the cottage where his sister and nieces were waiting, no doubt with hearts thudding as quickly as her own. Once he nodded in Mary's direction (did he see her?) and her heart skipped a beat—was he giving in to the agent? His face passed in and out of a dozen expressions; he was going through a crisis of indecision.

He wanted to help Bridget, yet remain loyal to his men. Which was more important to him: family or country?

"Sean," Liam suddenly cried, and spat on the agent's boots. The agent jumped back—he was a fastidious man. Liam made a threatening gesture; he was on the offensive now. Mary thought him beautiful standing there in his defiance, arms akimbo, his hair tangled in the wind, his face a volcano, threatening to erupt. He shouted out names and facts; pointed a finger at the agent. She caught the words "Toomey...packet boat...stabbed..."

Ah... So it was Willard Cutterby who had killed Mary's young sailor—or arranged it? She let out a whistling breath. Yet it was plausible. The agent despised the Defenders who had seduced his twin brother—and when Richard betrayed them, they had James kill him. James was loyal to the Defenders—Mary felt it to be the truth. Devin's only complaint was that James had not, for some reason she would never know, delivered the sought-after guns.

Liam was shouting in Irish; he was taller, stronger than the agent, in spite of his bad ankle. He began to box at the man, jabbing at his nose, his chin, his chest. Major Cutterby backed off but Liam grabbed him by the throat. The cottage door opened and the women poured out, shrieking in Irish and English all at once:

"Leave off now, Liam, 'twill do us all in. Let him go!" Bridget screeched, and Liam gave a final shove that knocked Cutterby to the ground. He dashed back into the woods as though he had never had an ankle wound. Mary glimpsed a flash of Liam's face as he leapt a bush. The agent pulled himself up and stood a moment, panting for breath. Then with a trembling of the head and shoulders, he stumbled away.

Mary clung to a tree but as he came close he saw her; his big moon face peered horrified into hers as though he had seen a ghost, and she shrank back into the scrub. Margaret and George scurried to the cottage after the others but Mary pressed on, taking the river path toward the falls. Though the sun was beginning to set, she needed to clear her head. The rush of the falls was magnetic. She thought of Odysseus' sirens, luring him onward. It was starting to rain; she tripped over a small rock and muddied her dress, but she kept moving.

She was glad to have heard Liam's defence: she knew now about

that killing on the packet boat, but to what effect? She could only tell the authorities what she had overheard, and Liam could not come forward to avow it. The agent would distrust him more than ever: the rebel knew too much. She tried to put herself into the major's head but could only hear the words, "Hang the fellow."

Now she was sorry she had earlier mentioned hanging to Liam. Once again her mouth had gainsaid her heart.

She slipped again as the rain came harder; she clung to a branch. It broke off and she fell. A hand yanked her up, then lifted in a threatening manner. It was Major Cutterby.

"You followed me," she said. Foolish words, but they were all she could think to utter.

He smirked. He was no tidier than she in his soaked breeches, the torn neckcloth where Liam had grabbed him, the muddy jackboots. She was afraid, though; he knew she had heard incriminating words. The cocked hat sat askew on his head. She thought of the biblical Samson and his hair, without which the Israelite was nothing (for once her mother's Bible reading was useful). She snatched the hat and hurled it at the river; it spun down the falls like a tiny unmanned vessel.

The act infuriated him. He stood a moment, one hand on his balding head, as though he might weep in his fury. Then he lunged at Mary and shoved her down toward the river, near the falls. Would he push her in?

She slipped on a wet rock. The rain thundered down—or was it the falls? She was on her backside; he was standing over her. She was humiliated. She scrambled up to face him. He had one foot on the rock that felled her.

"You'll be brought to justice!" she cried. "I was not the only one who heard. There were others." She did not say whom; she did not want him accosting the young people. "And we'll tell, oh, indeed we will. You killed Sean Toomey—or hired someone to stab and drown him, a fine young man with—"

"A young rebel," he bawled. "Running guns like the rest. They k-killed my brother. My men'll follow them, they were there in the w-woods—you d-didn't know that, did you? No, hee-hee. They'll find where those rogues are h-h-h—" He couldn't get out the word in his fury.

He reached out his hands to grab her; he gave a crazed laugh

that tilted him sideways on the rock. She seized her chance. She was wholly exhilarated. She had never felt more able. She gave a shout—a push. He shoved back—*"Ha!"*—then shuddering, losing his footing, he pitched off the rock and into the roiling waters.

He couldn't swim. She saw that at once. The current was hurtling him toward the falls. He floundered and choked and bellowed, and frightened now, she threw out a branch. She did not want him drowned; she just wanted him brought to justice. He grabbed for the branch but missed. It went sailing on down the falls, himself after it. She watched, helpless, as the balding head spun along in the foaming water, disappeared, then came up sputtering. He landed at the calmer bottom and caught on a log. He floated, one gaunt arm draped over the log, his head barely above water. At last he came ashore; he lay there, his eyes staring at the darkening sky. He lifted an arm....

Alive, she thought. Ah. Thank God.

She ran back to the Donovan cottage. Nora shrieked when she saw the governess in the doorway, a drenched, wild-eyed figure. She hauled Mary in like a wet fish and applied a dry cloth to the soaked head; she rubbed and rubbed until the governess cried out for mercy. Mary heard a familiar laugh: "Look what the cat pulled in," Margaret said.

The girl stopped laughing when Mary choked out her news. "Someone had best go after him. Send for a man—two men—with a light. No, not you, George," she said when the boy went for the door.

Nora sent Oona to fetch a neighbor. Fiona was in no condition to go herself. Her face was white as new milk; she had lost a deal of blood from the birth. The shock of the drowned infant was still on her face. She had lost James for good now.

TWO of the tenants brought the agent into the castle—Mary saw them from the window of her bedchamber, where she had come to change her muddy gown. She went to the staircase and started slowly down. Below, Mrs Cutterby was screeching like a banshee. One would think she cared for her husband. Perhaps she did, though she seldom showed it. The woman had a new headdress that resembled a windmill; it knocked a chandelier askew as she moved. It seemed not only a symbol for her intrigue, the way its

arms circled the air, but for the giants that her Don Quixote had fought in vain.

Mary looked hard at her. It is Mrs Cutterby, she thought, at the heart of her husband's malice—perhaps the instrument of Sean's and James's deaths. Or at least the instigator. After all, she, too, had set her headdress for James, and was repulsed. A reason for revenge, that?

Willard Cutterby was alive, yes, but babbling. He might have had an apoplexy, or lost his mind. Or both. Lady K scuttled down in her red slippers and sent a footboy after the physician. The man came post-haste, along with a bag full of leeches, snail tea, and horse-dung possets to cure the madness. Nothing availed. Major Cutterby gabbled on about water, rents, rebels, Armageddon. "Tha' governess—a dangerous female!" he muttered. "Ge' rid of her...."

He would have killed me in his rage, Mary thought. He might yet try. She excused herself to no one in particular and ran back up to her chamber.

She was too fatigued to read the four letters from her sister Everina, who had finally directed them to the right place. She did read a note from Mr Ogle, who was being very careful with her now. He did not want her talking in front of the others, particularly Mrs Cutterby. Don Quixote–Cutterby, Mary decided, was more than just a fool. A small man, he harboured big hates. Still, the man Mary saw lying on a settee, babbling and drooling like a new baby, was now little more than the shell of a man. The river had avenged the death of Sean Toomey. Just as it had swallowed up James's seed.

But if Willard Cutterby was on his back, his mischief was still afoot. With all the excitement, Mary had forgotten the men whom the agent had summoned to bring Liam into custody. They were to surprise the whole band of rebels, she had later discovered—that was why they had waited to follow Liam.

Once again she left her room to run down the steps—and straight into Lord K, the Cutterby, and half a dozen guests. "They have him," his lordship cried, his neck arched above his pristine collar, his face flushed with pleasure: "They have caught James's killer. They have Liam Donovan."

To be Hanged by ye Neck at Dawn

LATE THAT night Nora burst into Mary's room. She hovered over Mary's writing table; she could hardly contain herself with the story she had to tell. A dozen militiamen had followed Liam to the rebel cave in the foothills of the Galtees Mountains and surprised him and others as they ate their rabbit stew. "'Twas no ordinary rabbit, miss, but one Connor Ryan poached from his lordship's game forest—a double blow for the Defenders."

"Ah," said Mary, and laid down her pen.

"They took four of our men, miss, but Devin, God bless him, got Liam out through a rear opening in the cave afore the devils could catch him."

"Thank heaven," said Mary. "But I thought he was—"

"Then one of the devils," Nora rushed on, "went round that way to relieve himself—imagine, can you, the terrible luck? And there was Liam, like a lost sheep." She broke out in sobs that flushed Mary's heart up into her throat.

"And then?" Mary waited, kneading her fingers, for the rest of the tale.

"Me brother fought back," said Nora, who had heard the story from Fiona, who heard it from Devin: "They took him with two others to the Mitchelstown gaol. They'll take him from there to Dublin, to a place he'll never in this whole wide world get out of. And—" she choked out, "that'll be an end, surely, to our Liam."

Mary thought of the winsome face, the intense blue eyes made bluer in absence; she handed Nora a handkerchief and sank back, stunned by the news. There was nothing to do then. Liam was as good as dead. Did his sister-in-law know? Undoubtedly so, if Nora and Fiona knew. How would Bridget carry on without her man?

And what could Mary do? She felt as helpless as that baby coming breech into a world of misrule.

What did it all mean anyway? Did anyone care that a baby drowned or an innocent man went to the gallows? For now she was wholly convinced that Liam was innocent.

She shifted the talk away from the subject of Liam—she could not bear to think of him back in captivity, like a trapped animal. Instead she asked Nora about the baby; it was the first time they had talked since the infant's death. "Tell me, how did it come to drown?"

Nora turned her head away. "Someone took it, is all. It happens. 'Twas sickly from the start. It didn't make a sound the first twelve hours. I knew surely it wouldn't live, though I didn't say that to Fiona."

"But I heard it cry! I'm certain I did—did I not?"

"It would have been the cat you heard—she had her kittens that night on Pegeen's bed." Nora gave a nervous laugh and said good night before Mary could ask another question. She glided ghost-like to the door in her soft green slippers. The room felt eerie and cramped after she had gone.

Why would anyone drown a dead child? Mary asked herself. Was it because of the illegitimacy? Her head was full of questions. Questions that Nora, obviously, did not want to answer. Mary's nerves were like ground glass. She took a little of the spirits of hartshorn the physician had left. But it had no effect.

SHE woke before dawn the next morning. It was still quite dark but her mind was churning with the questions of the preceding night. She could not get back to sleep, and to clear her mind, she decided to take a walk; one could usually find a private path. She tiptoed downstairs with a candle. No one was about in the great hall, though she heard a clattering in the scullery where the morning meal was already underway. She went out a side door and down the steps, still slippery from rain, and entered the herb garden. Somewhere beyond the hedgerow she heard voices. She moved cautiously toward them.

The sun was just pushing up in the east; the sky was the colour of blood and she thought of poor Liam. For all her vows to dismiss him from head and heart, she could not. She hoped that his fellow rebels would be accused only of poaching a rabbit and then let go,

although reports of Defender attacks in the north were angering the landowners. Rebellion was brewing in Ireland, just as it had in the American Colonies and was in France, she'd heard, and it would not be quelled. She was thrilled, and at the same time, apprehensive. Too many, she feared, would die.

The voices were female, speaking Irish. She would have liked to learn Irish but she was having trouble enough with French and Italian. These were obviously tenants, but what were tenants doing in the castle garden?

She entered a path not taken since her arrival, where, it seemed, mostly new young plants were being established before removal to one of the other gardens. And there, to her surprise, she spotted Nora and Bridget Donovan.

Nora was bent over a spade, digging and lifting, tossing the earth into a growing pile. Then digging some more, whilst Bridget stood guard over a small wooden box. Finally Nora was done, and Bridget laid the box in the hole. Mary did not have to ask to know what was in it. The women tossed wild aster and tiny blue flowers of milkwort on top of the box; and then fell on their knees, crossing themselves. There was not a single tear. It was as though they were performing a perfunctory duty, neither pleasant nor unpleasant, one that had to be done now that the river could not keep the child.

Afterward they looked at one another in silence and joined hands. Burying the baby seemed a natural thing to do: the river had rejected it and so it must go into the earth. But why in such a clandestine manner? For Sean Toomey there was a processional through the land and then days of mourning and feasting. Where were the keening women now? Where were the neighbours who were present at the birthing? The hedgerow, where Mary was wedged, was like an armour of nails; the twigs scratched her skin as she pressed against them. But she did not want her presence known.

Finally Bridget Donovan broke the silence. In proper English now, as though it was the language one should speak in an English garden, Bridget said: "Well now, and 'tis done. I don't know where the soul is, but 'tis not here in this ground."

"Sure and it's somewhere in heaven," said Nora piously, pointing toward the sun that had turned to a liquid orange. "Isn't that why we tried to baptize it, poor helpless soul? But alive, the child would be a walking sin. And what other way was there for it?"

Bridget nodded, and letting go her sister-in-law's hand, dropped to her knees again by the grave.

"We must cover the place up," said the housekeeper, coming back to business. Stooping, she placed leaves and twigs over the grave. Bridget helped, the two women working furiously to leave the garden as they had found it.

Mary was confused. What did Nora mean about a walking sin? Bastards were born every day. James himself, Mary recalled, had entered the best society as a natural son. Had Shakespeare written of James King, he might have made the man a good revolutionary, fighting the evils of oppression.

The ritual completed, Bridget left the garden, and Nora came plodding toward the hedge with her spade. Mary pressed close into the brush. Her senses were fully alert; she barely breathed, but listened, her chin prickling. She heard the whinnying of horses in the stables, being readied for a fox hunt, perhaps—pleasure prevailed in this household. The hanging, if that was to be the fate of the new prisoners, must wait for a more convenient moment.

The sharp end of a twig pressed into her neck and she couldn't help but cry out. Nora loped toward her with the spade. It was a mean-looking weapon. Mary jumped out of the hedge and threw up her arms. "It's just me," she said in a breath. "I was taking a walk. You recall what we were talking about last night?" The spade lifted high in the housekeeper's hands. "It's all right, I won't tell," Mary blundered on," you know I won't. So you were burying the child. It was only right to do so, it was to be expected. But why such secrecy? Won't Fiona wonder? Wouldn't she want to be here to say goodbye?"

Mary held her breath while Nora's eyes bored into her own.

The housekeeper lowered the spade. She sank down on a rock, her legs splayed in front of her. She looked exhausted, her pocked face turned to chalk. "Fiona is sleeping," she said. "Bridget'll tell her about the burial when she wakes. We've left a marked rock in the upper corner." Her voice rose shrilly. "Does that answer your questions now?"

"But why bury the child here, and not by the cottage?"

"Well now, the Donovans don't own their home, do they." The voice was steely again. "It belongs to the big house—and so did the child's father. And this is the softer earth, it's been turned over more often. We didn't want to bring a man to help, did we?

He might talk. Fiona can come here if she wishes, but sure, and I don't think she will. Not after Bridget told her about James and young Eva. Aye, she did! It near killed Fiona to hear that. And now Devin's after hanging about the place. He's got his eye on Fiona, Devin has. Though she's a long road to move down afore she's ready for a new man."

"Poor Fiona." Mary was displeased with Bridget for telling the girl in that blunt way. Besides, she had written proof that James loved Fiona above Eva—he was done with the former governess. Margaret hadn't yet returned the letters from Fiona they had found in James's town house, and perhaps it was just as well. Fiona must not go on mourning a lost lover; it wasn't healthy. Mary had learned that, to the detriment of her nerves.

"Why did you call the child a walking sin?" she asked. "The world is full of natural children who *make* something of themselves."

Yes, indeed, she thought. Though at the moment she couldn't think of anyone who had.

Nora was just sitting there, staring up into the pumpkin sky. "Incest," she whispered.

"Incest?" Mary sank down on the grass beside her. She waited for an explanation. "Incest?" She was not prepared for the transformation in Nora's face. The expression was hard, as if cast in stone. The housekeeper was having difficulty finding the words.

"Nora?" Mary begged.

"Fiona was Lord K's child," Nora said finally in a flat, hard voice. "You see, can't you, why *her* child could not have a proper Christian burial?"

"You're certain of this, Nora?"

"Aye, and God help me, 'tis true! He took Bridget when she was but eighteen years of age. He was barely sixteen, the son of an earl, and betrothed to Caroline FitzGerald—though the girl wanted nothing to do with him then. At the time, he was in Mitchelstown to look over the castle he'd inherit, and make plans for rebuilding it. But Bridget was an innocent and he charmed her—what could she do but give in?"

The housekeeper looked pallid and worn as though she'd had no sleep, deciding what to do about the child.

"And what did Bridget do?" Milord's conquests had begun earlier than Mary had thought.

"Well, and shortly afterward Bridget married me brother Hogan. He always thought *he* was the father—God rest his soul—she never told him otherwise. But she knew, aye, she knew surely 'twas Lord Kingsborough."

"Did he know—Lord Kingsborough?"

"Oh, I doubt it, she'd never give him the satisfaction, would she now. And she was afeared he'd let it slip to Hogan. I was the only one knew. I was the midwife, you see—'twas me very first—she had to tell *me* at the birth. I promised I'd never tell another living soul and I never did. Never. Till now." Nora dropped her chin into her hands. "But what does it matter now, with James in the ground?"

"What had James to do with it then?" Mary sat up straight, clasping her knees.

"Can't you see?" Nora leaned forward, almost irritably—as though Mary was being particularly obtuse. "Fiona is Lord Kingsborough's daughter, I'm trying to tell you. James, I've said, was milord's brother—Cook says so, and she was there at the time of the birth."

"You're sure of that?"

"I'm not *sure* of anything but what I see around me, am I? But it's highly probable, I'm telling you. So Fiona's child would have the blood of both."

This is the stuff of Shakespeare, Mary thought.

"It's incest, miss! It goes against the laws of the church. We cannot have it so! And 'twas malformed to boot—I can't speak of it now. The skin, for one, a bluish colour, the eyes..." She crossed herself. "'Twould've died soon enough. Was it fair to Fiona to have her see him? That's why."

"Why you drowned him," Mary said. She leaned back on her hands as she spoke; she planted both palms on the hard ground. They felt bruised and hot.

"No, no—not on purpose! I would've taken him to a wise woman I know, to care for while he still lived. But me and Bridget were trying to baptize afore he died. You heard the high wind that night? The rain? The river started to rise—we couldn't keep hold of the small body. It got away from us. The river took it."

Mary thought of her sister Eliza's baby that she never saw again after the rescue. At the time she had thought only of her sister, not of the child. She would have to make amends for rushing Eliza off, although it was too late. Eliza's child was dead.

Impulse, she reminded herself. You must no longer yield to impulse, Mary.

Nora tilted back on her rock; she lifted her arms to the sky, as if in atonement. She had said all she was going to say.

"'There is a river...'" Mary remembered from her mother's Bible: "'God is in the midst of her; she shall not be moved.'" She would have to look up the rest—someone would have a Bible in this house.

She rose, using both hands to propel her body up. Her bones felt heavy, her head heavier still on its stalky neck. She backed slowly away, nodding at Nora with her arms crossed over her heart. She would show the housekeeper that she could trust the governess. That Mary Wollstonecraft could keep a secret—though it was a heavy one.

When she looked back again, Nora was still there with her head in her hands.

MRS Cutterby rushed at Mary as she slipped through the door. She was flourishing a Dublin newspaper. "Have you heard the latest news?"

Mary tried to brush past her. Nora's tale had quite undone her. The daily scandals that circulated through the castle seemed petty and stupid beside it. Her head seemed to float above her body.

"Liam is to be hanged," the Cutterby announced in her most portentous voice. "In two days' time."

"Liam?" Mary knew that already, did she not? She was still thinking of the drowned child, trying to make sense of it; thinking of the river and the waterfall. She said, "Tell me, pray, how is Major Cutterby?"

The windmill headdress teetered on the woman's head; the eyes blinked in their pinkish sockets. "At home in bed," the Cutterby said, full of self-pity. "It was those monstrous rebels did it. They assailed him by the river and pushed him over the falls. 'Tis a miracle he survived, although—"

She paused. Mary knew what she wanted to say: He might be better off left for dead. This was indeed true. But Mary said only, "How could the Defenders have been by the river—and yet they were surprised and captured, miles away in the mountains?"

She did not want the Cutterby to know her part in the trauma. She was no less guilty than Nora, was she? She *was* defending

herself. It was all an open question, like most of life's acts. But she must defend the Defenders, too. There was something about this shallow woman that *compelled* one to gainsay her.

"They are everywhere," the woman said dramatically. "Here, there, in caves and crevices. In trees and bushes. Spying and scheming and killing. My husband has a map. It *swarms* with their hiding places—though they keep changing places. We are none of us safe until they are wiped out, every last one." Her fingers flew up like a flock of vultures.

Mary moved on past. Oh dear, she had tracked in mud with her boots; Nora would be upset. Then she recalled that she had left the housekeeper sitting by the hedge, mulling over her deed.

Up in her chamber she cleaned her boots, put on a fresh gown and the tight pumps, and went back down to breakfast. Margaret asked if she had heard about Liam, and Mary nodded. The news had finally struck her. But nothing surprised anymore; she felt jaded. The silence was broken only by chattering children; and at the far end of the table, by Gladys Cutterby reciting the evils of the Defenders to a guest who clucked and shook her feathers like a red hen.

After a biscuit and a hot chocolate, Mary retreated to the schoolroom where her pupils were slumped in their chairs in attitudes of lethargy. "I think I've another cold coming on," Margaret complained. Carrie yawned: "It's this miserable rain, I'm so tired of it. I need sun, sun!"

Only Polly was animated, stringing dried rowan berries for the nursery. Christmas was approaching, and then Twelfth Night, when there was to be singing and dancing and a small exchange of gifts. "Am I too big now for dolls, Miss Mary? George says so. He says I'll stay a baby all my life if I keep playing with dolls. But I would love a porcelain one with curly black hair, I truly would." The matter loomed large in her six-year-old mind.

Margaret expressed concern for Liam and the Donovan family. "How can they think of hanging Liam at Christmas time? It's so cruel."

"My thoughts exactly." Mary could not seem to grasp the reality of such a hanging. The thought brought on a violent headache.

"Can we find a way to rescue him again? Do you think, Miss Mary?"

"Not in Dublin prison. There is no way. We can only hope to bring the true killer to justice. I think—" Mary bit her lip.

"You think?" Margaret repeated, gazing at her governess with huge blue eyes.

"Nothing, really." Mary waved away the question. The lesson must go on. She clapped her hands to bring her pupils to attention. Today they were reading *Othello*. Margaret was studying the speech spoken by Othello when, consumed with jealousy, he was about to strangle the innocent Desdemona.

" 'It is the cause, it is the cause, my soul.' " The girl read aloud, her voice choked with emotion for Desdemona. " 'Yet she must die, else she'll betray more men. Put out the light, and then put out the light....' "

Mary could think only of Nora now. What anguish to drown a newborn babe! Nora, who according to Bridget, had lost but one other infant (not to count three Donovan stillborns) in all her years of midwifery. And that one born blind, and with a cleft lip. Did she help that one to die? Though she claimed the drowning an accident, had she purposely drowned Fiona's babe? If so, Nora would undoubtedly call it *euthanasia*. A pretty word indeed: honey on the tongue. *Euphoria, euthanasia, euphemism*: sweet-sounding words, all from a Greek root meaning "pleasure, gladness." One could make up a poem of such prettily rooted words.

"I can't go on," Margaret wailed, and she threw down the book. "It's all too awful. Poor Desdemona. Poor Liam." She dissolved into a flood of tears. Mary put an arm about her shoulders. Carrie began to weep as well, and Polly sniveled into her rowan berries.

"*Un flambeau, Jeannette Isabelle*," Mary sang, in a futile attempt to teach a song in French, but only Polly joined in. The lesson had disintegrated; there was no point going on.

"We will take a walk," Mary decided. "We will go along a wooded path, away from the river. It will be a nature walk. You can take your sketchbook with you, Polly." Mary had little science in her self-taught background, but she did know trees, along with a few plants and mushrooms. Already Polly had filled the schoolroom with insect specimens: dead bees, wasps, beetles, worms that she sketched and then crudely dissected. "Wrap up well," the governess ordered her pupils.

"AND this, girls," she announced as they strolled along the path, "is a ginkgo tree. See how stately it grows, almost pyramidal. Its

leaves are like milady's fans, all fluttery in the breeze, but now they are yellow, like some older ladies' complexions."

"Like Mrs Cutterby," Carrie said, "though she wants us to think she is young and ever so elegant."

"Even young," said Margaret, "that female was never elegant. She was always a fool. I don't know why my parents tolerate her."

"Hush," said Mary, not wanting to speak ill of the woman in front of the girls. "Mrs Cutterby is, well, useful about the house—a companion to your mother. And now with her husband ill—"

"Ill?" said Carrie. "Demented, you mean. Our agent has gone quite mad. My nurse says so. And all because *she*—his wife—made him kill Sean Toomey."

Mary stared at the girl, round-eyed. "What? Pray, why do you say that?"

"Why, because I know she did, that's why. Because I was under a table when she was planning it. We were playing hide-and-seek, three of us, and I was in that dark little study beside Major Cutterby's map room. And Mrs C said what a weakling her husband was not to do something about his brother's death and get rid of those 'monstrous bad Defenders.' Those were her very words, Miss Mary. And she told how there was a British sailor named Lewis, someone who would stab Sean Toomey in the back for a few guineas and—"

"What? Why didn't you say something to Papa? It was a man's *life*!" Margaret pounced on her sister and shook her. Mary could hear the girl's teeth chatter.

"Stop!" Carrie screeched. "What could I say to him? You know he never listens. He would tell me I was a bad girl to eavesdrop on grown-ups and that I wouldn't understand what they said anyway. Papa *likes* the English. *We* are English! Do you want those rebels coming to attack our house? They have muskets and pikes, you know—they felled our trees to make them. Oh, yes they did, I heard Papa say so. They are wicked!"

"You," said Margaret, pushing a hard finger into her sister's pretty cheek, "are an idiot. Not only an idiot but a conspirator to murder. Your silence has cost a man his *life*. If Papa did nothing, *you* should have gone to see Liam Donovan. *He* would have seen to it that Sean was aware of the danger. Sean would be alive this very day if you had done so." Carrie wailed and Margaret shook

her again. "Remember the time you got lost and Sean found you and shared his bread and cheese with you and brought you safely home?"

Carrie collapsed onto the ground and howled out her distress. "But I couldn't tell Papa *anyway*. Because, if you must know, *he* was the one told Mrs Cutterby about the hired killer. I couldn't tell Papa, could I—that *I* knew?" The girl dissolved into self-pity.

Carrie's pink frock had dirt on it; she would have to change and the governess would be blamed. Mary pulled her upright, looked her in the eye. "You have told us now, Carrie. That, at least, is better than saying nothing—ever. We know now who was responsible for Sean Toomey's death. We have a witness. *You* are that witness."

"What witness?" The girl's eyes were huge and blue-black. "I don't want to be any witness. Papa didn't do anything, he didn't kill anybody. He only told Mrs Cutterby about that man."

Carrie let out another wail and Mary knew it was time to return. But she was not to have a moment's peace because Bridget Donovan was bustling down the river path, calling her name.

Mary told the girls to "go home. You, Margaret, are in charge. Now go!" She waved them off, and just in time. Bridget was in a state of hysteria; her hands twitched with what she had to say. Her mouth opened so wide that Mary feared she would swallow an insect.

She wrung Mary's hands. "I can't let them do it. I can't let him hang for me. No, never, never, I'm telling you!"

Mary gathered that Bridget had only just learned of Liam's imminent fate. The woman hung onto her—too tightly, but it was all right: this was Liam's sister-in-law. Mary looked back at Margaret, who had stopped to admire an insect that Polly had picked off a leaf. For a moment Margaret seemed her own child. If anyone tried to harm *her*, why then—Mary didn't think she could bear it.

She patted Bridget's back and shoulders, but in vain. "Liam will die now, and all for us," Bridget moaned, "when I was the one that—"

"Quiet now, quiet," Mary murmured, unclasping the woman's hands from her neck. "It was not Liam who killed James, we know that. We have reason to believe it was the land agent Cutterby and his wife. We know they did away with Sean on the packet boat. From there it's but a leap of the imagination to discover—"

"Nay, nay! It was *me* killed James. That's what I'm telling you!" When Mary turned, in shocked silence, Bridget said, "'Twas Samhain Eve and he's standing there by the bonfire—" She pointed a shaky finger as though she could still see it. "And him looking so, so arrogant-like, so sure he's the grand lord, stooping to our level for the night. I knew what he done to Fiona, his own relation, God save us—aye, truly, she was—I can't bring meself to say the word, miss...."

"I know," Mary said, "I heard." Bridget squeezed her arms about Mary's waist and this time Mary let them stay.

"I wanted to say it afore, I couldn't, I just couldn't. I had me young ones to think of."

"And then?" Mary was breathless from the squeezing. She believed and yet disbelieved the woman; she wanted and yet did not want to hear the full tale. But had to. "What then? Go on."

"Didn't I see him that night with his arm about Rose Hannigan—she's one for the lads, she is, I cannot abide her—always putting herself in their path. Fiona's with me, I see the look on her face when she sees James and Rose together, and I—" Bridget let go of the governess and covered her eyes with her chapped hands.

"And you?" Mary had to know.

Bridget took a deep breath and turned away as if she couldn't face the governess with what she needed to say. "God forgive me, I'm beside meself. I snatch that knife off the table from the feast—the one I carved the pig with. It's still bloody from pig flesh, I can almost taste it. James is just beyond the fire. I'm after seeing the awful shadow of him with Rose. She's kissing him now, and I hear someone weeping. 'Tis my Fiona, she's seen the pair of them, she's half-kilt, God help her, she's running home. I'm possessed! I'm standing behind a tree, and 'James?' I shout.... He turns, he's alone now, Rose has gone away. I step out from the tree and he sees me. 'You know who Fiona is, do you?' I'm asking and he says, 'Why she's your own daughter, why do you ask that?' And I say, 'Aye, me daughter, and Lord Robert Kingsborough's daughter, too.'" She took a gasping breath, and closed her eyes.

"And then..." Mary said. She held her breath.

"Not a word then," Bridget said. "I can see he's in a shock from the news. 'Well,' says he finally, 'too late now, isn't it?' And he turns his back and takes a drink from his flask. I can hear him humming to himself like he's not a care in the world. I'm in a fury to see him

so calm! The knife is here in me hand, I can see the blood on it. I plunge it into his neck—pull it out again—I've not done with him. When he comes about, he looks like he's grinning and I shove it, hard, I do, into his chest, like I'm killing the pig over and over...."

"Oh, dear God," Mary said, feeling the point of the blade in her own throat.

Bridget was hardly aware of an audience. She was standing there with an imaginary butcher's knife in her hand, dripping with James's blood. But she had not yet done with her tale:

"He's on the ground now and I run back behind the tree. Someone stumbles over his body in the dark and then everyone's running up and shouting. I hide the bloody knife under me mantle—I'm hurrying back home. I'm destroyed, I don't know what I done. I only know I did it, God help me."

She made the sign of the cross over and over, her fingers like frantic moths in a lighted doorway. Then her hands fell to her sides. She was drained, her uncombed hair fallen across her face. A pair of crows called out, like a chorus of shrieking females.

The women stood in silence. What was there left to say? Mary's blood was surging like the falls the land agent had hurtled down.

Finally Bridget lifted her head and turned back to the governess: "I must go to Dublin at once. That's why I've come to see you, miss." She snatched up Mary's hands. "Can you get me a fast horse? I can ride. Liam's to hang Friday dawn they're telling me now. I should've told all this earlier. I thought maybe Liam would stay free, God save him, and I'd be able to..." She fell against Mary in a fit of uncontrollable weeping.

The sun was almost directly overhead; the crows were flying across the sun—Annie would say it was a bad omen. Yet Mary knew she had to be reasonable in the face of the Irishwoman's passion. She was both horrified and sorry for Bridget, but sorrow resolved nothing.

"Go home," Mary told her. "See to Fiona, she needs you. See to Oona and Pegeen. I'll be back in an hour or two."

"But the horse, I must get to Dublin!"

Mary promised she would see to the horse. But first she had other thoughts, half-formed to be sure, but burning in her head. She was suddenly daft with them. She knew, though she dreaded it, that she had business with Lord Robert Kingsborough.

CHAPTER XX.

A Compromise, an Unexpected Gift, and Liberty for (almost) All

S HE FOUND his lordship in the stables, trading stories with a fellow huntsman. He was dressed in his riding clothes, about to ride off to hounds, a practice Mary disliked; she felt an affinity with the fox.

"We need to talk." She stared up into his face, not curtsying, no, she would not do him the courtesy and he knew it. He must know, too, by the set look on her face that she had something serious to say. Something other than the affair with Eva, something that his wife might be interested to hear.

He smiled indulgently, employing the old wiles; he waved away the huntsman. "My dear madam," he said, "do let us be friends now. You and I are alike, are we not? We both have our needs."

"Nay, we are not alike!" She would not ally herself with this man—never mind he had built up a whole town and homes for the townsfolk (who preferred their mud and thatch huts anyway, she'd heard, to the colder stone houses). But she would not let him cajole and use her. "We have business together, you and I," she said in her most authoritative voice.

"Do we now?" he said, still feigning unconcern, though she saw a muscle jump in his cheek. A mare's tail switched at a fly and then slapped his arm. He lifted an arm as if to hit it, and it flinched.

Mary had planned to invite him to converse with her in one of the gardens, but changed her mind when she saw that unkind gesture. When he ushered her toward the stable, she demurred. She was not wholly foolhardy; she would remain here in the open air where others might intervene. "We can talk on that bench." Without waiting for an answer, she took a seat. It was a marble bench, cold and hard; but then, she had nothing comfortable to say.

He remained standing, whip in hand, one foot on the edge of the bench; he looked down on her. She did not care for his superior stance but she held her place. "Milord, I have unfortunate tidings. The infant that was discovered drowned?" He lifted an eyebrow and she smiled, ready to thrust home. She kept him in suspense a moment and then: "They say it was your grandson. I must offer you my condolences."

He was clearly stunned. His eyes stared, a hard cobalt blue. She could smell the mare on him, even in the wind that was picking up from the south.

She told him she had heard about the "grandson" from two or three sources (she did not want to name those sources unless he forced her).

Suddenly his foot shot off the bench and slammed down on the earth; a shower of pebbles struck her boot. He was laughing. "Why, madam, that is simply ridiculous. Dame rumor is all. Is that what you brought me here to say?" He turned as if to leave.

Jumping up, she took hold of his arm. "Wait, sir. And the child, as you surely know, was the offspring of your relative, James—a half-brother was he? Making it—"

"James was my first cousin," he snapped, his cheeks inflating. "Now loose me." But she dug her fingers harder into his arm. One by one he plucked the fingers off. She saw a stable boy eyeing them. This time his lordship was quiet; she could tell he wanted to know all that she knew.

"Ask the mother," she said. "Ask any of your tenants who knew Bridget was with child when she married Hogan."

"That was years ago." He waved away Bridget's pregnancy.

"Someone drowned Fiona's babe. Someone who did not want it alive."

"Well, it was not me. I had nothing to do with it." He coughed and looked away, but she had more to say:

"Sean Toomey, the sailor on the packet boat who drowned? I saw him fall with my own eyes. I saw the knife in his back." (She had nearly, had she not—the flash of it?) "I spoke with him shortly before he died."

He pushed her back toward the bench, but it was all right, she had him now. She sat down. A stable boy ran out to lead the mare back in and they both watched. And then he spoke again. "What *of*

him?" he said, sitting beside her, lowering his voice. "Toomey was a rebel, an insurgent. A gun runner, a danger to our lives—everyone knew that. It could have been any of a dozen people killed him. He had his enemies."

"Enemies in high places," she said. "Lords of the realm, parliamentarians. Protestants?"

"As you are," he said.

"I am," she said, "but I do not believe in killing. Or oppression for the sake of religion."

He smiled. He was on safer ground; they were having a theological argument. He looked at her indulgently, put down his whip, and patted her knee. "Now, now," he said, "aren't we being romantic, though? We're at odds with more than mere religion here, we Protestants. Our differences concern economics, land use...."

They were moving away from the subject. She brought it back, though she longed to rebut—she did love a debate. But not with this man, who only in his thirties seemed locked into his ways, his views. "There are witnesses," she said, looking into the cold eyes, "to attest to the fact that you hired Sean Toomey's killer. You and the Cutterbys. My witnesses have it in writing."

He paled. Again she was fabricating; she had only the word of a minor. But undoubtedly the order to kill was *somewhere* in writing, if the Cutterbys had hired that fellow, Lewis.

"Nonsense." He waved away the accusation. "You can't prove this." He thrust out his chin, his lower lip. He was restless; his hands were twitching: he wanted the dialogue over. He would go straight to his rooms, no doubt, to destroy an incriminating document.

But she could not let him go, not yet. It was true she couldn't offer hard evidence. She could only effect a compromise.

"Major Cutterby has already told me he was guilty of Sean's death. What I did not know was that you and Mrs Cutterby were involved as well. Why, sir, it's only a mental step from there to James's killing. When the world knows about the drowning of your grandson—*your* grandson, James's child—it will speak your name as a suspect, will it not?"

She was enjoying herself now. She stood and lifted her spine with her breath until she was fully erect. She took pleasure in her eminence over him.

"I did *not* kill James. I would not kill my own blood," he said.

He was standing, too, but on slightly lower ground; he had to lift his chin to meet her eye. His eyes were dark; his hand was on the pocket of his coat. What did he have there?

"Nor did Liam. He is innocent. His sister-in-law, Bridget Donovan, continues to plead for his life." She saw his brows pull together; he was thinking. He did not kill James, she knew that. But she could not bring herself to incriminate Bridget; the woman had suffered enough, her family needed her. It were best that she leave the country and go to America, perhaps, with her daughters. George would lose Oona, but there was always the chance that he might escape his destiny and ultimately follow her there. Mary did like a happy ending, in spite of her distaste for romantic fiction.

Milord had out his hunting knife; he was cleaning a thumbnail with it. It had a carved handle with a short, sharp blade. It would not take much to plunge it into the governess's flesh. The sun glanced off the shiny steel; it hypnotized—she could not take her eyes off it. "You have a glib tongue, Miss Wollstonecraft," he said. "Pray keep it still if you want Liam Donovan freed."

He had her backed against a beech tree. She glanced quickly about but saw no one. The sun gleamed through the dying leaves of the tree. His face shone like a fine-honed blade.

Beyond the stables she heard hounds barking, the high-pitched laughter of children; a second stable boy came out with a bay mare in tow and Mary waved at him. He waved back. They were equals, both useful servants.

She laid out a plan to Lord K as it came to her. If he would exonerate Liam with the authorities, she would keep her witnesses quiet about his lordship's involvement. The world would not hear about Fiona's legacy—though a small annuity for the unfortunate girl, she reminded him, would be most welcome. As for Mrs Cutterby, *he* would have to deal with her. The agent's wife knew too much, of course; his lordship would be saddled with her for the rest of his life—a just punishment?

Mary smiled. They would keep a wary eye on one another.

"And you must send the Donovan family to America, mother and offspring, with funds enough to sustain them for at least a year. And Liam as well. Lady K will not want to hear about the liaison with Bridget Donovan, will she? You and she, I hear tell, were newlyweds when Fiona was born?"

He waved the stable boy back and sat down again. She glanced at him for a response but he wasn't looking at her now. His chin was in his hands; she heard the hoarse breathing, like a man at the end of the hunt when the quarry had escaped. "About Eva Noonan..." she began, but did not need to finish her sentence.

His hands acquiesced, a limp gesture. "I'll send the family off—and good riddance."

"Liam, too."

He nodded. Then sighed so heavily that a leaf fluttered off the tree. Purple-red and dry, it circled down and landed on his head. She saw where the brown hair was already receding on the crown of his scalp. He would be an earl when his father died, but he, too, was mortal. In his youth perhaps, he had once, like George, had a passionate love affair. With Bridget herself maybe, ending in the latter's pregnancy, though Bridget would never say. At the time he was betrothed to Caroline FitzGerald, with whom he had little in common. From the start, Mary gathered, he and his wife were two different species, struggling for dominance. She was indeed sorry for him. For both of them.

But she was no longer afraid of him. The shrill voices came closer as the children rounded the corner of the stables and she straightened up, sensing a freedom she had not felt since before she arrived in Ireland.

"It won't be as simple as you imply to free Liam Donovan," he murmured.

"You can do it, milord. I have the utmost confidence in you. You have a witness who saw Liam *elsewhere* at the time of James's killing, have you not? Another suspect or two but no witness, no hard evidence for those fellows so you cannot name them? And your testimony must be soon—before Friday at dawn, am I correct?"

Without curtsying, for she was in a burning heat now, and staggering a bit, she took her leave.

SHE encountered Mrs Cutterby in the great hall but the woman scuttled crablike into the drawing room, as though she already knew what might happen. Major Cutterby's cousin scurried up—not curtsying, for Mary was only a governess; she was chattering about having come from a visit to her "poor dear Willard." He was "quite infirm," she allowed. "An apoplexy, I think—or something

equally monstrous. I left him a stomach tincture; his bowels are upset. But the physician will have him trepanned; he thinks it might help the poor brain."

"Or kill it altogether. I do advise against it." Mary was not glad about the trepanation, by which the surgeon would bore a hole in the skull and virtually de-brain the man. He should be punished for his crimes, not made to lose his mind. She wanted him to meditate on his cruelties, then shut himself up into his candle shop.

"Oh dear, oh dear," said Mrs Thorndike, waving her fan in the governess's face, "I had not thought of that. Oh heavenly father! But we do have the very best physician, do we not?"

"I'm sure you can count on him," Mary said. (To do the man in, she thought.)

"Oh quite, 'tis a shame he had to come to this." The woman fanned her way into the drawing room where Mr Ogle sat on the lemon-coloured settee, reciting a poem to a group of ladies. Their faces opened up like dandelions to the sun. Mary waved at the man from the doorway as though all were well; he gave a tight smile and went back to his poem. He looked small and insignificant in his violet waistcoat that was unbuttoned at the bottom where the belly nudged through. It was too bad, she thought again, for he had many admirable qualities.

MARY saw Liam once more before he departed for America to claim the Massachusetts land that Sean Toomey had willed to him and Fiona. They were all waiting by the castle gates. Mary had hired a coach to take the family to Cobh where they would take ship—Lord K would pay for both coach and passage, of course. What money did a poor governess have?

Though she was bursting with it, she never let on that Liam's freedom and his exile to America were largely her doing. Nora knew, though: she had been watching from a window when the governess and her employer had their confabulation. It was like a mummer's show, Nora told Mary: the gestures and expressions, the changing colours of their complexions, what the housekeeper called Mary's "moment of triumph" at the end. At the same time Nora was worried, she allowed, knowing that the governess knew who had let the infant drown.

So many secrets. And who ever knew the whole truth?

"But you knew I would never tell," Mary said, and Nora smiled her rosy, pitted smile and whispered, "Sure, but in this household you can't trust a soul, can you, to keep a secret?"

Oona was the only one who wanted to stay behind. Fiona was anxious to begin a new life where no one knew about her dead babe, and twelve-year-old Pegeen was thrilled and frightened at the same time to think of encountering Indians. Bridget had gathered up clothing, skeins of wool and flax, roots, seed potatoes, and mementoes of her late husband. She was grateful for the salted bacon and cheese Margaret had brought from the castle kitchen for the long sea journey. She was altogether stoic: she knew she must leave. It was only a matter of time before someone would suspect that she had killed James—there were others milling about on Samhain Eve. But for now she alone would have to bear the guilt.

"I'm praying for James King every day of me life," she told Mary, crossing herself. "And may God have mercy on his soul."

Mary, too, had a moment of genuine prayer for James. He was an ambivalent fellow—it was still not wholly clear which side he had aided: English or Irish rebel. To all appearances, he had sided at one time or another with both. But Mary's was a short prayer: the man was a seducer of women, and she could not condone that.

Liam, though reluctant to leave his fellow rebels, was already telling Margaret that he would be back "in a year's time" to carry on the cause. His fate by then would be out of Mary's hands. Let them hang as they grow, her own mother used to say of her offspring: one must take responsibility for one's behavior. And so Mary had been left to hang as she grew. And so must Liam.

The coach arrived and the meagre belongings were stowed away for the jolting ride to Cobh. They said their tearful goodbyes—George and Oona in particular; Mary was quite undone to see their separation. She had turned away when someone pulled her about to give her a quick, hard embrace. It was Liam.

"*Agus beannachd leibh, tapadh leibh,*" he murmured in Gaelic. "I know what you done for us," he added in English, "and God bless you for it."

She felt his breath in her ear; smelled the sweet sweat on his brow. She wouldn't mind if he were to roll her back on the ground, she was that filled with feelings she could never put in words.

But he went as quickly as he'd come, leaving her alone. He

jumped into the coach, whistling, to join the others; he looked only inward, at his sister-in-law and nieces. She knew then that she had invented Liam. She had fallen in love with someone of her own making.

Long after the coach had rumbled off, with the Donovans alternately weeping and laughing and waving wildly from the windows, and Margaret and Nora sobbing, and George damp-eyed with loss, she leaned against an iron gate for balance. Even then she found herself reeling a little on her feet. She was seeing Eva, plunging off the roof, then Sean stabbed in the back and flying, piercing the surface of the sea, sinking into bitter waters. It was a strange sensation. She wondered what thoughts had rushed through before they stopped thinking altogether.

It was sensible Margaret who brought her back to reality; the girl hooked her arm under her governess's and walked her slowly back toward the castle, where Mary vowed to submit her resignation at once. For now she longed to recross the Irish Sea, manuscript in hand, for London.

But when they reached the great house a swarm of children rushed up to greet her as though she had been away for months. They would not let go until she had swung each one around and then submitted to a warm embrace. Margaret coughed beside her and Polly held up a chameleon she had unearthed.

How could Mary abandon them so soon to their careless parents? She resolved to stay on at least through the Christmas season, and perhaps even until spring, as she had contracted. She did, after all, have debts to pay off. The family would spend much of the winter in Dublin—there might be another chance to humiliate Joshua Waterhouse. And Henry Gabell might, by then, have discovered how shallow his feathery fiancée was, and open his arms to a more vibrant love.

If Mary had no money, she had her dreams.

The younger children raced away and she and Margaret moved toward the scullery door. Looking up, she saw Lady K's face in a window; milady frowned to see the governess arm-in-arm with her daughter. Mary waved her free hand at her.

"Promise me you won't let anyone control you, ever!" she said to Margaret. And the girl smiled, and squeezed her governess's hand; she understood perfectly.

IN the hall a footboy almost rammed into Mary with a packet of letters newly arrived by post. There were three for her: one from Eliza, one from her publisher, Joseph Johnson, with a favourable (praise be) review of her book; and one from generous Mrs Burgh, who had paid all of Mary's creditors so that Mary would have only her to repay. Smiling, she ran after the boy to slip a shilling into his hot hand and he gaped up in gratitude.

Back in her room, she found a missive from Lord K. She read it, open-mouthed:

> *Since Eva did not live to receive the annuity I had promised upon her departure from our service, I should like to offer it to you—as a one-time gift.*

Enclosed in the packet was a note for fifty pounds. Oh! But Mary knew what it meant: she must ever after keep her tongue still. She held it in her hands for a long time, smoothing out the note in her fingers, trying to decide what to do with it. Give it back? She had her pride, yes. But then she had needy siblings—not to mention herself.

And she had her fictional characters. There was no telling what *they* might decide to do. Or say.

THE next day she wrote to Eliza: *I have every reason to think I shall be able to pay my debts before I leave this position in spring.... But with respect to this money matter you must not enquire or expect any other explanation.*

That evening she asked Lady K in front of a group of her children for a holiday leave to visit some of her mother's relations in County Donegal. Milady looked up, surprised, and then blew out her cheeks—they were as red as the holly berries in the drawing room windows. She stamped her foot, twice—from which Mary interpreted, the governess was not to leave.

The children raised a storm of protest: "No, no, don't go, Miss Mary, we can't have Christmas without you!" Polly hung like a necklace about her governess's neck: "Oh, stay, stay!"

Mary did not want to give in to milady, who stood poised on the bottom step of the great staircase like a goldfinch about to fly off a feeder. On the other hand, she could not disappoint the children.

She looked from one to the other; their eyes searched her face.

Finally, milady resolved the question. "By all means then, pray, go to Donegal," she said. "We can get along quite nicely without you, can we not, children?"

Again they put up a howling that brought Nora and two nurse-maids running down the stairs, thinking someone had fallen from a chandelier and broken a tender neck.

"Of course I'll stay!" Mary cried, throwing her arms about the girl and boy closest to her person. "Do you think I could leave you lambkins for the holidays?"

Surrounded, indeed almost asphyxiated by the heap of small bodies, she watched Lady K drag her full skirts slowly off into the drawing room, like a child who had not been chosen to play her favorite game. Mary was truly sorry for her; she knew what it was to be rejected. She was even moved to apologize.

But the apology found no words, for Margaret and Carrie were running toward her, disappointed they had missed the latest drama. Mary waited until milady and her dogs had left the room before embracing the girls. Margaret tugged on her arm and led her to the kitchen. The staff was finished for the night. The room was dark; she sent Polly running for candles.

The small black dog lifted its head from a corner basket; it was a scrawny mongrel, not at all the sort worshipped by milady. The chain attached to its collar allowed no more than a few yards' run betwixt basket, water dish, and a box of putrid sand. It gazed grate-fully up as Polly, back with a candle, knelt to pat its head.

Mary knew what Margaret had in mind; she had considered it herself when she first saw the caged dog running round and round to turn the spit. The two smiled conspiratorily at one another, and then Margaret released the chain and led the dog to the door. Car-rie pulled down a small hunk of salted pork from a rafter, and threw it outdoors in front of the dog. The animal hesitated a moment, glanced back at the door, and then snatched up the meat in its mouth and trotted off in the direction of the gardens.

As Mary watched, it threw the meat up in the air, caught it again in its mouth, and dashed on ahead, its feet kicking up grass and pebbles. She could only hope it would find a home in one of the tenants' cottages. Freedom, she supposed, was not always the answer.

But yes, she contradicted herself, yes, freedom *was.* If only for that one joyous moment of knowing that you were your own person. That no one governed you.

Polly's hand was in the biscuit jar, helping herself. Margaret pushed a hunk of cheese into her mouth. She had allegedly missed supper and was famished. Polly set the jar on the long kitchen table, and governess and pupils sat around it, like a small family, stuffing their faces with cheese and chocolate biscuits, and giggling. They celebrated for a whole half hour before Annie came in "for a sip o'tea" and shrieked to see the "bit doggie" gone. "It turns into a streaky bat at midnight," she cried. "Cook said so, she were right!"

They persuaded Annie to have her tea and biscuits, though she glanced nervously about for the "streaky bat" and then back at the swinging door for the autocratic Cook. Finally, wary of Cook herself, but content, and dreaming of London, Mary blew kisses at the three laughing girls; and carrying her midnight candle, went up to her bedchamber to write.

❦❦❦

Afterword

MARGARET KING later wrote that "the society of my father's house was not calculated to improve my good qualities or correct my faults; and almost the only person of superior merit with whom I had been intimate in my early days was an enthusiastic female who was my governess from fourteen to fifteen years old, for whom I felt an unbounded admiration because her mind appeared more noble and her understanding more cultivated than any others I had known."

At the age of nineteen Margaret became the Countess of Mount Cashell—not because she loved the young earl but because he gave her an opportunity to leave home. She bore him several children in whom, like her mother, she reportedly took little interest. Instead, she rebelled against her own upper class and plunged into Irish republican politics; hundreds of United Irishmen rebels found sanctuary in her home. After the rebel defeat of 1798, she took up with an Irish lover, George Tighe, a man below her in rank. Under the name Mrs Mason (taken from a character in Wollstonecraft's *Original Stories*), she lived out her life with Tighe in Italy, where the pair grew Irish potatoes in pots on the window ledges of their palazzo. She was, by all accounts, a good mother to her "natural" daughters. She married Tighe after Mount Cashell died, and wrote a book on child care: *Advice to Young Mothers by a Grandmother.*

Lady Kingsborough never did forgive her daughter's defection or make peace with her philandering husband. Two years after Mary Wollstonecraft was dismissed as governess, she demanded a formal separation from his lordship, accusing him of "ill treatment." Ultimately she became a woman of power in Ireland, while Lord Kingsborough divided his time between his hounds and his militia and increased his violence against the Catholic rebels.

If Lady K had a favorite among her brood of children, it was her third daughter, Mary, whom I nickname "Polly" in my fictional account. The latter caused a sensational scandal when at the age of seventeen she eloped with one Colonel FitzGerald, her mother's illegitimate, married half-brother (not to be confused with my fictional James King). She became pregnant, and planned to run off with him to America. Lord K fought a duel with FitzGerald, and then threatened to kill the lover if he came near his young mistress. When FitzGerald did, summoned by the girl, her enraged father pursued and shot him. His lordship was tried for murder in the Irish House of Lords. The entire aristocracy rose to his defense and he was acquitted with no witnesses being called.

London society once again turned on Mary Wollstonecraft, not only accusing her of having corrupted the Kingsborough daughters, but of having been intimate with Lord K during her days as governess. Only Margaret spoke up in her governess's defense; but since she was a revolutionary, no one listened. "Polly" King ultimately married a a middle-class man, bore him six children, and died shortly before her fortieth birthday. Lord K, who had attained the rank of earl at his father's death in 1797, died a few years after the trial, making his eldest son, George, the 3rd Earl of Kingston.

Like his father, George became not only a philanderer (despite a wife and three sons), but also leader of the North Cork Militia. Later he founded the Protestant Orange Order, whose mission was to exterminate all Catholics—in particular the rebellious Defenders and United Irishmen. He was captured by the latter during the 1798 battle, but treated well as hostage. Released after the Orange victory, he failed to "evince any sympathy," according to one United Irishman, for the rebel sufferers. He and his mother, Caroline, vied for control of Mitchelstown Castle; he gained it only after her death. He tore down the great Palladian house and replaced it with a Gothic castle. Calling himself the legitimate descendant of his ancient ancestor, he added a soaring White Knight's Tower to the edifice. His mind, alas, became more and more delusional, and he spent his last six years insane in England.

During the Irish civil war of 1922, farming peasants who had formed a local IRA looted and burned the castle, and a dairy cooperative was built on the site. The great Protestant Kingsbor-

ough fortune and power was reduced to a handful of castle stones that, ironically, were used to build a local Catholic church.

Readers might also be interested to know that Wollstonecraft's former beau, Joshua Waterhouse, was found murdered in 1827 at the age of eighty-one. Among the letters discovered in his files were ardent epistles from our Mary. Author T. Lovel notes in his book on the murder: "How far the rev. gentleman sped in his wooing of this intellectual amazon we have not been able to ascertain."

Pray, stay in touch for the London adventures of this passionate Amazon.

Llyn Rice

About the Author

Nancy Means Wright is a longtime teacher and author of fifteen books, including eight mystery novels. Her short stories and poems have appeared in dozens of magazines and anthologies, including a collection of poems written in the voice of Mary Wollstonecraft. A former Bread Loaf Scholar for a first novel and Agatha Award winner and nominee for two children's mysteries, Wright lives and writes in the environs of Middlebury, Vermont. She welcomes visitors and e-mail at www.nancy meanswright.com

MORE MYSTERIES
FROM PERSEVERANCE PRESS
💀 *For the New Golden Age* 💀

JON L. BREEN
Eye of God
ISBN 978-1-880284-89-6

TAFFY CANNON
ROXANNE PRESCOTT SERIES
Guns and Roses
*Agatha and Macavity Award
nominee, Best Novel*
ISBN 978-1-880284-34-6

Blood Matters
ISBN 978-1-880284-86-5

Open Season on Lawyers
ISBN 978-1-880284-51-3

Paradise Lost
ISBN 978-1-880284-80-3

LAURA CRUM
GAIL MCCARTHY SERIES
Moonblind
ISBN 978-1-880284-90-2

Chasing Cans
ISBN 978-1-880284-94-0

Going, Gone
ISBN 978-1-880284-98-8

JEANNE M. DAMS
HILDA JOHANSSON SERIES
Crimson Snow
ISBN 978-1-880284-79-7

Indigo Christmas
ISBN 978-1-880284-95-7

JANET DAWSON
JERI HOWARD SERIES
Bit Player *(forthcoming)*
ISBN 978-1-56474-494-4

KATHY LYNN EMERSON
LADY APPLETON SERIES
**Face Down Below
the Banqueting House**
ISBN 978-1-880284-71-1

**Face Down Beside
St. Anne's Well**
ISBN 978-1-880284-82-7

Face Down O'er the Border
ISBN 978-1-880284-91-9

ELAINE FLINN
MOLLY DOYLE SERIES
Deadly Vintage
ISBN 978-1-880284-87-2

HAL GLATZER
KATY GREEN SERIES
Too Dead To Swing
ISBN 978-1-880284-53-7

A Fugue in Hell's Kitchen
ISBN 978-1-880284-70-4

The Last Full Measure
ISBN 978-1-880284-84-1

WENDY HORNSBY
MAGGIE MACGOWEN SERIES
In the Guise of Mercy
ISBN 978-1-56474-482-1

The Paramour's Daughter
(forthcoming)
ISBN 978-1-56474-496-8

DIANA KILLIAN
POETIC DEATH SERIES
Docketful of Poesy
ISBN 978-1-880284-97-1

JANET LAPIERRE
PORT SILVA SERIES
Baby Mine
ISBN 978-1-880284-32-2

Keepers
*Shamus Award nominee,
Best Paperback Original*
ISBN 978-1-880284-44-5

Death Duties
ISBN 978-1-880284-74-2

Family Business
ISBN 978-1-880284-85-8

Run a Crooked Mile
ISBN 978-1-880284-88-9

HAILEY LIND
ART LOVER'S SERIES
Arsenic and Old Paint
(forthcoming)
ISBN 978-1-56474-490-6

2278011